EZRA JACK KEATS:
Artist and Picture-Book Maker

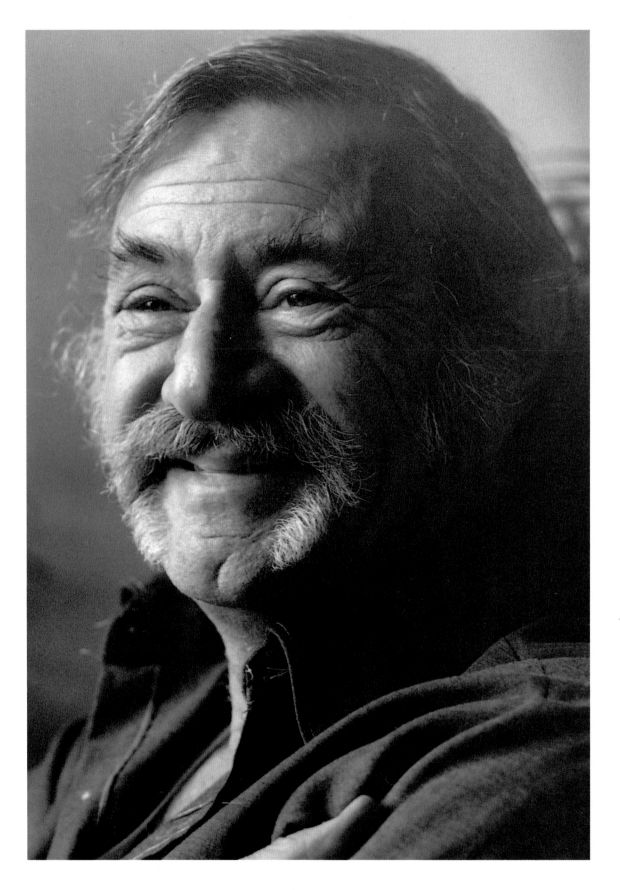

EZRA JACK KEATS:
Artist and Picture-Book Maker

Brian Alderson

Pelican Publishing Company
Gretna 1994

*The word "Pelican" and the depiction of a pelican are trademarks
of Pelican Publishing Company, Inc.,
and are registered in the U.S. Patent and Trademark Office.*

Library of Congress Cataloging-in-Publication Data

Alderson, Brian.
 Ezra Jack Keats : artist and picture-book maker / Brian Alderson.
 p. cm.
 Includes bibliographical references and index.
 ISBN 1-56554-006-9
 1. Keats, Ezra Jack. 2. Illustrators—United States—Biography.
 3. Picture books for children—United States. 4. Keats, Ezra Jack.
 I. Title.
 NC975.5.K38A86 1994
 741.6'42'092—dc20
 [B] 93-43206
 CIP

Manufactured in Hong Kong

Published by Pelican Publishing Company, Inc.
1101 Monroe Street, Gretna, Louisiana 70053

To
Martin and Lillie

—

fideles

—

Heron
Pelican
Walrus
Turtle
Sea-
Otter
Seahorse

Frog.
Penguins
Walrus
Polar Bear
Octopus
ducks

Dolphins

Drawing of a pelican; from a sketchbook.
148 x 100 mm
deG 0140.03

Contents

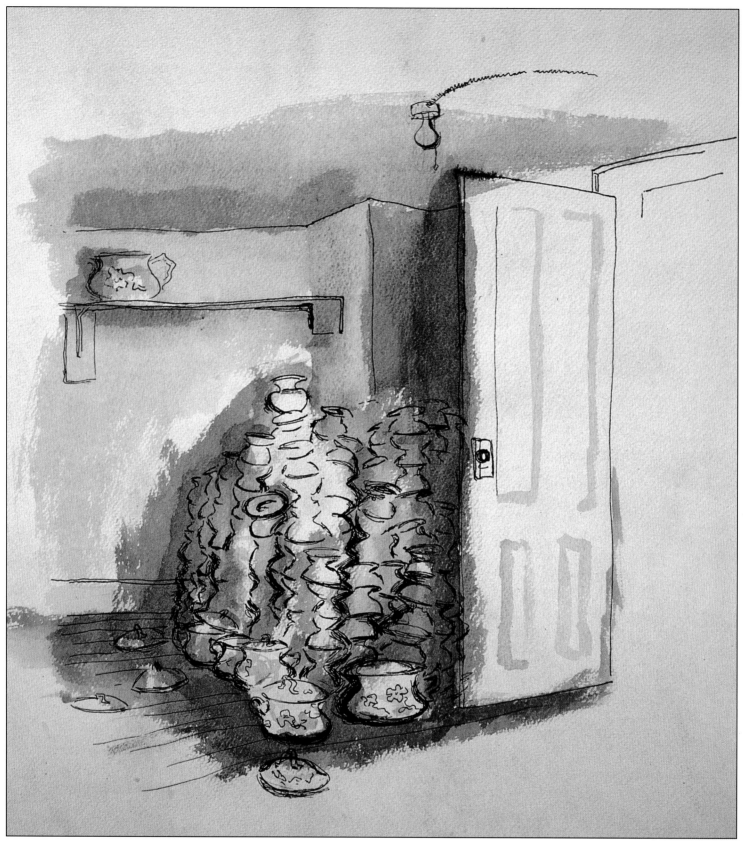

Maid's Room at the Murray Hill Hotel
Watercolor and gouache on grey paper, unsigned
468 x 606 mm, n.d. [ca. 1950]

deG 01.10c

Preface

In 1980 the University of Southern Mississippi awarded their Silver Medallion to Ezra Jack Keats "for distinguished services to children's literature." At the beginning of March in that year Keats attended the university's annual Children's Book Festival to receive the award.

Mississippi was not a state that had figured high on Keats' visiting list up to that point. Indeed, apart from an involuntary stay in Tampa, Florida, as a U.S. serviceman during the war, Keats had rarely spent much time in the South. He was born a Brooklyn boy and grew up a Manhattan man. Nevertheless, his visit to Hattiesburg made a deep impression on him. Not only did he relish the friendliness of the place —an unexpected freeness and easiness about the life of the university—he was also delighted by the attention that the university and its School of Library Service paid to children's literature. The programs for training children's librarians and school librarians were backed up by good resources and by the riches of the de Grummond Children's Literature Research Collection.

This collection, founded by a former professor of library science, Lena de Grummond, consists of wide-ranging holdings of children's literature, complemented by a remarkable archive of authors' manuscripts and illustrators' original art. The strength here (apart from a notable Kate Greenaway collection) lies in the holdings of modern American and British practitioners, and Keats was amazed by the attention that was given to the conserving and cataloging of the material in this rather unlikely quarter of the American Empire.[1]

The collection seemed to him to be an ideal repository for his own substantial archive if that could be arranged. He had long nurtured the hope that his artwork, working papers, and personal records might be kept together after his death.[2]

No formal moves were made at this stage, and within all too short a time Keats suffered the heart attack that killed him. His enthusiasm for the de Grummond Collection was known however and, after his death, Martin and Lillie Pope, heading the Ezra Jack Keats Foundation, made inquiries about a possible transfer of the Keats archive to the University of Southern Mississippi. At that time the university librarian was Onva K. Boshears, who, with great foresight, carried through negotiations, and in 1985 the Ezra Jack Keats Collection was established as part of the de Grummond holdings.

From the time that he made his first survey of the Keats material, Dr. Boshears realized that the importance of the collection lay in more than the dramatic and, at times, spectacular run of original artwork that it contained (both paintings and original graphic art). For Ezra Jack Keats, through most of his working life, had been a free-lance artist, managing his own affairs without the intermediary of an agent. In consequence (and because he was something of a hoarder) his archive formed a very complete record of his day-to-day professional career. Although, regrettably, much contractual and artistic material has disappeared from those years before he achieved fame in 1963, his papers do supply a very unusual record of "the illustrator at work." The creation of illustrations and their accompanying texts can be seen taking place alongside negotiations with editors, visits to printers, and the everyday toings and froings of a New York artist.[3]

Although no specific agreements were made about the subsequent exploitation of the Keats Collection, both the University of Southern Mississippi and the Ezra Jack Keats Foundation were keen that conservation and cataloging should not be the end of the acquisition procedure. An Ezra Jack Keats lectureship was set up to take place in conjunction with the university's annual Children's Book Festival, and the idea was mooted of a published account of the collection. For reasons more accidental than contrived, I found myself involved in discussions on the subject, and, through the persuasive endeavors of Martin and Lillie Pope, discovered that I was to be entrusted with the exposition that follows.

I volunteered to introduce a published catalog, and found that I was not only to compile the same but to write this supplementary study as well. The foundation, the university, and, eventually, the

publisher concurred in deciding that the most fruitful account of the archive would be through two books: the descriptive catalog and this discursive commentary. They are designed to complement each other and, as a unit, to pay tribute to an artist who significantly widened the scope of modern picture books. They will also be seen to honor a maker of books for children who understood and enriched the lives of innumerable members of that responsive tribe.

Friends, admirers, and students of Ezra Jack Keats may be surprised that the work on these two books should fall to an Englishman. I never knew Keats; his work has not figured prominently in my few critical excursions into children's picture books; and I was not close to the American publishing scene at the time when he came to the fore as an illustrator. Nevertheless, Martin and Lillie Pope suggested that what experience I have as a writer about children's books might be put to good use in working on the Keats archive, while the oblique view of his achievement gained from a transatlantic stance might have a certain dispassionate freshness. The two books, in any case, would focus on the man and his work, rather than the man and his life. We all agreed that hagiography was not required.

Venturing towards Ezra Jack Keats from this foreign direction has brought me into contact with a large number of people who knew him and with many parents, teachers, and librarians who have directly experienced the pleasure that children take in his books. All of these people showed a keen enthusiasm for this project and I have incurred many debts of gratitude as a guest in the United States.

First of all, during several visits to New York, I received wonderfully tolerant hospitality from Ray Wapner and Peter Courmont, Selma Lanes and Helen Andrejevic; and while in that city I was able to meet and talk to many friends and associates of Ezra Jack Keats: Dean Engel, Harold Glaser, Betsy Hass, Esther Hautzig, Susan Hirschman, Fran Manushkin, Elizabeth Riley, Joan Roseman, Mira Rothenberg, and Ava Weiss. In other quarters of the United States I have had much help from Florence Freedman, Millie Keats, Bonnie Keats, and Lloyd Alexander, while visits to Washington, D.C., were given a holiday flavor through the hospitality of Jessie Hodnett and Judith Plotz. Back home in England I have also benefited from conversations with the three editors who were chiefly concerned with publishing Keats' books: Judy Taylor, formerly of the Bodley Head, Julia MacRae, formerly of Hamish Hamilton, and Kaye Webb, formerly of Puffin Books.

At Hattiesburg I have received much support in my work from the president of the University of Southern Mississippi, Dr. Aubrey

K. Lucas, and from the assistant vice-president for academic affairs, Dr. James Hollandsworth, who has attended to several tiresome and not-very-academic negotiations with great patience. Jeannine Laughlin and Onva Boshears in the School of Library Service are friends on whom I have been able to rely for encouragement at all times, but the burden of work on this book within the university has fallen upon Dee Jones, the curator of the de Grummond Collection. Not only has she carried out all the sorting and cataloging of the Keats material (as I describe in *Ezra Jack Keats: A Bibliography and Catalogue*) but she has been indefatigable in helping me to find my way through the two hundred or so boxes of the holdings as well as through the inscrutable mysteries of the Library of Congress system for classifying and shelving books. My thanks to Dee must also be extended to her graduate assistants, Kim Jones and Carol Thiesse, who have shown both patience and extraordinary skill in deciphering my handwriting and converting it into the mechanical form on which this printed text is based. Dona Helmer, from various points of the compass, has given me regular information about obscure manifestations of Keats' work in pamphlets, posters, and audiovisual aids.[4]

My wife, Valerie, has been a constant support through the months of travelling and truck-stopping that this project has involved—playing the now discredited role of housewife and helpmeet—but my greatest debt of gratitude is to Lillie and Martin Pope. They got me into this complicated job, but they have shown unswerving support and generous kindness in helping me to do justice to their friend, Ezra. I hope they will not be too disappointed at the result.

EZRA JACK KEATS:
Artist and Picture-Book Maker

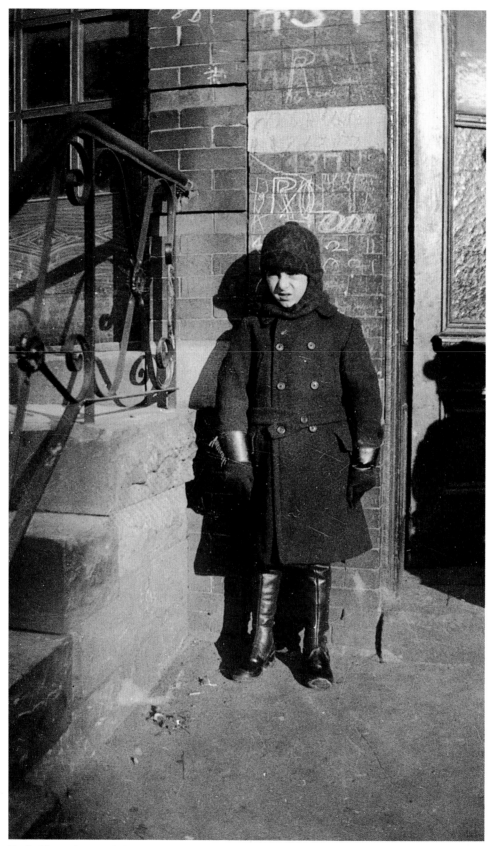

Jack Katz dressed for winter on Vermont Street, ca. 1921-22.

CHAPTER ONE

"A Very Fine Chap"

He was not Ezra Jack Keats to begin with, but Jacob Ezra Katz, known to everyone as Jack. His father, Benjamin Katz, had been born in Warsaw around 1868 and had emigrated to the United States in 1883. He had settled into what was then a predominantly Jewish quarter of Brooklyn known as East New York and had entered into a marriage, organized by a matchmaker, with another Polish immigrant, Augusta—"Gussie"—Podgainy. She had been born in Warsaw too, about nine years after Benjamin, on May 15, 1877, and had come to America in the early 1890s. She had travelled steerage, in extreme discomfort, and her sister who accompanied her had died during the voyage.

These were not, then, very propitious beginnings for Benjamin and Gussie, and they illustrate what was the lot of thousands of their fellow Jews who had made the same journey westward. From the shtetls and ghettos of Poland the United States looked like a new promised land, a refuge from the anti-Semitism that was rife on their own doorsteps, obstructing all hope of individual betterment. On arrival, though, they found a raw urban society, very different from their expectations. Finding—and keeping—work was not easy; poverty was a way of life; the need to make common cause with those of like experience, who spoke the same language, led to the creation of a new kind of ghetto on the streets of East New York.

For Benjamin and Gussie the difficulty of adjusting to this new life was increased by their union through the arranged marriage. They were not temperamentally suited to each other and although Benjamin seems to have made a way for himself as an insurance salesman for the Prudential Insurance Company,[1] hunger was never far off and family tensions worsened with the coming of children. A first child died in infancy; a second, Mae, was born with a deformed spine, which shortened her stature and led to her being stigmatized as a hunchback. William, the third child (who came to be known as Kelly because of his red hair), did well, but Jacob Ezra—last of all— was a difficult birth. "I was an incubator baby," he said, "premature by a few weeks,"[2] and the ailments to which his mother was prone from that time on came to be laid at his door.

The date of his birth was March 11, 1916, and for the early years of his life (perhaps while the insurance sales were going well) the family occupied a "railroad flat" in a two-family house, probably no. 438 Vermont Street. These railroad flats were designed rather like a series of railroad cars with each room leading directly into the next and no space allotted for a corridor so that there was none of the privacy afforded by single rooms. Even so, such apartments in a two-family house were a cut above tenement dwellings, and it was to a tenement dwelling that the Keats family moved in the late 1920s when Jack was in junior high school. The place was on the third floor of a walk-up tenement at 666 Dumont Avenue on the corner of Pennsylvania Avenue, a building still standing among the battered houses and empty lots of the area today. The move was made of necessity, for the live-wire insurance man had now become a counter-hand at Pete's Coffee Pot, a diner across the East River in Greenwich Village, and although he would retain that job through the worst years of the depression, the ill-paying and exhausting work did nothing to ease the tensions of family life.[3]

The young Jacob Ezra seems to have been early aware of his parents' "loveless marriage . . . bitter marriage,"[4] and the general unhappiness of his childhood ("I had a very sad face . . . they used to call me 'Watermelon Face'")[5] found focus in a contempt for his father and a feeling towards his mother that was as powerful as it was ambivalent. Gussie seems never to have known how to deal with her sensitive son, whom she encouraged and castigated by turns. As a result, Keats found himself loving her but simultaneously blaming her for imposing on him burdens of guilt that he carried all his days. The frequency with which, in later life, he reverted to descriptions

and analyses of his childhood years—in conversation, in interviews, and in the many drafts of his planned autobiography[6]—endorses the trite but ancient truth of the child being father to the man and explains why, after the war, Keats so regularly sought the help and support of psychotherapists. (Indeed, it was one of these sage persons who pointed out to him that the tree which Peter thwacks with his stick in *The Snowy Day* is nothing else but a silhouette of the artist's mother, "her hairdo, her nose, her chin, her bosom . . .") [7]

Despite these fundamental crises in his early development Jacob Ezra also gained from his parents a wondering sympathy for

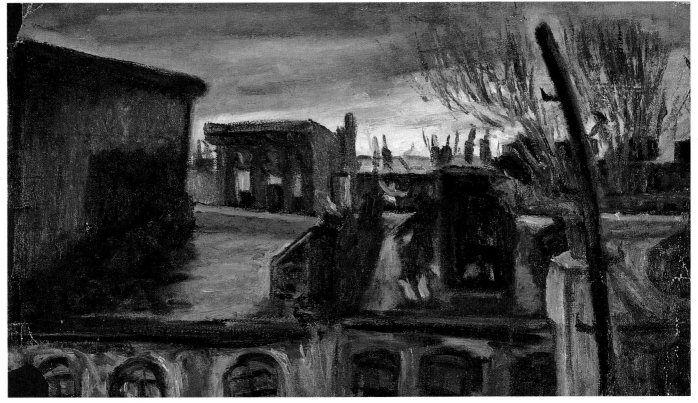

Scene from a Rooftop in Brooklyn
Oil on unmounted canvas, unsigned
230 x 395 mm, n.d. [?1934]

A fragile relic of an early oil by Jack Katz, but the serried windows at the bottom would make a transformed reappearance in *Dreams*.

deG 0154.08

what they must have seen as his unusually sensitive temperament:

> When I was six or seven I asked [my father] why I had a cleft in my chin. "When you was born," he said, "an angel came and whispered into your ear. To keep the orders he gave you secret, he tapped your chin with his little finger. That mark is your agreement with him." He looked at me ruefully. "You must know things I don't."[8]

This temperament, this secret agreement with the angel, found its expression in art. From almost as far back as he could remember, Keats was amazed at the gift that had come to him apparently from nowhere, and if ill fortune must always be balanced by good, then it was his luck to find within himself a means of countering the desperate circumstances of his childhood: "the only hook I had on life was my drawing. . . ."[9] He was also fortunate that his mother expended devoted admiration, if not a very demonstrative love, on her son and his talents and encouraged his skill.[10] Even the opposition of his father had an element of "form" about it. Ever since Keats' Caldecott Medal speech of 1963, the story has been widely disseminated of how his father brought back tubes of paint from Pete's Coffee Pot, pretending that they had been bartered by a starving artist, whereas he had actually been buying them for his son; and covert support was given more openly on the occasion of a famous visit to the Metropolitan Museum, when the boy discovered Daumier while his father was hoping that he would be impressed by portraits of the nation's heroes. How touching too, not only the equally well rehearsed story of Jacob Ezra being called upon to identify the dead body of his father and finding in his wallet newspaper clippings about his own early success, but also the father's naïve hope that his son's gifts would lead to a great career as a sign painter, as witnessed by this commission, now lost to history:

> New low prices at Pete's Coffee Pot
> Two eggs w/potatoes & Coffee —10 c.
> Pigs Feet & Sauerkraut—25 c.
> Pancakes & Sausages—25 c.[11]

Benjamin's incomprehension of his son's artistic aspirations is itself entirely comprehensible. At that time and at that place there could be no other reaction to signs of talent in one's offspring (whether artistic or scientific) than that the potential should be

directed to practical and financially rewarding ends. Such narrowly conceived domestic support gained more fiber through the recognition that came from the East New York schools. Jack Katz first went to PS (Public School) 182 on Dumont Avenue, where perhaps the earliest public display of his work occurred. The details and the chronology have been swamped by the impact of the event itself, but it seems that one day he brought to his teacher (Mrs. Hoffmann—he always remembered her name) a collage that he had done, a piece of shaped yellow paper glued to a backing sheet. The teacher immediately pinned it up on the wall and the small boy was struck with wonderment and pride that not only did she leave it pinned up, but pinned up beside it further work that he gave her.[12]

Encouragement of this kind was to be Jack Katz's fortune throughout his school career. After leaving PS 182 in 1929 he went to JHS (Junior High School) 149 on Sutter Avenue and Wyona Street, where very recently the foundations had quivered beneath the antics of a pupil who was on his way to becoming Danny Kaye. Here Katz is reported to have "won many awards"[13] and, indeed, to have won some public recognition as well, for, on February 2, 1931, the *Evening World,* a highly regarded New York paper, published a picture of Jack Katz standing beside a large charcoal sketch of a mural he was working on for the school auditorium, a view of the skyscrapers of Manhattan with sundry ships and aircraft representing "science." He also won a (rather inelegantly designed) medal on a red and white ribbon for "Drawing."

(From this period too comes a poetic effusion, written with true liberal sympathy on behalf of Governor Al Smith, who was running for the presidency on a "wet" ticket against the "dry" Herbert Hoover:

TO AL

Vote for Smith anti dry
He'll be president by and [by]
Down with the dry
Up with the wet
Roosevelt will be governor of New York yet,
Vote for Smith he's a real New Yorker
Oh, Boy, he sure is a corker
Of Thomas Ottinger, Hoover and all the rest
I think Smith is the best
Vote for Smith anti dry
He'll be president by and by.[14]

Much as one may be drawn to the sentiments, there must be doubts about whether these lines augured well for a future in poetry.)

The years at the "Danny Kaye School," as it has since been named, brought forth two other events that were to be of enduring consequence. The first of these was an accidental encounter with a fellow student, known to close friends variously as "Itch" or "Itz," during summer school, when both boys were having to repeat algebra (Itch because he had cheeked the teacher, Jack because his grades weren't good enough). Onlookers might have seen the friendship as an unlikely one, for Itch was of a scientific disposition, headed for a distinguished career in chemistry and in university teaching as Martin Pope. But he lived close to the Dumont Avenue tenement, and before long he and Katz had established one of those intense boyhood friendships through which, it may be argued, more intellectual growth and more self-understanding come about than through formal academic channels. In junior high school, in high school, and walking the neighborhood streets, the boys argued over everything from higher metaphysics to how to earn another dime, while neither was capable of knowing that they would both eventually win renown in their chosen métiers and that the closeness of their friendship would be of lifelong duration.

The second extracurricular event of these years came about partly through this friendship, which was opening Jack Katz's mind to new ideas, and partly through his lovelorn wanderings past the house of a certain Harriet Tawarski, which carried him one day, in a state of euphoria, into a smart neighborhood where he discovered the Arlington Branch of the Brooklyn Public Library. Ezra Jack Keats has himself written of this thrilling event (however undramatic it may now sound to generations brought up on information and culture—of a sort—piped through the living-room walls):

> I wandered around and discovered that I could get a card, become a member of the library and actually take these books home. I returned regularly and began to read the art books from one end of the shelf to the other; [and in the Reference Room] I'd take my place at the tables with stern, silent, studious adults, with my own pile of books. . . . Life welled up inside me. I would be an artist. . . .[15]

Martin Pope confirms how the two of them would walk through the sequestered, treelined streets of Arlington and then, within the library, take their separate ways to "Science" and to "Art" to find equivalent, treelined avenues of the mind that suddenly made the depression and the crowded blocks of East New York more bearable.

WORMS CAN'T CRY

《 On Seeing A Breadline 》

DR. ELIAS LIEBERMAN

NOT eat,
t sleep;
ant beat way down deep,
man's rhythm
n my blood,
n a flood:
ms can't cry," it breaks to me—
ms can't cry,"
ms can't cry."

eel the sun-rays
down my spine,
ee the blue sky
toward a line,
hear forevermore
underground,
ices, grimy voices
rom a choked Inferno:
ms can't cry!" they plead to me—
ms can't cry!"
ms can't cry!"

he heart within my bosom,
ull of lead;
tride the upland hills
ith the dead
nd and wait for bread.
g dead who day and night
ying press
ainst the earth's core
tter-keen distress:
ms can't cry," they signal me—
ms can't cry,"
ms can't cry."

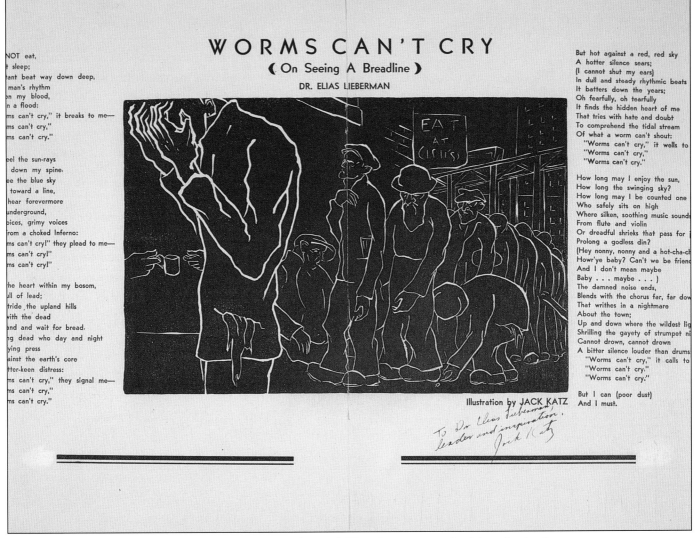

But hot against a red, red sky
A hotter silence sears;
(I cannot shut my ears)
In dull and steady rhythmic beats
It batters down the years;
Oh fearfully, oh tearfully
It finds the hidden heart of me
That tries with hate and doubt
To comprehend the tidal stream
Of what a worm can't shout:
 "Worms can't cry," it wells to
 "Worms can't cry,"
 "Worms can't cry."

How long may I enjoy the sun,
How long the swinging sky?
How long may I be counted one
Who safely sits on high
Where silken, soothing music sound
From flute and violin
Or dreadful shrieks that pass for
Prolong a godless din?
(Hey nonny, nonny and a hot-cha-ch
Howr'ye baby? Can't we be friend
And I don't mean maybe
Baby . . . maybe . . .)
The damned noise ends,
Blends with the chorus far, far dow
That writhes in a nightmare
About the town;
Up and down where the wildest lig
Shrilling the gayety of strumpet ni
Cannot drown, cannot drown
A bitter silence louder than drums
 "Worms can't cry," it calls to
 "Worms can't cry."
 "Worms can't cry."

But I can (poor dust)
And I must.

Illustration by JACK KATZ

Illustration (after a linocut?), 140 x 210 mm., by Jack Katz for a poem by his principal at Jefferson High, printed in the school magazine, the *Jeffersonian*, n.d. [1933] (tear sheet). This copy is inscribed to Lieberman by Katz; the archive also possesses a copy inscribed in the reverse direction.

deG 0157.01

On February 3, 1932 Jack and Itch took part in the graduation ceremony from JHS 149 and moved around the corner and up the street to Thomas Jefferson High School, diagonally opposite the Katz tenement block on Dumont Avenue. The school had only opened ten years previously, but under its principal, Elias Lieberman, it had already gained one of the highest reputations among the high schools of New York. Lieberman sounds to have been the perfect type of schoolmaster, one who is capable of combining a demand for the highest level of performance from his students with a tempered liberalism as to methods for achieving it. He was certainly a man dedicated to the arts (the opening lines of "Endymion," by

JACK KATZ (above) of 666 Du-
mont Ave., a student at Thomas
Jefferson High School, was
awarded first prize in the nation-
wide competition held recently.
His paintings will be exhibited in
leading cities of the United
States during the year.

Cutting from an unknown
newspaper reporting the
Scholastic award.

another Keats, were mounted on a plaque at the school entrance)
and during Jack Katz's three years as a student at Thomas Jefferson,
he was able to build on the foundations of his junior high school
years. Surviving honor cards show an assured progress through the
subjects that he studied and in his major, art, he established a repu-
tation both within the school and beyond it. He also gleaned from the
Lieberman ethic and from excited debates with his peer group a pow-
erful sense of social justice, which was at first tested by the turbulent
economic and political events of the thirties and remained as a philo-
sophical constant in his working life.

Something of the varied scale of his activities and successes can
perhaps be indicated by an abbreviated calendar of events for 1934,
which must have seemed a whirlwind year to the family in the walk-
up apartment on Dumont Avenue—and also a welcome justifica-
tion for Jack Katz's persistence in following his own bent. In Febru-
ary he received a scholarship that would take him to the art branch
of the Educational Alliance in New York City to study under the
etcher Abbo Ostrowsky. In March he was elected president of the
Brooklyn Society of Younger Artists at the Brooklyn Museum, while
at Thomas Jefferson High School he was installed as a member of
"Arista," the high-school equivalent of Phi Beta Kappa. (Of the first
of these official positions, the school magazine, *Liberty Bell*, was later
to report that he was "trying to re-organize the Society,"[16] but we
hear nothing of the results.)

Then, in April 1934, there occurred what was perhaps the most
important event of Jack Katz's school life: the announcement on
April 28 of his winning first place for an oil painting in the National
Scholastic open competition, which was sponsored by the Carnegie
Foundation. The subject of the painting, *Shantytown*, was dictated
by his direct awareness of the miseries of the depression; its execu-
tion—forceful in composition and in its somber hues—suggests a
practiced confidence. The award brought him praise well beyond
the *Liberty Bell*'s local assertion that he was a "potential great man in
the field of art."[17] The national magazine *Scholastic* carried a report;
there was a report and a photograph of the painting in *The New York
Times*; and a mixture of more directly personal responses also
occurred. These ranged from his first fan letter (from a girl in Hono-
lulu) to an opening up of further contacts with the good and the
great. Herman Sobel of the Rich Art Color Company wrote to
Lieberman, who was an acquaintance, saying that he would like to
meet Jack Katz, and Lieberman commended his pupil to him as "a
very fine chap as well as a talented artist."[18] Soon after this, in July

22

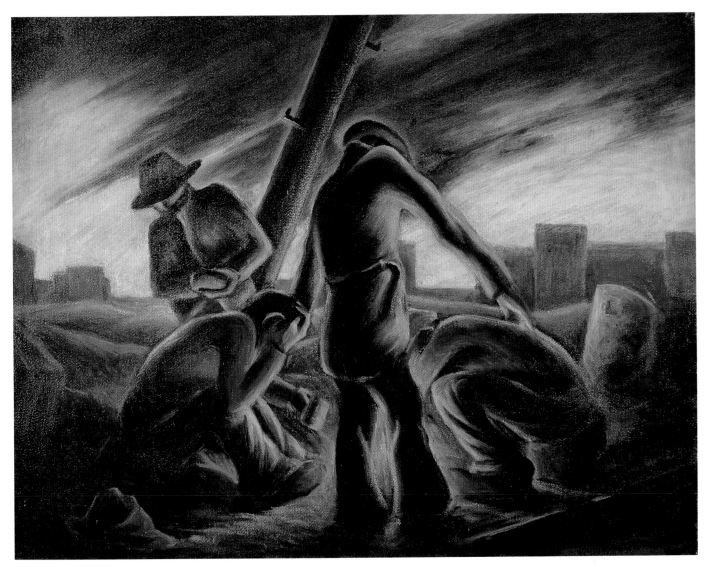

Shantytown
Oil on canvas
472 x 606 mm, n.d. [ca. 1934]
deG 01.03

1934, Katz paid a visit to the home of the great Max Weber, the artist who, years before, had brought the fauves to America and who was living at Great Neck on Long Island. The visit has been the subject of several late, and slightly embarrassed, reminiscences in which Keats recalled his naïveté (he asked rudimentary questions such as "how do you clean your palette?" and made gauche comments such as an uncalled-for comparison of a Weber painting to one by Cézanne) but Weber must surely have expected such things and the invitation says much for his professional generosity. Indeed he did not forget it, for meeting Keats later at an exhibition he remarked, "Ah, the boy from Brooklyn!"[19]

During this year at Thomas Jefferson, Jack Katz was also reported

Silas . . . appeared for the first time within the church . . .

Jack Katz could hardly have foreseen that he would eventually publish an illustration (and a book jacket) for *Silas Marner.* This two-color drawing is reproduced from an unidentified textbook.

deG 0157.14

as preparing a group of murals for a corridor in the school. By October, *Labor* was already finished, and in that month too he took up another scholarship to study oil and mural painting under Jean Charlot at the Florence Cane School of Art in New York City. Moreover, within Jefferson he had also, by this time, established a firm friendship with his English teacher, Florence Freedman, whose presence —like that of Itch—was to become a permanent reference point in his life.

Florence Freedman has herself written of her early encounter in the classroom with this boy who, in answer to a question about the miserliness of Silas Marner, replied with an unexpected defense: that Marner's love of gold was indeed a love, just the same as Katz's love of tubes of paint, and thus more understandable and more forgivable than was generally admitted.[20] Intrigued, Freedman sought to discover more of this surprising pupil and, before long, found herself mounting the stairs to the apartment on Dumont Avenue, where she became a regular visitor at the end of each school week, to be regally sustained by Gussie Katz on Jell-O and cream.[21]

Embarrassing though it may have been to Jack Katz to see this meeting in his home kitchen of the representatives of two such disparate worlds—educated, respectable, understanding Mrs. Freedman and temperamental, depressed, poverty-stricken Mrs. Katz—the relationship nonetheless made for stabilization at a time when stabilization was a paramount necessity. For not only was the question of a future after school becoming pressing, but its urgency was dramatically increased when Benjamin Katz dropped dead in the street from a heart attack the day before his son's graduation in January 1935.

This was the occasion when Jack was called out from home to identify his father's body, and the trauma of the event, the conflicting emotions that it must have brought to the surface, coupled with the sense of the ending of a phase of his own life, made for a crisis that called for all the help that friendship could muster. Life at home had never been easy but it had challenged rather than repressed his creative instincts, and the support that he gained outside home —from friends; from school; from the mute assurance of what he found on the shelves of the Arlington Public Library—enabled him to make something of the challenge.

If any one thing could be seen as symbolic of this East New York childhood then it is surely the outstanding portrait of his parents that Jack Katz painted circa 1932. He tells in his autobiography that his father wanted to dress up for the "sitting," but that both he *and* his mother agreed that the portrait should—Daumier-like —be from life,[22] and that these two people, "a pretty defeated guy" and a

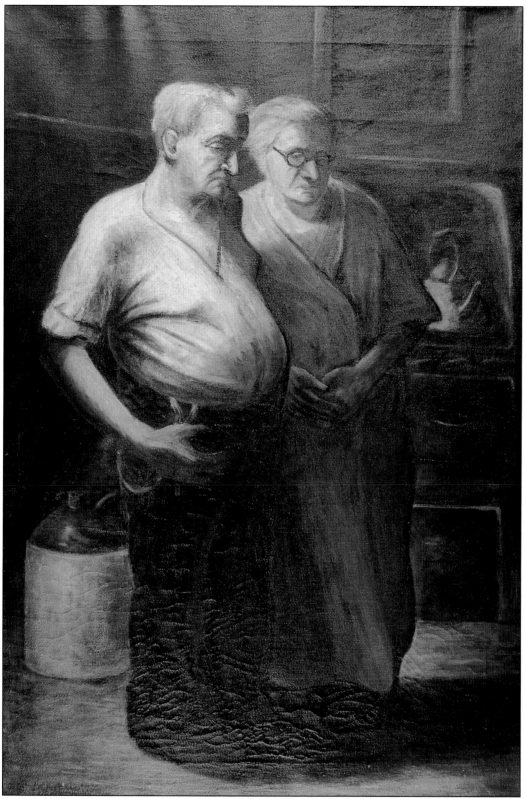

The Artist's Parents
Oil on canvas
760 x 505 mm, n.d. [?1932]

deG 01.13

woman "not *all* bad, but mostly,"[23] should be taken as found. That was, in effect, a gesture of support and confidence in their son's abilities, and their son repaid them by painting a double portrait that is a tour de force. Here is the painter, not the son, seeing to the heart of things and interpreting what he saw with a skill and a compassion far beyond his sixteen or so years.

"PAINTING THE DESPAIR"

"Jacob Ezra Katz has satisfactorily completed the General Course of Four Years," said the Thomas Jefferson High School diploma awarded in January 1935 (the pupil himself not being present because of the death of his father). It was not, however, a very propitious year for American graduates, especially one from a home full of emotional tensions and with little in the way of influence or support to get him into a job or into college. Jack Katz found himself in the classic, but unenviable, position of the boy who had done well in the small community of school suddenly confronted by a large, messy, and disorganized world where any future accomplishment would take a deal more energy to be noticed.

What he actually did is not entirely clear. For certain he left home. "When I got out of high school . . . I just tried to leave; I said 'I'm leaving,' and I found a dive in the village."[24] (In fact, he moved to 1425 Elm Avenue, Brooklyn in March 1935 and only later crossed the East River to Greenwich Village.) How he then occupied himself is not explained. "He just got jobs," says Martin Pope, and both Keats, in his later years, and Florence Freedman note that although he had three scholarships to study art he never used any of them. Even so, there is evidence in the Keats papers that he not only studied under Ostrowsky at Educational Alliance but that he took up both the Florence Cane scholarship and a scholarship to study drawing and watercolor at the Art Students League under George Grosz, and oil painting under Alexander Brook. The probability is that he "did jobs" during the day, insofar as jobs could be found during the depression; attended classes, perhaps irregularly, in the evening; and continued to paint as well.

From adolescence on he had been moved by the plight of the unemployed and the homeless, and his prizewinning oil, *Shantytown,* had been an expression of this. (The summer before he left Thomas Jefferson the *Liberty Bell* had reported on his searching for "visages" among the hoboes of the Bowery.) So far as can be judged now, this was a subject that he not only felt he should record but with which he

could identify. He too might have been among these derelicts, "like some strange set of lizards,"[25] were it not for the angel's secret, "the magic of creativity,"[26] which gave him a means to express his sadness and bewilderment. At some time, possibly in the early 1940s or soon after the war, he suffered some kind of depressive revulsion against both the conditions and the work of this time and, despite the efforts of his sister to prevent him, he destroyed a number of his canvases,[27] but from what has survived we can gauge the perennial dilemma of the artist who is both outside and inside his subject. Martin Pope recalled of their schoolboy walks how impressed he was by his friend's perception of color and detail. "Look there," Katz said on one of their walks to the reservoir in Highland Park, above the Arlington Library, "look at the browns and reds"—and suddenly a sheet of apparently dull grey water took on a transformed appearance.[28] But how could this sensitivity find place in the gross circumstances of the time?

This instability of the artist's life during the prewar years is figured out in his restless moves around Brooklyn and Manhattan. After six months at Elm Avenue he moved on to a six-month stay at 214 Bleecker Street (at a rent of $3 a week) and from there he moved seriatim to Coney Island Avenue (two addresses), MacDougal Street, Lincoln Place, and Jones Street, with what looks like another spell on the East Side at 148 East Twenty-eighth Street. By 1937, however, he had gained a regular job, perhaps through Jean Charlot, as an assistant mural painter working for the Mural Division of the Federal Arts Project, which had been set up as one of the recovery projects of the U.S. Works Progress Administration. Again there is no record of specific murals on which he worked, but, as we have seen, this was a form of applied art that he had encountered as early as his time at junior high school and he was later to acknowledge the practical value of the work in relation to picture-book illustration: planning a composition around doors and windows had an equivalence later in planning full-page illustrations around areas of type.[29]

More relevant still, perhaps, was the work that followed. On May 2, 1940, Jack Katz signed off from the WPA project "to seek other employment," a move that led him to some Dickensian adventures in the comic-book trade. In all probability he had already had thoughts about this industry as an outlet for the talents of a budding draftsman, for his account of the job interview with an obscure and miserly comic-books producer in Manhattan seems to refer to an incident that occurred during or soon after his school days:

I'll tell you about my first experience getting—applying for a job in the great comic books industry. I saw an ad in the paper—somebody wanted an assistant—what is known as a clean-up and background man. Well, I thought I was great as a background man. I'd been in the background for a long time, and figured I might as well earn some money at it.

So, I called and he told me where he was. It was way out in Manhattan. And I brought my own brushes. He said bring your own brushes, because he didn't want me to ruin his brushes. And I could show him how I worked.

So I took the trip all the way out there—and I entered this dimly lighted studio with a naked light bulb hanging down. It was the home of a miser. And he could hardly find his way around, and I was supposed to sit there and work. I really strained my eyes trying to see. And he had pencils and some things—some drawings, and I was to ink in the backgrounds, and it's known as "feathering." It meant that you started with a very thin line and made it thicker and thicker, and then another thin line, and thicker and thicker. And it sort of functioned as shading, and made a form, as the thicker lines met and become a darker area. It would be a way of turning a form.

And I sat there for about forty-five minutes, maybe an hour, in this poorly-lighted room, following his pencil lines. Such terrible corny drawing. Clichés carried to the most florid and grotesque extremes. And he had a comic book he was putting out, and it was such dreadful drawing. And here my background, you know, had been the great, great art: El Greco, Van Gogh, Modigliani—I can't bear to mention those names in the same breath with what I had to do. And I was trying very hard to apply myself. And I did what I thought was a pretty good job. Somewhere's it was clumsy. Imagine being clumsy in this context. Trying to render this dreadful, rotten, cornball crap. And I was clumsy at it. I didn't reach the heights of finesse that he expected of me. And I showed him the stuff and he said, "This won't do. This won't do."

And I had literally worked up a sweat. I tried so hard, my hand ached. I showed it to him.

"No, it won't do."

So, I put my jacket on—my coat and cap. I was ready to leave, defeated.

He said, "I'm sorry, you know, I can't use you, and you owe me fifteen cents."

And I said, "For what?"

And he said, "The ink."

I'd used up his India ink. Fifteen cents worth of India ink. And you know, I paid him. I was so tired and so bewildered and so disoriented. I had lost this effort to get this job. I gave him fifteen cents for his ink. The dirty fingernails. Scrubby character. And I went home.[30]

The curious mixture of the mean and the ludicrous that is to be found there must have served as useful preparation for Jack Katz's more successful application to join the team preparing drawings for the comic books and horror comics put out by Harry "A" Chesler:

I finally applied for a better, "better" job, with a guy whose name was Harry Chesler. Chesler, like in "chisler." And he had a big round face and double chin, and bald head. He smoked real "el stinko" cigars. And he kept spitting—"ptt, ptt"—spraying that tobacco spray all over the place. If you spoke to him for any length of time, you walked away reeking of cheap cigars.

And I applied, he looked at my work and he said, "That's very nice, son."

And he didn't offer a salary to me, you know. He said, "Whattaya want?"

And I could see the other guys sitting at the desks. They were all listening, all sweating away. It was a real sweat shop; some guys wore visors, other guys in their shirt sleeves, working. And he said, "How much do you want a week?"

I said, "Twenty-five dollars."

Man. And he thought and thought, and he said, "I'll tell you what I'll do, son. How about $23.50? I'll start you at $23.50. How about that?"

So, I thought about that.

"O.K., $23.50."

"You start Monday."

"O.K."

I came in Monday and I worked, and Friday came around. He walked down the aisles dispensing his largesse. And I counted—I got my pay envelope. The first pay envelope I ever got. Paid in an envelope. He had a real system, he was a great guy. He thought he had a real system. And I counted my money. I was glad I counted it before I went home. Because there seems to have been a mistake. It was $24 bucks. Not $23.50. I thought I'd better tell him.

So I said, "Say Boss, there's a mistake here. It's 24 bucks."

He said, "That ain't no mistake, son. That's a *raise.*"

He said, "That's a raise. First week you're working here, and you got a raise already."

So I said, "Thanks, Boss."

And the next Friday I got my pay envelope, and I thought it would be best if I counted my money. And it was $24.50.

So I said, "Say Boss. Uhh, it's $24.50."

He said, "That's right. Another raise. See? Another raise. You worked here two weeks and you got two raises already. And you didn't even have to ask for it. Right?"

And I said, "Right."

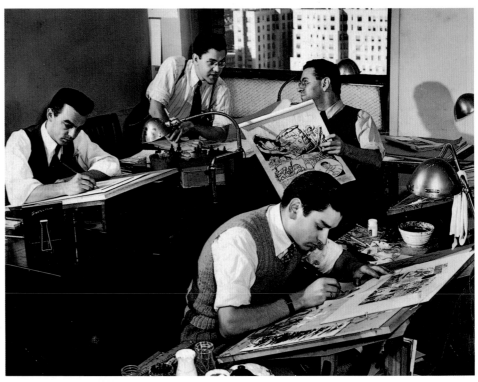

A scene in the Captain Marvel studio ca. 1942. Katz is beside
the window with the paper.

unnumbered—folder with deG 0141.17

He wanted me to repeat it, like I was taking an oath.

"Why yes, I worked here two weeks and I got two raises, and
I didn't have to ask for it. Yes, yes Boss, that's right."

The third week I got 25 bucks, and it was becoming a habit
now, so I pointed out that I had 25 bucks.

He said, "Right!! A third raise."

He said in a loud voice so all his slaveys could hear him.

"Three weeks, the first three weeks, a raise each week. Have
you ever heard of such a thing?"

No, I never did. I admitted I never did.

He said, "No other place is as generous as I am. No other stu-
dio is as generous as I am. You come in here, and you get raises
every week."

He said, "I want you to understand something. I gave it to you
because right now I c'n afford it. And from now on I want you
to understand one thing. I wanna make one thing clear. Please,
please don't ever ask me for a raise. Because if I can give it to you,
I'll give it to you. As you can see, I gave you three in a row. And
you'll only hurt my feelings, askin' me for a raise. Because if I can
give it to you I do, and if I can't, I won't. So do me a favor. Don't
ask me for any more raises. You'll only hurt my feelings."[31]

Harry Chesler's attitude towards employees' advancement seems to have impressed Jack Katz more by its eccentricity than its golden hopes and by 1942 he had moved on to a more upbeat company, Fawcett Publications, the publishers of the Captain Marvel comic strips. Notwithstanding his skill and experience, Katz was still compelled to take his place in the pecking line of the draftsmen working on the strip, which meant dourly working at backgrounds to begin with, and only later the more prominent details of character and action.[32] This was "just a means of earning a living through a skill"[33] and who is to say how long the artist would have stuck to the job had it not been that—just as he was being promoted to drawing Captain Marvel's head—he was drafted into the U.S. Army and for two and a half years found a permanent address for himself a long way from Brooklyn at Tampa, Florida.

Lance Corporal Katz, no. 32883558.

deG 0117.01 #25

Katz entered the Third Air Force division of the U.S. Army on April 13, 1943 and after preliminary training at Fort Dix, New Jersey, he went to Tampa as a "draftsman," which is to say an artist-cum-art-instructor working primarily on camouflage. There was not much room for military heroics in this humdrum position, but from the surviving records Katz seems to have proved a competent soldier. At some stage he qualified for a Rifle M1 Marksmanship badge, and, by the end of the war, he had also gained promotion from private to corporal. His work though was largely concerned with "charts for statistical control" and the drawing up of "posters and booklets for camouflage training." In 1944, we find him attending a Third Air Force Camouflage School at Dale Mabry Field, Tallahassee —where he was one of the students marked "Ex" for Excellent—but no charts, booklets, or posters have so far been located that can be attributed to him. The sole graphic creation that comes from these years is a fruit of his experiences in the comic-book trade rather than among the down-and-outs of the metropolis. It is, in fact, his first pictorial narrative: a thirty-page sequence of comic sketches that stand as an Awful Warning to gullible GI's, and make for unexpectedly pointed reading in view of the artist's later career. "Our Hero" heeds the official admonitions about consorting with camp followers and valiantly shuns the allurements of several girls in favor of the less obvious attractions of a demure librarian. The result, which is observed by two cupidons, who form a kind of Greek chorus, is predictably disastrous since the librarian is not as virginal as she seems.[34]

On November 24, 1945, Cpl. Jack E. Katz received an honorable discharge from the army, bearing with him a Good Conduct Medal,

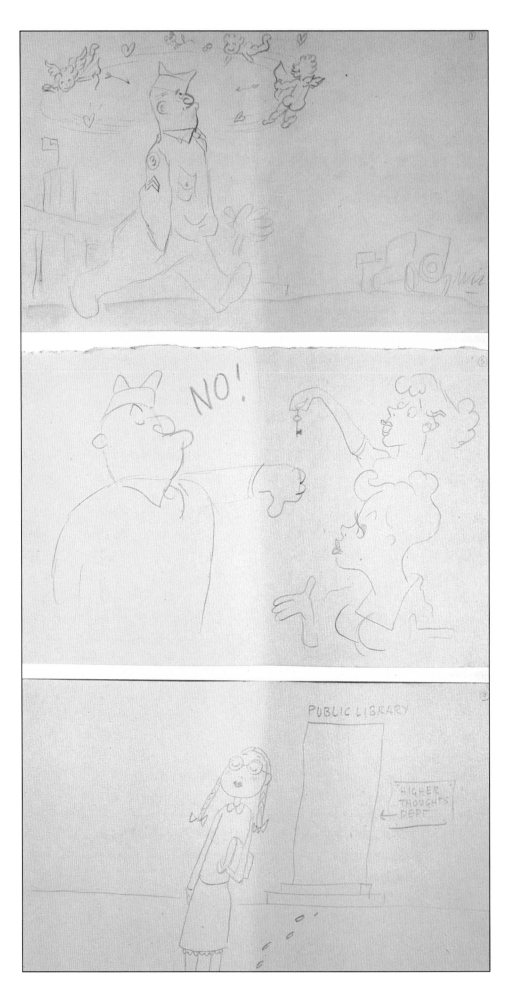

Three glimpses of Our Hero on the primrose path . . . a) setting out; b) not yielding to temptation; c) heading unwittingly for trouble
Pencil on paper
Approx. 135 x 200 mm, grouped with other leaves to make up the cautionary tale, n.d. [ca. 1944]

deG 0141.07

an American Theater Ribbon, and the Victory Medal. By this time his mother had moved to the Jamaica district of Queens, where her health was deteriorating and where she was being looked after by her daughter, Mae. Mae was clearly feeling the strain of this relationship and was asking Jack for help, but his own health was not good, and from this time onward a latent nervousness about his physical condition became more pronounced and established itself as a permanent, though not always dominant, hypochondria. Certainly there was some justification, for during 1946 he was admitted for a month to the Veterans Administration Hospital in the Bronx for treatment of a peptic ulcer, and the Veterans' Re-adjustment Allowance, which he had begun to draw as soon as he left the army ($6.90 per week, or thereabouts), was augmented by "disablement compensation" on the grounds of a 40 percent disability because of the ulcer and a "nervous condition" ($55.20 per month). In the next couple of years he also suffered from a form of gastroenteritis, and when in 1949 the VA carried out a further physical examination they found that, although the stomach condition had improved, there was still a combined disability of 40 percent.[35]

The wavering in health over this period is paralleled by what looks to be a serious crisis in confidence and in sense of purpose. (Martin Pope says that he was afflicited with doubts about his talent both before and after the war.) Victorious, reconstructionist America of the late 1940s was a very different place from the depressed prewar years and Jack Katz was deeply uncertain about what place there was in it for him and his talents. Recorded evidence is not strong (not even in the various autobiographical fragments) but he was probably thinking of this time when he wrote, "I went through such a long period of my life when I didn't think anything I had to say was worth while,"[36] and what meager evidence we have of life beyond the handouts and the doctors' prescriptions suggests that his creative impulse was subordinated to the business of making a career in some area of commercial art.

His uncertain aims were reflected in his fluctuating addresses. For a couple of years after the war he lived in the Village, first at 91 Perry Street, then at Bedford Street, and in 1948 he crossed back to Brooklyn to lodgings on State Street. His relationship with his family also remained tenuous. Mae continued to look after Gussie[37] in Jamaica—although the sons, William and Jack, provided some financial support—and Jack's personal life hinged, as it was to do throughout adulthood, on a sequence of lovers. In later years he was inclined to blame his mother for the fact that he never married.

Not only did she hold her own marriage up as an example of the destructive potential of the custom, but she also warned him against ever having children—an admonition that she stirred into the powerful brew of guilt and possessiveness and failure in love that she prepared for him. As a result, his quest for a purpose that would fulfill his artistic talents was matched by a lifelong quest for an ideal relationship with a woman. The matter may not seem germane in this study, whose primary purpose is to record and discuss the work of a maker of picture books (leaving aside the elucidation of dedications, or the interpretation of pictorial references). Nevertheless, although the artist remained entirely preoccupied with the problems of his art, any examination of those problems and their solution would be lacking a dimension if it did not comprehend Keats' constant need for the companionship of women as a foundation, however unstable, for creative work.

After the war, two events occurred that point to a shift from Jack Katz' disoriented condition. The first of these may be significant only in hindsight, but on December 12, 1947 Jacob Ezra Katz filed a petition to change his name to Ezra Jack Keats, which petition was formally granted on February 8, 1948. Some optimistic persons have seen in this change either evidence of the impression that the "Endymion" quotation had made on the student entering the portals of Thomas Jefferson High School, or else a wish to adjust "Katz" so that it bore an association with a fellow creative spirit. The truth, though, looks to be more mundane, for we find as early as July 1945 a document in which Jack Katz' brother is designated "William Keats"; thus it was William who initiated the name change, possibly at the time of his marriage, before the war.[38] The reasons for the change itself were distressingly practical, since Jewish immigrants to the United States had by no means shaken off anti-Semitic prejudices. Wholesale discrimination before the war, particularly in the depression, gave no confidence that life would subsequently be easier, and many families Anglicized their names in order to facilitate getting work.

Even so, the coming of a new name could be distantly construed as the acceptance of a new attitude to one's own personality and this period, at the end of 1947, did see Keats reviving his study of fine art. In October 1947 he had gained an Educational Subsistence Allowance of $16.25 a month from the Veterans Administration to enable him to take a course at the Art Students League. A year later he began to make arrangements for a period of study in Paris. The Veterans Administration deserves credit for this too, since Keats was

eligible for subsistence benefits under the GI Bill of Rights, but the decisive shove seems to have come from the unexpected quarter of brother William: "One day, in a deep fit of depression, having broken off an affair with the first woman with whom I was really involved and had lived with, I met [William] one day, and I was flat broke. He was in business, not doing spectacularly well, but I guess making out okay, and I said, 'I've got to get out of this country, I just want to leave and get away from everything, and . . .' He thought I must have been in trouble with her in some way . . . so he gave me two thousand dollars, which was a *staggering* amount of money to me, and I lived in Europe on this for nearly a year. . . ."[39]

Letters were dispatched to the Académie Julian (where Max Weber had once studied) and the Académie de la Grande Chaumière; a passport was obtained (hair, brown; eyes, grey; height 5'10"; occupation, artist); school French was brushed up through a spell at the Berlitz School of Languages; and on April 13, 1949 a little gathering of friends, which included "Ruth & Ina & Little John & Itch & Mae," assembled at the quayside to wish him "bon voyage"— and RB, the woman of the broken affair, decided to come too.[40] Then the U.S. Lines SS *Washington* carried Ezra Jack Keats off for what his visa called *"une année scolaire en France."*

INTERLUDE: "CASTING MY SHADOW ON THE STREETS OF MONTPARNASSE"

The *année* was not really that, for it only lasted from April to November, and the *scolaire* element was to a large degree swamped by the euphoria of the experience. Within a day or two of arriving in Paris, Keats went to the Louvre and noted in a little journal that he tried to keep:

> It's difficult to describe what an experience it was entering the grounds of this immense place. Again it was the terrific feeling that I knew this building. But this time it was real. I tingled with joy. How did I get here? What made this come true? . . . I realized that all things are possible of realization. An inspiring thought in such difficult times . . .[41]

And the sense of magical release is present too in a letter written at about the same time, the first of a sequence addressed to RB:

> The first night I was walking down the street (there are gas lamps on these streets) and I saw a shadow of a man in front of me—it may sound strange, but it was thrilling to realize that I was casting my shadow on the streets of Montparnasse after reading about it almost all my life!

Every street in Paris is beautiful!
Pissarro, Daumier, Utrillo, Lamotte, Cartier-Bresson in the streets and parks![42]

In any event, Keats had elected to carry out his course of study at the Académie de la Grande Chaumière: *"la seule institution mondialement connue, qui représente, face à l'Ecole des Beaux-Arts et à l'Enseignement officiel, les tendances diverses de l'Art Indépendant, qui a fait la gloire de la France depuis le début de ce siècle."*[43] That sounds grand enough and radical enough to have stimulated the enthusiastic newcomer, but, in fact, we learn little in his letters or his reminiscences about what went on in the courses on painting, sculpture, and drawing that Keats followed from June 1 to October 1. We hear much more about his delight in the artistic life of the city, and about a number of erratic affaires du coeur.

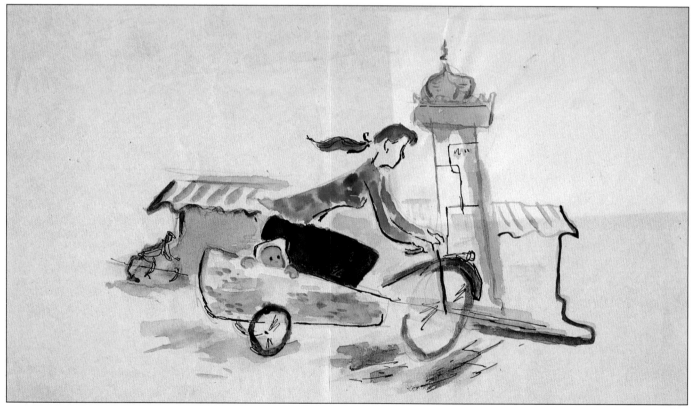

Girl on Bicycle with Baby-Cart
Watercolor over pencil on torn paper
145 x 270 mm, n.d. [1949]

One of several color sketches of people riding velocipedes done during his stay in Paris.

deG 1041.16 numbered 464

An amusing glimpse of these is given by the writer Jay Williams, who was touring Europe at the time, and who incorporated some anecdotes in his book *A Change of Climate* (1956), which Keats was to illustrate. The Williams family had known Jack in New York, and when Jay wrote to tell him of their impending visit to Paris he arranged for them to have cheap lodgings at his own *pension,* the Résidence Jéanne in the rue Stanislas just off the boulevard Montparnasse. The Williamses were pleased with the cheapness of the place and entertained by their companion's account of his sequence of misadventures with a World Citizen, an overmaternal American student, and a very grand emigree with an even grander dog; but what is crucial to the report (even though published long after the event) is the high-spirited friend that they now found Keats to be. The man suffering from peptic ulcers is not easily discernible in the fellow who was tucking in to the "disheartening" *table du jour* of the Résidence Jéanne "with a good appetite as if nothing out of the ordinary were taking place." The person, once known to his family as "Watermelon Face," and so recently overcome by wretchedness, does not seem to be the same one of whom Jay Williams wrote: "In spite of these [amorous] setbacks, Jack enjoyed Paris as, indeed, he seems to enjoy every place. . . . He attracts to himself all sorts of odd events and relishes them as much as he does food, or drink, or his work."[44]

The born-again Keats who is beginning to emerge in accounts of this kind was probably revivified as much as anything by a rediscovery in Paris of the satisfactions of painting. Evidence again exists in *A Change of Climate,* where, in the chapter called "How to Eat a Painting," Williams gives us a glimpse of Keats working with a steadiness—an insouciant steadiness—at his watercolors of the scenes around him.

The Williams view is to some extent corroborated by documentary evidence, where we find not only Keats' excitement at being able to see such a profusion of the art that meant so much to him, but a renewed confidence in his own powers. Writing to RB two and a half weeks after arriving, he confessed to disappointment at the seven paintings he had already done, but he also perceived that the atmosphere of a place may dictate the way that we see it and that you could not paint Parisian subject as though you were in New York. "Anyway," he adds, "there are emerging some new colors, some new combinations of media perhaps & slowly and quite certainly the painting is improving and taking shape."

As time went on the "taking shape" continued, although the difficulty in dating Keats' paintings prevents a sure description of what

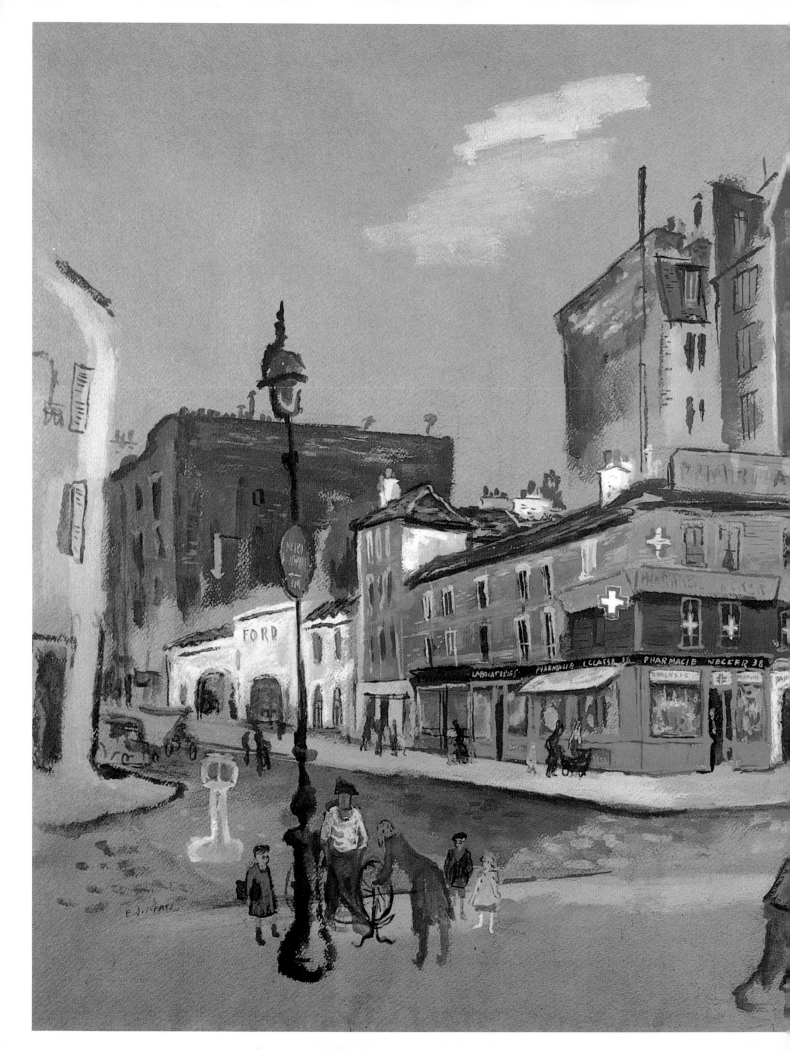

Street Scene in Paris
Watercolor on tinted paper
508 x 407 mm, n.d. [1949]

Private collection

was involved. "Reality" (however that may be defined) remained a touchstone; Jay Williams reports him as saying: "I always wanted people to see and feel as I saw and felt, I wanted to communicate with them. Life is . . . so rich, so full of color. . . . Everything in life is waiting to be seen!"[45] But certainly, now, the observed life no longer consisted of the lizard existences of the Bowery, but presented itself in simpler, less dramatic terms. What Keats may well have been after in his renewed quest was perhaps technique as well as emotion—a fine rendering of the play of light on surfaces so that a scene would grow with life under his brush. This may be what he is referring to when, later in the summer, he writes with a frustrating lack of specificity: "As for my work out here . . . I've recently decided to experiment and develop my style rather than limit myself to safely repeating my old style. Much, much has become clearer to me. . . ."[46]

The letter in which those words appear is part of the RB sequence. It is full of asides about the many excitements that both Europe and European art were arousing in him, as well as about his attempts to gain some commissions to raise more money than his VA stipend and Kelly's gift allowed. (Florence Freedman reports that he was also writing to friends in the U.S. offering drawings, sight unseen, in return for cash.)[47] Part of the impulse behind this need to raise funds was his wish to see more of Europe than Paris and its

"Professor Keats" in class at the Workshop School.
deG 0117.02 #15

40

environs. Before term had started at the Académie he had already made his first, fleeting visit to England, intending to spend two days there "to see some advertising people" but finding it "so damn interesting" that he "stayed a week" (well—five days, to be precise).[48] Now, though, he was planning a brief trip to the Low Countries, for which the Académie had given him four days leave of absence (September 12-15), and once the term was over on October 1 he had made arrangements to go to Italy for a brief, VA-approved period of study at the Academie delle Belle Arti at Florence.

That was to prove a perfect ending to the *année scolaire*. For a brief four weeks he rejoiced in the unparalleled wonders of Florence and Rome—and, just so that he would no longer suffer the loneliness that he had tended to complain about during the summer, RB joined him in Italy. On November 1, though, he returned to France, and on November 10 he made for Le Havre, where he took the steamer *Ile de France* back to New York.

"I DIDN'T EVEN ASK TO GET
INTO CHILDREN'S BOOKS"

In the letter to RB that dwelt on his stylistic experimentation, Ezra Jack Keats also wrote about crossing his American bridges when he got back to them: "I'm not worried about the sort of thing I'll do when I get back—the only way to handle that is to see what gives in the field . . . contacts won't be too hard to re-establish. I'm pretty sure I can get a job teaching part of the time if necessary and a better one than I had. . . ." The implication of this, taken with other stray remarks in the letters, is that he is planning to continue the precarious life of a free-lance artist, but with an emphasis on commercial work rather than "gallery art."

And that is what seems to have happened. For the next four years Keats attempted to develop a career on several fronts, a policy that may be construed as pragmatic—keeping his options open—or as opportunist—tailoring his activities to meet the needs of the moment. He undertook some training courses: two thirty-hour certification courses at New York University in 1950 and 1953 on "Methods of Teaching a Vocational Subject" and on "Practice Teaching and the Evaluation of Instruction."[49] These must have been related to the part-time teaching that he had envisaged. Initially, that occurred at the Workshop School of Advertising and Educational Art, where Harold Glaser remembers Keats as being a sympathetic teacher, very good at working one-to-one with the students in the

Among commissions following his Paris visit was this poster for the Muscular Dystrophy Appeal, for which he is here seen receiving an award.

deG (unnumbered)

class. Later on, in 1954-55, he also worked for an outfit called Famous Artists Schools Inc., which sought to teach art through correspondence courses, and whose methods (understandably) brought swift disillusion.

Keats also made efforts to continue his own professional education, for in 1950 he wrote to the Veterans Administration, "At present I am working as a commercial artist, but my area of training is limited. Job possibilities are greater if I had training in 'vis and layout.'"[50] Presumably the work he refers to here is primarily in advertising, but he also toyed with ideas of his own. There is a curious, inconclusive note on the patenting of a "coloring kit invention" with a "telescoping double-ended paint brush,"[51] which seems to have come to nothing, although more success attended the "Contempo Notes" that he devised for the Eaton Paper Corporation of Pittsfield, Massachusetts. These were lettercards, illustrated with watercolors, which were sold with envelopes that had a matching pictorial interior, and Brentano's, the Fifth Avenue booksellers, certainly enjoyed them: "one of the most attractive displays ever," wrote the lady who managed the Stationery Department, adding, "Your three original paintings . . . were a constant source of comment. . . . As you no doubt know by now, one of these paintings was sold during its first week in the window."[52]

Selling paintings through Fifth Avenue window displays and the like, rather than through galleries, seems to have been a regular procedure at this time. Jay Williams, back in New York, dashes across the street because he has spotted a Keats picture in the French Lines window;[53] the I. Miller Shoe Store exhibits a mural that prompts a Mr. and Mrs. Cleland of North Carolina to buy a picture that Keats painted on a trip to the Virgin Islands ("It fits in very nicely and adds the colors that we desire," they said);[54] at a more august level, the Pierre Hotel by the Plaza lays on a midsummer exhibition of Keats watercolors and retains two for its Oval Room.[55] There were also less regular procedures. Lillie Pope notes that Keats needed money badly when he got back from Paris and that she undertook some informal agenting on his behalf. She sold "some of his French sketches and watercolors, and even some that he had tossed into the wastepaper basket. One painting went for seventy-five dollars, but most were between three and thirty-five."

Further progress, both in gaining commercial commissions and in making sales of paintings, came about through a connection with the Association of American Artists, whose vice-president was Estelle

Mandel. Apparently Florence Freedman had shown some of Keats'
work to Mandel, and in 1952, when Mandel left the organization to
set up as an independent agent, she carried with her some of the
artists with whom she had dealings, including Ezra Jack Keats. A for-
mal agreement, dated August 13, 1952, was drawn up showing that
Keats was already working on commissions that Mandel may have
obtained for him (two *Readers Digest* covers and "a few unfinished
drawings" for Lenthéric cosmetics) and appointing her his "sole and
exclusive agent for the sale of any and all work . . . with the excep-
tion of easel paintings produced for gallery exhibition and sold . . .
through regular exhibition channels . . ." Mandel was to use her best
efforts to promote the artist's work and to take care of all billing pro-
cedures, for which she was to receive a commission of 25 percent.[56]

The formality of this letter of agreement, if not its typing, was
probably the work of a lawyer, but the fairly detailed provisos were
probably initiated by Keats himself, who had developed a healthy
concern for gaining fair shares in the marketplace. Unlike some
free-lance artists, he realized that he needed to keep a sharp eye
on the way in which his expense of time and talent was rewarded,
since a future built upon individual commissions is a very fragile
thing. This is apparent in subsequent business letters to Estelle Man-
del, which show a gathering dissatisfaction over the agent-client rela-
tionship, and when, in June 1958, Keats decided to close down their
already very shaky association, it was probably with a belief that he
could best conduct his business affairs for himself. From that time
onward he relied primarily on his own efforts in handling all con-
tractual matters and showed himself to be well aware of the value
that should be set upon his work.

From the 1952 letter of agreement we can see that Keats was con-
tinuing to work on a broad front, but already (vide the *Readers Digest*
covers and such things as a set of watercolors to illustrate the Octo-
ber 1952 *Wings: The Literary Guild Review*) he had begun to diversify
into graphic work for the press, with commissions for illustrations
coming from a range of sources including *The New York Times Book
Review, Collier's,* and *Playboy*. In addition, as a colorist, he was a man
whose work could be used by book publishers for dust-jacket designs,
and it was through this small and seemingly insignificant line of
trade that his whole future creative life was to burgeon.

The story has been frequently rehearsed. Many of the jacket
commissions that Keats received were from Doubleday, a publisher
who also had a shop on Fifth Avenue. One day (as with Brentano's

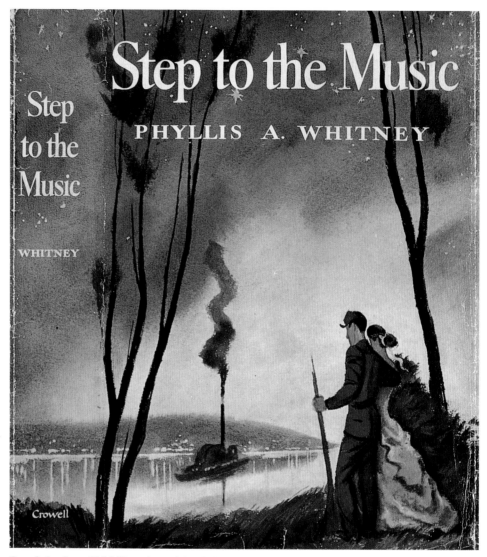

Book jacket (1953) printed in full color.

deG (unnumbered)

"Contempo Notes") the bookshop had put on special display a new book with a Keats jacket. Keats says that the book was by Victoria Sackville-West (presumably *The Easter Party*) and apparently his original was exhibited with it,[57] but the salient fact is that the display was spotted by the editorial director of another publishing company, Elizabeth Riley of Crowell, and that she arranged to meet the artist and forthwith commissioned first a book jacket for Phyllis A. Whitney's *Step to the Music,* and then a set of line illustrations for a new children's book: *Jubilant for Sure,* by Elisabeth Hubbard Lansing. "I didn't ask for it," he was to say later, not plaintively but with amazement; "I didn't even ask to get into children's books"[58]—but Elizabeth Riley's

experienced eye had seen in Doubleday's window an illustrator destined for better things than dust covers.

The story of *Jubilant for Sure* is set in the Kentucky hills and Elizabeth Riley must have taken a bit of a gamble in asking Keats to illustrate it—the Brooklyn boy, whose lengthiest spells away from his home-patch had been at Tampa, Florida (care of the U.S. government) and at assorted cities in Europe. Keats, moreover, with his dedication to realities, liked to see what he was meant to be illustrating. He would not have cared for Edward Ardizzone's dictum: that the illustrator does not copy from life, but "makes it up"; and there is not much evidence that Keats had the capacity for convincing invention. Thus it was arranged that the apprentice illustrator should pay a visit to some lookalike hill-country, and around tobacco-harvest time he set out with his current girl friend, whom he referred to as "Ilona" in his autobiography, for a trip to the hill-country of Tennessee.

The visit was an unqualified success—not so much because of finding the right material to sketch, but because of an unanticipated induction into country life. The couple put up the first night at a hotel and the next day Keats set off looking for likely territory:

> So we arrived in Tennessee and put up in a tiny hotel the Wrigley, which looked like something from an old postcard. I told Ilona to remain there for the afternoon while I scouted around for places to sketch where we could go the following days.
>
> Out on the road I hitched a ride on an ice truck. "Where ya'all goin?" Two guys were in the cab up front so I rode in the back. "Truth is, I'm not sure," I called. "I'll rap on the window when I want to get off." I carried a sketch book, some pencils, and a newspaper. We rode on and on, as I scoured the countryside for a shack like the one described in the book. The landscape was rolling and dotted with an occasional ramshackle wooden structure. Suddenly there it was! A wooden, rickety shack, rusty corrugated tin roof, porch, rocker, and stone chimney, perched on a hill. Corn and vegetables were hanging to dry, chickens on the porch strutted in and out of the house. I rapped on the window. The truck stopped. "Thanks!"
>
> I found myself alone on an empty road in a hot, barren, unfamiliar landscape. Standing on the opposite side of the road, I opened my sketch book, shielded from view by my newspaper, and began to sketch. From out of the grey browns of the house, I made out a blonde, curly-haired little girl, four or five years old, clad in a dusty shift. She sat barefoot on one of the steps, looking squarely at me. I sketched and she studied me. Then she shifted a little to the right, then a little more, then just a tiny bit more,

and came to rest, clearly in my line of vision. I put her into the picture, and then approached the sagging gate and called to her:

"Hi. Do you know what I was doing?"

"Uh-huh."

"What?"

"You was draw-ing-me."

"How could you tell?"

"Ohh—I dunno."

"Did you ever seen anyone draw before?"

"No-o-o."

"Would you like t'see it?"

"Uh-huh."

I folded the newspaper, and turned the open sketch book toward her.

"Yup, that's me—an' that's are house." She came over to take a good look. The screen door opened and a woman stepped out.

"Hi," I said.

"Yes?" she asked.

I explained that I was illustrating a book for children written by a native of the Smokies and showed her my sketches.[59]

That conversation led to more introductions, the result of which was that he and Ilona became houseguests of Mr. and Mrs. McCain and their daughter, Judy, who made over the best bed for the "fureners" and looked with kindly indulgence on these New Yorkers on a sketching expedition in the thick of harvesttime. Later in the year, Jack and Ilona dispatched Christmas presents to the family at Bon Aqua, Tennessee, and in 1954, when the book came out, a copy of *Jubilant*. "The pictures looked familiar, especially the kitchen," wrote Mrs. McCain, thanking them and saying she'd "love" for them to "visit us again."[60]

Hindsight allows for a larger interpretation of this adventure. So far as we know, Keats had never hitherto contemplated illustrating children's books, and with *Jubilant for Sure* he found himself facing experiences that were not only quite new but that were sketchily to prefigure so much of what the genre would hold for him: the uncomplicated friendship of strangers, the opportunity to make something out of the everyday lives of humble people, and a delighted recognition of the pleasure his drawing could give to children. Up to this point he may have seen Elizabeth Riley's commission as one more element in the sequence of individual jobs that are the free-lancer's lot, but beyond this point there is the glimpse of a new territory opening up for exploration.

Certainly, little time elapsed before book illustration began to take a prominent place in his work schedules. *Jubilant for Sure*, which

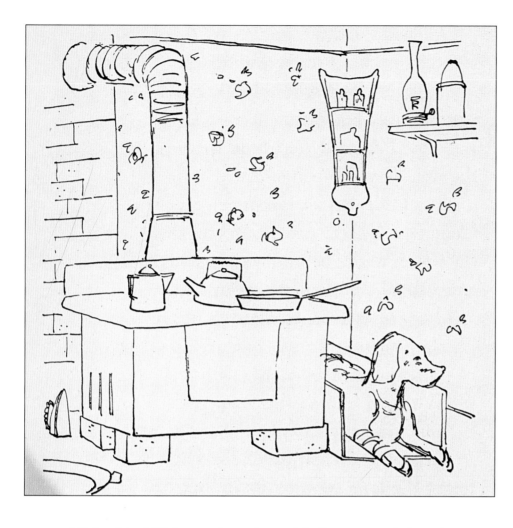

Part of the McCains' kitchen as interpreted in E. H. Lansing's *Jubilant for Sure* (1954).

deG copy p. 85

was published in 1954, may have been his first commission, but that year also saw the publication of Keats illustrations in Eleanor Clymer's *Chester* from Dodd Mead, and in a popular edition of "Uncle Remus's" *Animal Stories* put out in Doubleday's Garden City "de luxe" series of classics. These last two jobs probably came through the agency of Estelle Mandel and she was certainly instrumental in helping him to build on the start that he had made. A big, and fairly lucrative, commission for a large English textbook, *Panoramas*, arrived in 1954 via Mandel,[61] and when Keats closed down the relationship in 1958, he writes of work that might still materialize from Doubleday, William Morrow, Harcourt Brace, and Follett (as well as two advertising contracts).

The spread of publishers is significant. In the eleven years from 1954 to 1964, the period of his most prolific output, Ezra Jack Keats provided illustrations for fifty-four books divided up among twenty publishers. The commissions varied. He continued to produce line drawings for children's fiction, of which the four *Danny Dunn* books

47

by his friend Jay Williams, with Raymond Abrashkin, are probably the best known. (Abrashkin, incidentally, was also a graduate of Thomas Jefferson High School.) He illustrated a variety of simple educational books, of which Tillie S. Pine's series on the knowledge possessed by various native peoples proved a regular commission. He worked on one or two larger-format storybooks for younger children; and, on one occasion, he provided spot drawings for a book for adults.

This is very much the schedule of a free-lance journeyman, who has not yet established a defined position for himself. Admittedly if anyone could be seen as trying to nurture his talent it was his first editor, Elizabeth Riley, who commissioned ten of the fifty-four books, but these, like most of the rest of his work, were not really texts that called for any intense engagement of the imagination and he must have felt serious doubts about how far any lasting value could be placed on his contributions. (Tillie Pine especially seems to have depressed him, and Florence Freedman has remarked on how goaded he felt at having to crank out illustrations to such stuff for the sake of preserving the series and the commission.)[62]

Altogether, therefore, this first spell as a children's-book illustrator did not seem to fulfill the promise of *Jubilant for Sure*. So far as one can see from the manuscript autobiography, these eleven years were a period of renewed self-doubt, when—despite a growing reputation, which resulted in a move from Brooklyn to Manhattan, and a gradually improving solvency—he had no clear sense of direction for his talents. Girl trouble persisted; he fell prey to those twin dependencies of the time, Seconal and its like and psychotherapy; and professionally he did not have the good fortune of some of his contemporaries in finding an editor who could take his work in hand and point him towards an expansion of his vision rather than a repetition of it.

In one instance, however, a theme emerged, a voice was found, which did not call for a mechanical response or the replication of a

AT LEFT:
The Peterkins Celebrate "The Fourth"
Frontispiece for the Junior Deluxe edition
of Lucretia Hale's *The Peterkin Papers*
Four-color halftone
210 x 136 mm, 1955

One of Keats' few full-color illustrations from the 1950s.

deG copy

familiar technique. Around 1952, while he was still living in Brooklyn, Keats had encountered a Puerto Rican (or, possibly, Italian) boy—Freddie—"who entered and left our place like a member of the family."[63] The relationship does not seem to have been significant or long-lasting, but several years later, working with a journalist, Pat Cherr, Keats began to devise a book about just such a child: a Puerto Rican boy in the city streets, hunting for his dog.[64] *My Dog Is Lost!* (1960) was a collaborative effort, nurtured by Elizabeth Riley, in which Freddie—who had now become Juanito—meets children from Chinatown, Little Italy, Park Avenue, and Harlem and engages them in the quest for his dog, which is made more difficult by the

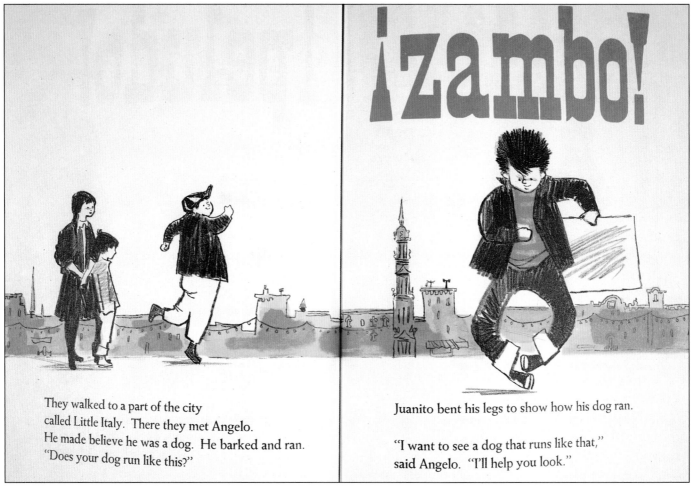

Spread from *My Dog Is Lost!* by Keats, assisted by Pat Cherr, printed as a two-color separation (illustrations in chapter five show the separation process for this spread)
234 x 318 mm, 1960

deG copy pp. 20-21

fact that Juanito only speaks Spanish. The book has no pretensions. It is conducted in the most straightforward manner—heavy lead pencil drawing and a single red color separation. But there is a finely controlled dynamic, which amusingly incorporates the heavy Spanish interjections *¡rojo! . . . ¡peludo! . . . ¡zambo! . . .* and which allows a denouement that comes from comic-book art at its best. *My Dog Is Lost! ¡Mi Perro Se Ha Perdido!* was something new and unexpected from the studio of Ezra Jack Keats and was probably the leading impulse that would prompt him towards the unanticipated adventure into real picture books.

"HIS LIFE STARTED AT FORTY-SIX"

Freddie was not the only small boy to have made an impression on Keats' faculties:

> One snowy night some friends and I reminisced about the fun we had as kids when snow transformed the city. White, silent manna from heaven. We jumped and rolled in it. Ate it. Built and attacked each other's fortresses, pelting each other with snowballs, some feather-light, leaving splashes of gentle snowflakes, others so tightly packed and well aimed they left us stung and reeling. I thought I would do a book about it. "If I do, I'll dedicate it to you guys."
>
> Then began an experience that turned my life around— working on a book with a black kid as hero. None of the manuscripts I'd been illustrating featured any black kids—except for token blacks in the background. My book would have him there simply because he should have been there all along. Years before I had cut from a magazine a strip of photos of a little black boy. I often put them on my studio walls before I'd begun to illustrate children's books. I just loved looking at him. This was the child who would be the hero of my book.[65]

Keats then goes on to say how the work seized him, growing in new ways "in a world without rules" and completing itself almost under its own compulsion, "different from anything I'd ever done . . . I don't think I will ever experience again a dream of such innocence and awaken to find the book finished."[66]

These photographs from *Life* magazine (8, no. 20, May 13, 1940) of a small boy's dismay over being vaccinated were the foundation for *The Snowy Day*.

deG 0060.06

Sirs:
—This little Negro boy was at school in Liberty County, Ga. the day a State Health Officer and Health Nurse came to take blood tests of the schoolchildren for a malaria survey. His reaction to the blood test is shown in the pictures.
EDNA CAIN DANIEL
Quitman *Free Press*
Quitman, Ga.

CHILD IS CAREFREE AT FIRST

HE ASKS IF TEST WILL HURT

TRUSTINGLY HE HOLDS OUT HAND

TEST HURT AND HE STARTS TO CRY

Different collage effects, combined with paint, give varying energy in the
original artwork for *The Snowy Day* . . . a) cut paper, en masse and filigree,
in a static scene; b) cut paper superimposed upon a marbled background
lending movement to the snowball fight.
Ca. 250 x 505 mm, 1962
deG 0061.04 and 0061.09

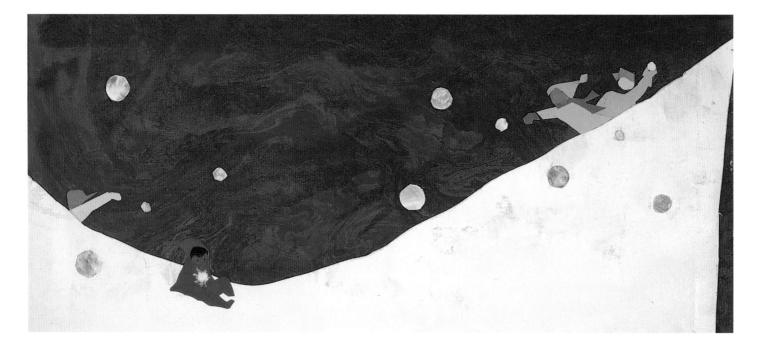

The book that emerged from this trancelike experience was *The*
Snowy Day. He had taken his preliminary dummy to Annis Duff,
the senior editor at Viking Junior Books and successor to the fabled
May Massee. Nervously he had planned for black and white spreads
to alternate with color ones, for cheapness—but she dissuaded him
and insisted on full color throughout. To the distant spectator this
shift of editors may not look like fair play for Elizabeth Riley who,
more than anyone, had provided so much previous vital encour-
agement; but Riley, who was not really a picture-book specialist, is
philosophical about the matter. "To be published by Viking in those
days," she says, "was a kind of accolade —everybody wanted it—and
I don't blame Ezra for one moment."[67] Indeed her business rela-
tionship with Keats seems never to have been too darkly clouded
and a few years later, when Harper published *Peter's Chair,* she wrote
to him: "I wanted to tell you that Ursula [Nordstrom] showed me a
copy of *Peter's Chair* and I think that it is one of the dearest chil-
dren's books that I have ever seen (and man and boy, I have looked
at a lot of them.) Thank you for making it."[68]

Elizabeth Riley's feelings about the dearness of Peter had been
replicated across America from the moment that he had first
appeared in *The Snowy Day* in 1962, and the book turned the artist's
life around. Here was the moment when all the potentialities that
were present in *Jubilant for Sure* attained a complete fulfillment, and
for the next twenty years Keats found himself a changed person.
Fran Manushkin, who met him first in 1965 and remained one of his
closest friends, asserted that "his life started at forty-six,"[69] and the
claim can be substantiated from several points of view.

Unquestionably the most important aspect is his discovery that
he had found a language. He may not even have known that he was
looking for one, or what he would say with it once it was found, but
his revelation with *Snowy Day* was that there was something central to
himself that he could articulate through a picture book. Most crit-
ics have claimed that this came about through his fascination with
collage and, as we know from many examples, collage was the tech-
nique that stimulated his imagination. But collage was really only a
symptom of the more illuminating discovery: the opportunity that
picture books offered for a dramatic use of color. Looking back, we
may now find difficulty in explaining how Ezra Jack Keats could
work as an illustrator for nearly ten years, and turn out work for over
fifty books, without being involved in anything significant in full
color. True, there had been picture books and there had been

Panoramas and the works of Tillie Pine, but such color as these used was mostly of the separated variety—large patches slapped over the linear framework. The artist who had fallen among publishers on the strength of his jacket paintings had never been invited to work on a full-color picture book. *The Snowy Day* was his own delighted discovery that color was for him a way of talking.

Keats' revelation that he was "working on a book with a black kid as a hero" also is only a partial measure of his discovery. As I have already hinted, Juanito, in *My Dog Is Lost!* may be seen as no less crucial a figure than Peter; what matters in these two books is that Keats has moved into territory where no sketching trips to the Tennessee hills are called for. He is suddenly at home on his own porch, conscious that forty years of the internalized experience of a "city boy" are there for the harvesting. Illustrators aplenty would have seized on a success like Peter and made a series out of it (*The Summer Day, Peter's Halloween*, etc.), but for Keats the book opened up the way into direct rather than schematized experience. Peter grew and would not fit into his chair before his creator realized what had happened,[70] and the private/public lives of Peter, Archie, Louie, and the rest were brought into the studio straight off the sidewalk. In the twenty years between *The Snowy Day* and *Clementina's Cactus* there were no fewer than sixteen of these books, which explored the hidden life of children—mostly urban—cast upon their own resources; and, taken with ten or so other books that may be seen as alternative experiments in the art of the colored picture book, they drive home Fran Manushkin's perception of Keats coming to life.

What he also had not reckoned with during that inspired creation of *The Snowy Day* was the change in patterns of living that one book would force upon him as a person, with a daily life to lead, rather than as a creative artist. As we have seen, the years before 1962 were hardly genial ones, what with the pills, the therapy, the unfocused work: "I tried to drum up work, visiting the art directors of publishing houses, regaling them with endless stories . . . [until] it finally got back to me that I was taking up too much of their time—that they wished I'd show them my samples or deliver my job and bug off."[71] It was hardly surprising therefore that when, early in 1963, Ruth Gagliardo, chairman of the New-bery-Caldecott Medal Committee, telephoned Keats to tell him that *The Snowy Day* had won the Caldecott Medal he should do a double take, for he had never heard of the Caldecott Medal; and,

never having heard of it, he was unaware of what was about to happen to him.

For such is the nature of American children's librarianship and such is the nature of the publishers' publicity machine—and perhaps I might perilously add, such is the nature of some part of the American soul—that nothing succeeds in the United States like officially sanctioned success. *The Snowy Day* was a winning book in itself, but, being also a winning book in the Caldecott stakes, it skyrocketed the Brooklyn hack artist, so recently just seen as taking up valuable office time, towards national fame.

The most immediate consequence of this (apart from some very healthy sales figures) was the need to appear under the spotlights—perhaps even wearing a suit. Keats has written amusingly of the ordeal of giving his acceptance speech in Chicago on receiving the Caldecott Medal[72] (and Ruth Gagliardo afterwards wrote, "You were simply grand!"—adding for good measure, "The rest of it is—you looked mighty handsome!").[73] But despite the strain of this first encounter with the children's-literature groupies, Keats was by no means averse to making public appearances, and, as time went by and the simplicities of *The Snowy Day* grew into the haunting resonances of such books as *Apt. 3* and *Louie,* he was involved more and more in a variety of encounters with his admirers.

At their simplest these would be "meet the people" occasions or children's-book conferences, which would include the all-American custom of the signing session. (Success could be almost overwhelming: in October 1976 Janice Szelich wrote to him to tell of her delight at his presence at a Language Arts Conference at Trenton State University and remarks, "My friends and I stood in line a total of 2fi hours for your autograph and found the waiting enlightening. How you find the patience to be so courteous to each and every autograph seeker, I'll never know. . . .")[74] In addition, though, there would be more formal or more festive occasions. In 1970 he won the Boston Globe/Horn Book Award for *Goggles!* which was also a runner-up for the Caldecott Medal, behind William Steig's *Sylvester and the Magic Pebble,* and although none of his later picture books achieved an equivalent public distinction (were his subjects coming to be regarded as repetitious? was so unusual a book as *Apt. 3* beyond local comprehension?), there was a widespread desire to recognize his contribution. This is summed up in 1980 with the University of Southern Mississippi's award of its Silver Medallion for "distinguished service in the field of children's literature," but there were

Keats did not simply wear a suit for the Caldecott Medal ceremony. Arthur Bell of Viking made some celebratory underwear too.

deG 0060.13-14

also less formal accolades, as when, in 1973, the Warrensville Community Branch of the Cuyahoga City Public Library dedicated a Children's Room in his honor.

That would seem to be a fashionable thing to do in Cleveland, Ohio, where Cuyahoga City is to be found. Other branches there had rooms named for Beatrix Potter, Laura Ingalls Wilder, Mark Twain, and suchlike laudable figures. But the occasion was one of particular warmth and friendliness, and may perhaps symbolize here the appreciation that Keats had for gestures of this kind and the affection that he inspired in his hosts. For Eula Lane, the children's librarian at Warrensville, planned the event with great care, and such was its success that when a year later the library decided to use three Keats books for a theater workshop, to be held on his birthday, the author suggested lending them some of his original materials, including a clay head of Archie, and added, "I would like to be there . . . to participate in the fun."[75] And fun it seems to have been. Keats wrote on March 19:

> I want to tell you that what I experienced that day made me feel that all my work these past two years was worthwhile. And for that I cannot thank you enough. . . . You gave me the best birthday party I've ever had.[76]

He also had a high old time a few years later in Portland, Oregon, where an extraordinary Keats-fest was organized. The beginnings were humble. In the spring of 1977 the children of Sabin School in northeast Portland sent him some samples of their efforts at paper marbling, and from this initial contact there developed the idea of an Ezra Jack Keats Day when the children of the town would celebrate his work. Funds were raised through popcorn munches and bake sales, and at the end of May 1979, after a visit to the booksellers' convention in Los Angeles, Keats travelled to Portland to take part in a motorcade through the northeast neighborhood of the city. Sitting on a white Volkswagen convertible, the belaurelled artist led a procession in which the schoolchildren dressed up and performed as characters in his books—"a memorable and touching experience," he wrote a week after the event.[77]

While junkets like these —but not always so spectacular—could be a fairly normal part of the timetable of a Caldecott winner, they were in Keats' case linked to a fairly intensive involvement with "the media." At its most predictable this involvement was with Morton

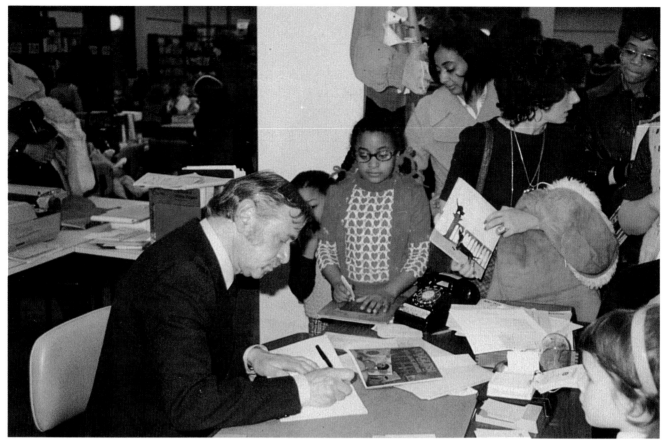

The patient book-inscriber. Keats at the Warrensville celebration in 1975.
deG 0119.01 #14

Keats about to set off on the parade in Portland.
deG 0090.01

Schindel's company Weston Woods Studios, which had, in its own inimitable words, "emerged from a marginal activity seeking a foothold in the audiovisual field to an established business with a secure position in the knowledge industry."[78] What Weston Woods had perceived was that a good deal more could be done with a lot of the artwork in picture books than merely have it lie around on library shelves. Their "foothold" had been the making of slide productions of a quantity of these picture books so that they could be screened in class or library story-hours, and the "established business" had grown through the expansion of this relatively simple procedure into the conversion of picture books into animated films or full-dress movies.

One of their early successes in this vein had been a version of *The Snowy Day,* which had won the Lion of St. Mark Award in the International Exhibition of films for children at the Venice Film Festival in 1965. From then on Keats maintained a bumpy, but fairly amicable, relationship with Weston Woods, who went on to use many of his books in their various programs, and who made a film of Ezra Jack Keats himself. Keats was, however, led on to further involvements with media productions, for he had a natural inclination both towards cinema as an art form and to the way in which film and theater could be adapted for a young audience. In the autumn of 1967 he had been invited (as "Mrs." Ezra Jack Keats—"Dear Madame"!) by the wife of the shah to attend the Second Tehran International Festival of Films for Children "as the delegate of the United States and as our guest of honour."[79]

The Weston Woods film of *Whistle for Willie* was apparently one of the few highlights of a fairly lackluster festival, but the opportunity of seeing such a diverse body of material—from the Canadian "Notes on a Triangle" (5 minutes) to the Chinese "Call of the Mountains" (100 minutes)—was not easily repeatable, and no doubt it stood Keats in good stead. He was later to attend as an advisor the Carnegie Corporation's seminar on "Curricular Goals in Language and Reading" organized by Children's Television Workshop, and was a member of the 1970 White House Forum on "Child Development and the Mass Media." (It was at this forum that he met Fred Rogers, who invited him onto the television show "Mr. Rogers' Neighborhood," where he proved a considerable hit—a relaxed sage talking with passion about the importance of childhood.)

Already, by this time, Keats was conscious of a distinctive quality in his children's books that was compounded of their urban

ambiance and their forceful graphic style. In 1969 he made a proposal to donate his "literary estate"—sketches, drafts, final artwork, etc.—to the Monroe C. Gutman Library of the Graduate School of Education at Harvard University.

A press release (undated, but issued early in 1970) described the scale of the gift, which was received with much pleasure by the university, and was celebrated by a luncheon organized by Macmillan. Most of the constituent material was transferred to the library and, for a number of years, Keats continued to send further manuscripts and artwork when he felt he had no need of immediate access to them. The library was put to some trouble by the arrangement, since it fell to their lot to ship material back and forth to publishers and to organizations like Weston Woods who might need it for photographing or display. Nevertheless, there was much cordiality, and in July 1975 Keats gave a lecture to the graduate school, which was received as "a generous gesture" from which "some excellent feedback" resulted.[80]

At this time too, arrangements were being made to formalize the gift, which led to the involvement of lawyers and talk of "necessary documents." What actually occurred is not clear, and the Gutman Library no longer has information about the transaction, but there seems to have been some uncertainty over how far the material would be maintained in its entirety. Later, in 1975, negotiations ended and the material was returned to Keats, who stored the artwork and papers in Manhattan. Thus, Harvard's loss was to be Southern Mississippi's gain.

Throughout these years when spells of creative work on the making of picture books were interwoven with the public activities which those books engendered, Keats presided over his own fate. His association with Estelle Mandel as agent may well have been an energizing influence at the start of his work as an illustrator; however, once that association was ended he did not seek out another agent but handled all his business affairs himself. This placed a considerable strain on both his time and his temperament. The administrative labor of keeping track of a growing body of contracts, both with publishers and with subsidiary operators like Weston Woods, was considerable, and it was not lessened by Keats' persistent negotiations to receive what he considered fair terms and his determination that the highest standards be met in the conversion of his original artwork into print or film. Before ever he started on *The Snowy Day* he had become a professional hand at "vis and layout."

The Snowy Day
Cut paper
253 x 510 mm, 1962
deG 0061.13

He knew the problems that his often complex color-work presented to the camera, but he clung to the almost otherworldly belief that everybody else would care as much as he did about achieving perfection.

As his own self-appointed agent, therefore, Keats made a considerable rod for his burdened back, but he also had the sense of being in control of his own destiny. Struggles to achieve the right voices and the right music for Weston Woods films, or his regular trips to Brussels to supervise the color separation for the picture books, were not chores for him but were an extension of the creative process that was the center of his existence.

Ever since the *année scolaire*, Keats had enjoyed travel and, according to Fran Manushkin, one of the pleasures of the life that he began at forty-six was the opportunity to go places. London, Brussels, Paris,

Venice, Tehran—the cities were a stimulus—and perhaps the greatest stimulus of all came from Keats' connection with Japan. This began in the way that many of his international adventures did: by negotiations over Japanese editions of his books.[81] The publishers were Kaisei-sha of Tokyo ("fine children's book publishers since 1956") and they had written to Harper & Row on January 9, 1969 about *Peter's Chair*: "We would like to issue a beautiful best book for Japanese children in nice sentence, in good binding, and in good delicate printing, enlarging the book a little."[82] The enlargement had to do with fitting *Peter's Chair* into a series format, and led to some awkward moments, but Keats had also written to the publishers that he "would be proud and happy to have my books read by the children of Japan"—a wish that was to be fulfilled in ways that were both exhilarating and touching.

Kaisei-sha proved to be a sympathetic company with whom he established an enduring relationship (for all that, they had described him in the first Japanese edition of *Snowy Day* as a black author, later changed to "world famous"). They undertook publication of the "core group" of Keats books, expending much energy to try to ensure that the translation and printing met the author's high standards. Meanwhile, another children's-book firm, Holp Shuppan, had expressed an interest in some of the Keats jeux d'esprit and got into correspondence with Franklin Watts over the Japanese printing of the new titles *Pssst! Doggie* and *Skates*. Negotiations here led to the proposal that Keats should visit Japan, and at the beginning of 1973 he flew into Haneda Airport, Tokyo.

The visit, as Keats later reported to Jean Mercier of *Publishers Weekly*, was "one of the most exhilarating and lovely experiences of my life,"[83] taking him into a dream landscape, prefigured in the Japanese prints that he had come to love many years before, and taking him also into the thick of the Japanese enthusiasm for children's books. He was bowled over by the work of a group of adults who ran the Ohanashi Caravan, a kind of travelling library in the suburbs of Tokyo, which ran puppet shows and storytelling sessions, and he developed firm friendships with its staff and especially with Sachiko Saionchi, who was to become an admired translator of his books.

Out of this connection was to develop a sustained correspondence with Japanese friends, through whom came news that, such had been the success of *Skates* in Japan, a deputation of parents and children in Kiyose City had persuaded the mayor and the local administration to build a roller-skating rink for the town, and had

named it after the author who had inspired it. In consequence, at the beginning of 1974 Keats was again able to visit Japan to attend the ceremonial opening, a home-movie record of which is in the USM archive.

His final journey to the country in the autumn of 1977 included an altogether more somber element in its itinerary. Apparently, during one of his visits to the Ohanashi Caravan on his very first trip, a little boy called Akira Ishida had come to him to get his signature in a copy of *Peter's Chair*. Akira had loved the book and had been proud to show the copy to all his friends, but on June 6, 1977, at the age of nine, Akira had been killed in a traffic accident and his mother, in her grief, wrote to Keats to tell him of her loss and to say that "one day before his death, I checked out 'Dreams' for him from the municipal library, which proved to be the last book for him to have read." As part of his autumn visit, therefore, Keats went to see Akira's mother and he continued to correspond with her and send her copies of his books almost up to the end of his life. The dedication for the Japanese edition of *The Trip* reads, according to one translation, "With my memory of loving Akira Ishida, I dedicate this book [to him]."[84]

This episode points up one further vital element in the reconstitution of Keats' genius during the last twenty years of his life. *My Dog Is Lost!* and *The Snowy Day* may owe their success to observation and to an instinctive awareness of the nature of childhood, but they and their successors also reflect an attitude towards their immediate audience. Keats needed to be in touch with children to formulate his images ("Hey, Esther," he would ask Mrs. Hautzig on the phone, "can I come and see how children climb out of a pillowcase?" or "I'm going to the zoo; can I borrow a child?")[85] and the formulated images then seemed to speak with an authentic voice to the child-audience as well. Further direct experience came to him through the custom of getting children in classrooms or libraries to write to famous authors and illustrators. Large packets of such letters came to Keats through the mail, and, because he encouraged children to experiment at drawing or collage making, he often got bulky samples of artwork too. But he was always moved by the way his books could summon up responses out there among an unknown audience. He once fiercely berated one of his publishers for failing to send on children's letters quickly enough: "These letters had been sent to me by children, teachers and librarians, some needing immediate answers in connection with their work"; and he not only re-

plied to every letter if he could but also kept many of the children's submissions.[86] If you look at the photographs of that slightly bemused figure aloft in the Portland motorcade, you don't see an eminent visiting dignitary but a confirmation of what an editor had once told him: "You're an ex-kid."[87]

The success of Keats' later years brought an unprecedented degree of affluence. From living in apartments where he had to share studio space, or rent bits out to other artists, he moved into more distinguished quarters, first on East Fifty-eighth Street and then high up in a modern block on East Eighty-second Street. His mental space also expanded, letting in fresh responses to film, to the theater, and especially to music. But hypochondria and depression were never entirely absent and in his last years these were exacerbated by the diagnosis of a heart condition, which led, at the end of 1980, to a double-bypass operation. He was also worrying (probably needlessly) about his financial security, gloomily foreseeing a time when his books would go out of print and he would be confronted by declining royalties and an inability to make both ends meet.

Such uncertainties were not conducive to the blithest of creations and the impulse behind such late books as *Regards to the Man in the Moon* and *Clementina's Cactus* seems to be an uncertain one. On the other hand an argument could be adduced that these were the works of yet another transition period (and *Clementina* is indeed a new kind of book for him, but one not well judged in graphic execution). During 1982 he was, on the one hand, working with a publicity firm to try to follow up ideas for merchandising his books,[88] and, on the other hand, toying with ideas for books for younger children. He had met a young author-illustrator, E. A. Hass, and they had entered into a contract with Scholastic for a range of "activity books," of which only a few very early drafts survive. They had also begun to fashion a series of very simple movable books and had gotten as far as making a dummy, using cut and marbled paper, which they submitted as a specimen during negotiations with Simon & Schuster and Intervisual Communications of Los Angeles, market leaders in the pop-up industry at the time. There also looks to have been a similar sketchy proposal for some board books, a suggestion that had once been put to Keats by one of his English publishers, Judy Taylor, of the Bodley Head.[89]

At the same time another plan was bringing a largish wheel full circle. For Florence Freedman, the teacher at Thomas Jefferson who had given Keats early encouragement, invited him to illustrate *Broth-*

A promotional idea using the motto "Whistle for Books"
Sketch in pencil and color pencil
230 x 310 mm, 1982
deG 0163.04

Keats and Florence Freedman
in Israel.

deG 0127.04 #2

ers, a version of a Hebrew folktale that she had prepared. She had, from Thomas Jefferson days onward, never lost touch with him. In the fifties he had drawn pictures for the Freedman family's New Year letters.[90] In 1965, when Freedman was teaching at Hunter College, he had been one of the children's-book authors to take part in a series of "Tea and Talk" sessions.[91] And in 1971 he had illustrated her story of escaping slaves, *Two Tickets to Freedom.* But *Brothers* was a project dear to both of them. At the beginning of March 1982, Keats flew to Israel to make his own pilgrimage to the holy sites of Tel Aviv and Jerusalem and to meet up with Freedman to look at settings for the story. It was a regenerative trip, and along with his plans for other books and his involvement in yet another groundbreaking project—a stage production, with mime, of *The Trip*—it augured well for new creative departures.

Dean Engel, who spent much time with Keats during these latter years, has spoken of the vivacity that he brought to such projects, and especially the delight with which he accomplished the

64

Drawing of a primitive ox-drawn plough by Jonathan Asede (?), sent to Keats by Florence Freedman; presumably for *Brothers*
Blue ball-point on blue paper
deG (unnumbered)

set and costume designs for *The Trip*. She describes qualities in his character that had been manifest ever since the dark days in Dumont Avenue and which many of his friends and associates confirm: a compulsive gregariousness, once he escaped from the solitude of his studio; a winning sense of humor—especially when he took on the role of raconteur ("he was a fabulous storyteller"); and, above all, a gift for revealing to people the unrealized extent of their own capacities. As teacher, as colleague, as friend, he was able to perceive the latent abilities in others, and the force of his enthusiasm encouraged them towards unexpected fulfillments. Even his faults were closely related to these virtues. As a sensitive man he could be prickly about what he saw as slights to, or unjust estimates of, what he was trying to do. As a professional illustrator he could be pigheaded in some of his relationships with professional publishers. But his life-enhancing qualities transcended these natural enough aberrations.

Always, though, there was the sadness of old "Watermelon Face" behind his wonderfully expressive and photogenic visage—a premonition of untoward events. And untoward events came upon him abruptly, just as he was devising for himself new opportunities. After returning from Israel, his worries over his health redoubled. In July 1982 he flew to Switzerland for treatment at the Clinique La Prairie at Montreux, and although no serious diagnoses were recorded, he was moved to make a will and to give instructions for

his funeral (a nonreligious ceremony to be conducted by Martin Pope, his ashes to be "scattered to the winds").[92] Despite such depressive thoughts, he remained busy—sending a homemade greeting card to Lucille Fiorelli, a Warrensville librarian who was taking retirement; pondering a visit to RB, the old friend of his Paris days who was now living in California and who sent him "warm and affectionate memories"; and starting to work on *Brothers*.[93] But his mood fluctuated between energetic enthusiasm to proceed with his plans and despondency over his future health. Late in April 1983, he was taken to New York Hospital suffering from another heart seizure and it was there, with Martin at his bedside, that he died on May 6, 1983.

CHAPTER TWO

A Memoir by Martin Pope

I see my task here as that of providing a sense of the times in which Ezra and I lived and forged bonds that held us together for essentially all of his life. Some parts of my recollections do, of necessity, duplicate the biographical account given by Brian Alderson in chapter one, but we both thought that these personal memories and insights would give body to his chronological summary.

I met Ezra in 1930 when I was twelve years old. He and I were then students at Junior High School 149 in Brooklyn. From that time until his death, fifty-three years later, we had the good fortune to be close friends.

He was an artist/illustrator and author of children's books, and I am a scientist. How did this apparently disparate friendship come about? We met as children, with embryonic skills, but with similar curiosity about the surrounding world. We lived in the same neighborhood, went to the same schools, our parents were immigrants from Poland, we suffered the same privations, and read many of the same books, always enjoying each other's retelling of these books. Our relationship developed into one resembling brotherhood, without the complications of sibling or any other form of rivalry. Our interests were complementary. We taught each other to see the same scene through different windows. We took each other

for granted, to be called upon at any time for advice and/or assistance. Neither the passage of time nor the occasional distance that separated us had any impact on our shared memories, and each of our conversations throughout our lives was a continuation of endless other conversations.

During the years that we were in Junior High School 149 and continuing until the beginning of World War II, this country and the rest of the industrial world were in the grip of the Great Depression. Our families were poor. Securing food and shelter was the major focus of our lives. There was essentially no money for anything else. Our mothers developed incredible survival skills in making something out of nothing: soup from bones and clothing from fragments of cloth. Potato soup was delicious and went a long way; bread was home-baked and cheaper than at the store. Borrowing and lending of small kitchen necessities among neighbors was a way of life. Yet, although women could be neighbors for decades, they never called each other by their first names. Mrs. Katz would always address her dear neighbor of many years as "Mrs. Blatt." We never learned how to roller-skate, and it was well into later years that we learned how to ride a bike. Both of us, and most of the boys on the block, peddled candies, pretzels, and ice cream to supplement family income, and to earn the five cents to pay for an occasional movie.

Our chief form of intellectual excitement came from reading. We were both voracious readers, consuming everything in sight: Horatio Alger's rags-to-riches tales, Nick Carter detective stories, the Tarzan of the Apes series, Rover Boy adventures, Tom Swift's inventions, and other books written for our age group. Other favorites included Jack London, P. G. Wodehouse, Booth Tarkington, Rudyard Kipling, Robert Benchley, Mark Twain, and O. Henry. We never bought any of these books, but they appeared miraculously, passing from hand to hand, and disappeared just as mysteriously. We also managed to read every book of interest to us in our local library; this included all the books on art for Ezra, and all the books on science for me. The most popular for us were biographies of the masters. As do most children, we looked for guideposts to a future in our chosen fields in the lives of the great.

For us, the movies were the ultimate in the theatrical arts. Adventure and comedy were our chief fare. For comedy, we had the living Charlie Chaplin, Buster Keaton, Harold Lloyd, Ben Turpin, and Our Gang. For adventure, we had Douglas Fairbanks; for Westerns, we had Tom Mix, Harry Carey, William S. Hart, and

Bill Boyd. The Westerns came as a series of weekly episodes, and we couldn't wait to see if all of our plot predictions were correct. For thrillers, we had *Dracula* and *Frankenstein,* and *The Phantom of the Opera* with Lon Chaney.

In 1932, both of us entered Thomas Jefferson High School. Ezra lived less than two blocks from me, and both of us were less than one block from the school.

He lived on the third floor and I lived on the top floor of four-story walk-up tenements. On the first floor of his building, in Apt. 3, lived one of his good friends, who was also an artist. This probably influenced his choice of the title for his book *Apt. 3.* The roof was our mountaintop. We had unobstructed views of the great expanse of the sky. We marveled at the grand maneuvers of the pigeons, guided by the hobbyist pigeon fanciers. Ezra painted scenes from his roof.

At this time extremism was taking over the world. Communism was getting under way in the U.S.S.R., and fascism with its accompanying anti-Semitism was making headway in Germany, Poland, and Hungary. Japan was preparing to march into Manchuria. These events were grist for almost daily, and heated, extracurricular discussions during our high school years. The miserable economic conditions and unemployment brought about by the virtual collapse of U.S. industry contributed to discussions among young people of the relative merits of capitalism and socialism. It was the heyday of the soapbox orator. Interchanges between the speaker and audience were heated, and, at times, escalated into violence.

It was also a time for idealism, and Ezra was captivated by the dream of a humane, just, and truly democratic society. A ray of hope at home was generated by the landslide election of Franklin Delano Roosevelt as president, who quickly initiated work programs, including the Works Progress Administration (WPA). Our discussions touched on every concern of bright, idealistic young people. We spoke out for issues that now everyone takes for granted, but that then were considered to be Utopian fantasies: unemployment insurance, social security, financial support for education, health benefits, a respectable form of welfare or public support for the hungry. We fully expected that some day soon, the exploitation of humans would come to an end. Ezra's sympathies were distinctly with the underdog, and his eloquent paintings during this period focused on the despair and loneliness of the unemployed.

In addition to his undisputed position as the master artist in the school, Ezra was an honor student whose wit, sense of humor, and

talent as a raconteur made him popular with his peers. He was also the captain of the fencing team, an athletic skill that was compounded by his exquisite eye-hand coordination and his romantic flair.

After graduation from high school in 1935, Ezra was in a quandary. He was without doubt a gifted painter, skilled in oils. Internally driven, he never entertained the notion of being anything other than an artist. To continue with his fine art would mean a life of extreme uncertainty, at best. There would be times of financial distress, and who would support him? His older brother, Kelly, had just married and left home, and his older sister, Mae, was the sole support of the family. It was therefore necessary for him to earn his livelihood as a commercial artist. His first job offers came from the field of comic books. Sometimes he brought home work to be finished, and, in his absence, his mother would invite her neighbors in to admire the beautiful work being done by her magnificent son. In passing, it should be mentioned that Ezra's mother was an exceptional naïve artist. My mother visited her on occasion, and was more impressed with Mrs. Katz's talent than with Ezra's, which she took for granted since he had more opportunity for development.

He worked in the comic-book field for about one year while still living at home, but kept up his fine art skills and interests by attending classes at the Art Students League. From comic books, he moved into work as an artist in the Federal Arts Project, part of the WPA, set up by Roosevelt to provide employment for artists while giving them opportunities for creative expression in the service of society.

I pursued my college career at the tuition-free City College. During the first three years of college, my time was almost completely taken up with course work. But in 1938, my last year, my course load lightened and Ezra and I spent more time together. We had much to talk about. There were books by Mann, Faulkner, Joyce, Hemingway. He introduced me to the works of the great Mexican muralists, Orozco, Siqueiros, and Rivera. But most important to us were the menacing events in Europe and Asia. The world political situation had worsened considerably. Hitler had taken over in Germany, and attacks on Jews were a frequent occurrence. Stalin had instituted his purges in the Soviet Union. The Japanese had seized Peking, Shanghai, and other cities in China and Franco was winning his war against the legal democratic government in Spain. During our endless conversations, Ezra would walk me home, I would turn around and walk him home, and this would go on until we would finally say farewell

midway. On December 7, 1941, Ezra and I were walking in Greenwich Village when we heard that Japan had attacked Pearl Harbor.

In 1942, we were separated by the war. I went to the Far East and Ezra stayed in the United States in an army camouflage unit, using his artistic skills. Ezra returned to civilian life in 1945, and shortly thereafter was hospitalized because of a serious bout with stomach ulcers. I returned to civilian life in 1946, and in that year, Lillie Bellin and I were married. While everyone savored the varied food at our wedding reception, Ezra had to stick to milk and crackers.

Our close friendship continued, and Ezra became a frequent visitor at our home. He accompanied us on several of our vacation trips, one of which was to a visually spectacular part of Arizona. His inspiration for *Clementina's Cactus* came from that desert adventure.

In our later years, when Ezra was an internationally renowned author and illustrator, and I had a faculty position at New York University, we would meet regularly, about once a month or so, either at the Society of Illustrators' Club in Manhattan, or at a restaurant near my university, to discuss his personal problems, as well as questions of social, artistic, or philosophical interest. He was a deep thinker, constantly probing for universal and just principles of behavior. We discussed his artistic work when he was having problems, such as with an agent, an editor, or a critic. He consulted me about the nature of heavenly bodies when he was doing *Regards to the Man in the Moon,* and whenever he was unsure about some physical principles.

His personal problems often involved his health, which was of great concern to him. As a young man, Ezra suffered from a chronic sinus complaint that never disappeared. He was mindful of his peptic ulcer too, which he managed to control by medication and diet. He would often consult me about particular foods and their possible harmful effects. In the last decade of his life, he developed severe cardiac problems. This was familial, since every member of his immediate family died of heart failure.

Ezra was highly intelligent, good-looking, widely read, had a marvelous sense of humor, and was a spellbinding storyteller. He was much sought after as a dinner guest. With all of this, and his artistic gifts and stature, he was attractive to women. He formed serious attachments to several women during his life. These women were intelligent, interesting, attractive, talented, and self-reliant. However, he could never overcome the psychological obstacles to marriage that were set up during his childhood. He placed most of the blame

on his mother, with some complaints about his sister as well. The constant refrain was that, according to his mother, he was an unwanted child, he was the cause of all of her ailments, and therefore, she did not love him. There is no doubt in my mind that his mother loved him, despite her complaints. I can bear witness to her pride in him, her hopes for him, and her solicitude for him.

However, she did complicate his life. Ezra told me that she warned him never to get married, because "marriage is hell," and never to have children, because they might be handicapped, as was his sister Mae. Mae, who was older than Ezra, never expected to have the affection of a man, and never expected to get married. She was otherwise a woman of great charm, wit, a keen observer of the bizarre aspects of everyday life, and an enchanting storyteller, who was also artistically inclined. With such talents bursting for expression, and with Ezra as the only captive audience, it is to be expected that her devotion and attention could become a burden to a young person struggling to find his own identity. Between his exaggerated interpretations of the admonitions of his mother and the perceived oppressiveness of his sister, the two who fashioned his vision of women, he entered adulthood in a state of conflict between his natural attraction and love for women and the conditioned reflexes that prevented him from making a permanent commitment.

Ezra loved children, and when engaged with them, his entire persona changed. He was completely open. He accepted their comments with patience and humor, and provided encouragement to them in their efforts. He enjoyed my children, and those of his other friends. He especially took pleasure in Kelly's daughter, Bonnie, born in 1943.

Kelly was street-wise and had a magnificent sense of humor. This gift, together with a flair for artistic expression, was a family characteristic. He opened the first photofinishing shop in our area, where he developed and printed film. One of his specialties was the tinting of portraits, and this was done by Mae, using fine cotton swabs. He was also a portraitist, and captured the images of several celebrities, including Winston Churchill, whom he photographed during the war. Kelly was a good provider for his wife, Millie, and daughter, Bonnie, and supplied funds that enabled Ezra to spend a period in the city of his dreams, Paris. Millie was representative of the young women of that period who took homemaking as a calling. She was kind and loving to Ezra, and tried with great insight to ease his bitterness towards his mother and sister.

Animal pets play an important part in Ezra's books. When we were youngsters, the only pet that could satisfy our need to nurture another living creature and that fell within the bounds of frugality, limits of space, and absence of excreta was a goldfish. As an adult, Ezra took great comfort from his dog, Jake, and at the end, from his cat, Samantha. Jake was a Weimaraner, and wrote delightful letters to Bonnie. Samantha was a red Persian who often perched herself inches from the work Ezra was occupied with, watching his brush as if it were a mouse. Samantha was still alive when this memoir was written (1993), sixteen years old, and enriching the life of one of Ezra's admirers.

Those of us who experienced the Great Depression bear many emotional scars. In Ezra's case, it was a baseless fear of poverty in his old age. When we were young, he and I would walk miles to Highland Park along streets lined with trees, in front of beautifully kept private homes, each separated from the next by spacious driveways. These homes were situated at the edge of a high ridge, with a spectacular view of Brooklyn, stretching to Jamaica Bay. To us, this type of home, and way of life, could not be more unreal and unattainable. It was particularly depressing to Ezra, who was convinced that he would always be a spectator. Lillie and I spent many hours in those last years attempting to reassure him and helping him plan for a trouble-free future. To complicate matters further, his old heart problem was returning. He was experiencing angina pains, despite having undergone open-heart surgery to bypass clogged coronary arteries, and he had to be hospitalized. He assigned to me the task of serving as intermediary with his physician. It was my responsibility to question his doctor about his latest findings and prognosis, to interpret the answers in a manner that would be understandable and optimistic to Ezra, and to share in the decision making. However, Ezra's heart was seriously damaged, and nothing was available at the time to prevent his death in the hospital.

I have attempted to describe the times during which Ezra grew up, and some aspects of his personality and personal life, with the expectation that this information would rationalize the path he took in the expression of his artistic genius. Ezra's themes in the books he wrote and illustrated in many cases can be traced to his childhood experiences. His suffering in early life from economic privation and anti-Semitism, coupled with his firmly held egalitarian philosophy and love for children, made the minority child a natural subject for his creativity. In fact, the schools we attended and the neighborhood

in which we lived are now inhabited by the very children of whom he wrote.

I was privileged to have his friendship over almost the entire span of his life. He was cultured, attentive, and curious; he taught me how to look at and read a painting; he kept me in stitches with the humor in his stories; and he encouraged me when I had doubts. He graced my home and enchanted my children. His work has had a profound influence on children's literature in the twentieth century, and will be loved by children in the next century.

When I look back on the days long ago when we walked arm-in-arm as youngsters on our way to the library, laughing much of the way, and recall that grim time at New York Hospital when, with disbelieving eyes, I was horrified to see his life slipping away in my hands, I feel as if we were actors in a Greek tragedy, moving about with apparent freedom of choice, but all the while in the grip of the Fates who had predestined the alpha and omega of our friendship.

CHAPTER THREE

The Painter

A full appreciation of Ezra Jack Keats' strengths and weaknesses as a book illustrator must be grounded in the recognition of his relish for painting. This was something that he found inexplicable, something inbred in him from his earliest years, before any external influences could have put it there. "As a kid you didn't know what you were going to draw; you just knew that you had to draw with whatever images and with whatever was at hand"[1] and his earliest painterly recollection has to do with color. He tells how he dipped a brush into some white paint and dabbed it across a blue board:

> I stepped back and got the greatest thrill I can remember. I saw a little cloud floating across a blue sky. It was very real to me. . . .[2]

There is no reason to believe that this anecdote is in any way apocryphal, but even if it were its essential truth is incontestable. Keats—born in drabbest Brooklyn—possessed an innate feeling for, and delight in, color, and this was eventually to account for most of the more momentous steps in his erratic pathway to success. Everyone who knew him confirms the experience that Martin Pope has described of how Keats could make you discover nuances of color in even the most unpromising circumstances.[3] What was also needed

was a purpose, a confidence, that this sensibility could be directed towards fulfilling ends.

At a near-facetious level, Keats has described his early discovery of one such purpose. From what has come down to us of his childhood efforts, it seems that he tried to improve his command of technique by copying various printed illustrations and pictures that came his way. The USM archive contains several examples where he seems to have been making copies of pictures in children's books or magazines, but he has also recounted in his autobiography how he adapted these skills with nefarious intent:

> I copied a postage stamp from my modest collection. . . . It came out looking pretty dull, so I decided to create my own stamps— oval, triangular, elongated. I put into them . . . exotic creatures who inhabited a fabulous world out there, far, far from Brooklyn. With my sister's manicuring scissors, I cut out the serrated edges. To give them a touch of authenticity, I carefully copied the cancellation marks and then smeared the stamp with my dirty fingers.

The result of this piece of graphic invention was the defrauding of Cross-Eye Bubbie, "who had the most coveted collection in the neighborhood and was considered to be a first-class stamp connoisseur." Fooled by the dim light in which the transaction took place,

A much later game with the mails came with *A Letter to Amy*. Here, greatly enlarged, is Peter's envelope —with stamp—addressed to "Amy Alcott," which is featured in the collages for that book.
92 x 165 mm, 1968

deG 0028.07

Bubbie swapped some treasures—only to discover his mistake in the light of common day, to the discomfiture of the artist.[4]

None of these philatelic experiments has survived, and very little else from Keats' junior years. But the encouragement that he received from his mother and at Jefferson High, and the stimulating atmosphere of that school in the thirties, gave full rein to his devel-

A copy by Jack Katz of Norman Rockwell's *The Clockmaker*
Oil on kitchen linen, rebacked and stretched

Private collection

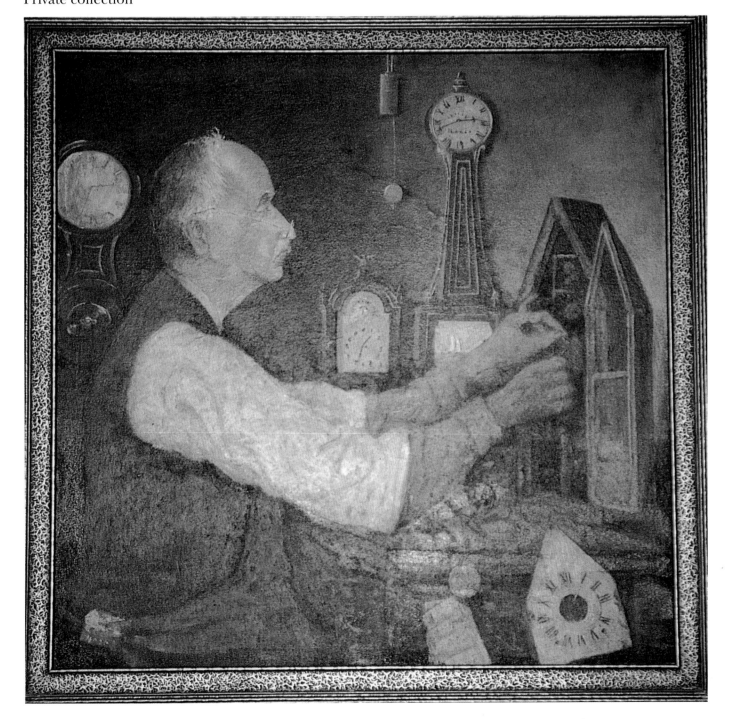

oping talents. He continued to copy—a fine attempt to reproduce Norman Rockwell's *Clockmaker,* done on kitchen linen for cheapness, is even said to date from his twelfth year—but it was undoubtedly the discovery of Daumier that startled him into the realization that painting was not just the exercise of a craft, the elaboration of decorative fancies, but was a way of saying things. Daumier's *Third-Class Carriage* may have had irreproachable technical assurance, but what mattered was the degree to which composition, form, light, and color expressed the artist's compassion for the third-class travellers who were his subject. He disclosed a direction for Jack Katz' own art.

A copy of Daumier's *Peintre* and two signed copies in oil of Daumier's *Saltimbanques au Repos* probably date from Keats' high school years (0154.06 and 0145), but his full creative reaction to this experience is embodied in a group of surviving oils in which he combines the "second vision" of his master with an awareness of the graphic language of the time. Despite so little remaining evidence, we can see from his copying of other artists' work that Jack Katz had a technical assurance that was remarkable for a boy brought up in such unpromising conditions. What is really impressive, though, is the way in which he applied this technique to "painting the despair."

The portrait of his parents and the prizewinning *Shantytown* are exemplary here. "Realism" is heightened by a degree of distortion and by a slight exaggeration of gesture or movement, showing a capacity to manage the difficult medium of oil combined with an instinct for the needful weight of each emotional statement. These two pictures, however, seem to be typical, rather than outstanding, representatives of a substantial output that may have continued sporadically up to the war.[5]

The USM archive contains a dozen or so other original oils from this period which demonstrate the force of his vision. One or two focus upon individuals, like the *Circus Clown* (0151), which was also submitted for the Scholastic competition of 1934, and which makes the conventional, "Pagliacchi" distinction between outer gaiety and inner grief without overdoing it; or like the *Reclining Man* (0150), an intense portrait of—presumably—"one of the bums" whom Keats painted down at the Bowery. For the most part though these early oils are preoccupied with street scenes, but with the intention of reflecting the wasteland of impoverishment rather than any particular locale.

Two rooftop scenes among these pictures were used by Keats in a film about his art made by Weston Woods (0154.08-9; see one of these reproduced in chapter one), when he characterized them as

part of the topography of his childhood. As Florence Freedman has noted, however, there is an eerie stillness about these and similar pictures. The angular composition and the drab coloring (lessons learned from looking at Cézanne?) form the backdrop to a depopulated cityscape, and when people do appear, as in the almost obsessive pictures involving the sweet-potato vendor (01.05; 0143), they are faceless properties, and the black, chimneyed stove is there not for any descriptive reason but for its ominous symbolic force.[6]

The precocious skill behind some of this work should have augured well for Jack Katz' future as a painter, particularly since it

Sweet Potato Vendor
Oil on canvas board, signed Katz
407 x 305 mm, n.d. [ca. 1934]

deG 0143

was wedded to a passionate interest in the expressive potential of painting. This is revealed in a brief essay that he wrote, probably for the school magazine, the *Jeffersonian,* and that may have stemmed from his experience as president of the Brooklyn Society of Younger Artists at the Brooklyn Museum in 1934. "Art: New Style" may have the callowness of adolescent proselytizing, but it is an articulate defense of symbolism and of the possibilities of nonrepresentational art. Indeed, at one point it almost reads like a justification of *The Artist's Parents*: "The distorted portrait is in reality a truer likeness than the careful academic one. It is not a surface likeness but something more; it delves deep into the soul of the sitter and reveals his character. . . ."[7] And how perceptive too was Jack Katz in 1934 with his judgment of Albert Pinkham Ryder as "undoubtedly America's greatest painter"—a view that may have been formed from the Brooklyn holdings of Ryder's seascapes, but that has only recently been endorsed by critics, not least through the 1990 definitive exhibition of Ryder's tormented (and decaying) paintings.

With such an understanding of the techniques and the "philosophy" of painting, how did Katz/Keats the artist come to sink without trace? How can we account for the fact that the boy who left Jefferson High with scholarships, with golden opinions, and, above all, with a body of work that already proved his gifts, never developed into an artist of significance?

The answers to that question—which, ultimately, will have a powerful bearing on his development as a maker of picture books—can only be speculative. His own accounts of the years after Jefferson are patchy, agitated, and sometimes ambiguous, and the friends who recall that difficult period were, understandably, preoccupied with their own lives and had no complete access to the inner workings of Jack Katz' ambitious but frustrated temperament. What is fairly certain is that he found leaving the enclosed world of school particularly traumatic. The death of his father and the continuing tensions at home took away an immediate foundation on which he could build; his own emotional reaction to the miseries of the nation's economic slump, and the sheer worry of finding an income, were surely an additional distraction from any single-minded pursuit of painting. Perhaps too, at a social level, the tenor of New York life at this time was not hospitable to that spirited development of talent that was still occurring in European artistic centers. Katz' frequent changes of lodging, often back and forth across the East River between Brook-

Parisian Corner
Wax crayon and pen and ink on the disjunct leaf of a
sketchbook, enlarged
230 x 314 mm, 1949

deG 0153.09 numbered 463

lyn and the Village, bespeak a highly unstable life-style with no central point of reference —no "home"—and this was not conducive to any systematic attempts at developing a painterly language.

Even if Katz was building on the foundations that he had laid, nothing from this period seems to have survived to show it. Fourteen years span the time from his leaving school to his departure, as Ezra Jack Keats, for Paris—years occupied either by army service or by a series of jobs amounting to little more than drudgery—and, for all the evidence that remains to us, painting could almost have been in abeyance. Only through the applications to La Grande Chaumière and the Académie Julian in 1948 can we perceive that Keats was holding fast to his understanding of himself as a painter, showing that some painting had always been going on amidst this variety of dissatisfactions.

(One of the problems in discussing Keats' career as painter is caused by his permanent failure —refusal?—to date anything. The early work is usually signed *Katz* and may have labels, or some evidence, on the back of the canvas to fix dates around 1935, but, beyond this, the dating of sketches and finished work has to be done by inference, usually from the subject and location of the picture. Furthermore, Keats' own later comments on this rocky period of his life are never very specific. When he speaks so deprecatingly of the time "when I was so hooked on theory and dialects [*sic*; presumably "dialectics"]," he notes that he was "already painting professionally" and engages in sharp self-criticism: "I heard—I really heard myself saying, paint, paint, with a big brush, underpaint, get the plastic quality . . . instead I was using a palette-knife and applying little dabs of color in a dry, sour, systematic way [surrendering] everything to theory, politics, art . . ."[8] Unfortunately, he sets no date for the events and, although we may hazard a guess that he is referring to oil paintings of the postwar years, he may be talking about earlier times. Anyway, there is no present record of any of the theory-obsessed pictures that he was making.)

What emerges most strikingly when graphic evidence reappears is the total change in the vibrancy of Keats' art. We possess some sketches (0141.11-13) and many drawings and paintings that relate more or less directly to the European trip of 1949 and these have all the attributes of the conventional observer-painter. What interests Keats is catching the features of a person, or, more usually, a place, in a way that will look good as a finished design. The emphasis is on the interplay of light, color, and shape in the makeup of a satisfying

Flower Shop
Watercolor on paper
330 x 407 mm, 1949

Private collection

Woman with Umbrella
Pen and ink sketch on paper, signed Keats
300 x 228 mm, n.d. [ca. 1950s]

deG 0156.02

Man with Hands in Pants
Pen and ink sketch on paper, unsigned
310 x 229 mm, n.d. [ca. 1950s]
deG 0156.03

visual whole. Heavy symbolism has gone; there is rarely any attempt at narrative content; catching the fleeting look of a thing at a given moment is everything. And with this change of stance there comes also a change of medium. Drawing is now used to capture shape, and watercolor to render atmosphere and the harmony of color for which Keats had so sensitive an eye.

Unfortunately Keats has given us no explanation of this shift in his attitude towards the purpose of his art. In his letters from Paris, and in Jay Williams' accounts of their meetings at that time, it appears that he saw this new métier as one that held possibilities of development and from which he derived satisfaction. There is a very attractive balance between the informality of the drafting of these pictures and the solid reality that they portray, and this is heightened by Keats' obvious delight in the subtle powers of watercolor. His French landscapes and his Parisian street scenes confirm that perception for the nuances of color that had been with him since boyhood.

From 1949 onward the record of Keats' work as an artist is of a sufficiency that stands in strong contrast to the dearth of evidence for what had immediately preceded it. The archive possesses a quantity of material clearly datable to Paris, backed up by a photographic record of paintings that were dispersed in a sale of 1985, and, building upon the confidence gained from the Parisian trip, Keats poured out a mass of sketches, drawings, and paintings for the next dozen years. There seemed to be a place for his skills in that intermediate world that existed between the dedicated art of the Master Painters and the Sunday enjoyment of the gifted amateurs.

So far as significant development goes, however, little need be said about these post-Parisian years. A calendar of work in the archive and of traceable work in private hands would be difficult to establish, not just because of the absence of dates but because of the homogeneity of the art. What Keats perfected in Paris was a command of painterly resources that would answer the needs of commissioning agents or of people wanting pictures for their living-room walls, rather than assure the fulfillment of some personal vision. He described himself, after his return, as "a commercial artist"[9] and much of his energy during the next ten years was devoted to meeting the needs of a variety of clients.

Such a limiting assessment of his studio work is confirmed by an analysis of material in the archive and what is known about the reception of his work elsewhere. Sketchbooks and individual sketches, usually in pencil, charcoal, or pen and ink, bear witness to his con-

Bedford Street
Gouache on board, unsigned
407 x 330 mm, n. d. [1950]

Private collection

stant activity, and show his natural ability to find telling gestures and viewpoints and to catch these with a vital economy of line. So far as more finished work is concerned, though, this assured technique seems to run free under no other pressure than "a job in hand." Paintings, usually in watercolor or gouache, are commissioned for magazine stories and covers, for advertisements, and for trade journals, etc.; individual works, again usually in watercolor, are prepared for sale through galleries or through his agent, Estelle Mandel. Some of these, such as the watercolors painted in the Virgin Islands, or the interior scenes in the Murray Hill Hotel, take the form of subject suites and they help to emphasize Keats' liking for landscapes and buildings as the subject for finished pictures. (This is not to say that he was averse to figure drawing. An overwhelming number of his sketches and monochrome drawings are of men and women—finely, and sometimes comically, observed—but people are much less frequently found as the central preoccupation of his paintings.)

Through all this post-Parisian work there runs a professional consistency, which suggests an even greater potential. After all, commercial art does not preclude any other kind of art and plenty of modern painters have successfully combined work in, say, advertising with the creation of their own, more personal statements. With the benefit of hindsight a case could be argued that Keats had before him, in 1950, the possibility of becoming not just a recorder but a celebrant of urban New York. Born in the city complex, knowing Brooklyn and Manhattan as a native, he might have pursued his powerful adolescent visions of the place into maturity. There is nothing unsatisfying about watercolors like the Murray Hill Hotel series; they are quirky, amusing—true—representations. But they are nothing more than that, and one is conscious that Keats has more to tell us than he admits. In pictures like *Bedford Street* or *The Fulton Theater* (01.08c) or *The Tombs* (01.10a), an interpretive force creeps in which carries the representation of these three—admittedly dramatic—studies of architecture beyond naturalism and towards metaphor. Keats is here on the brink of using the extravagant, grim, bizarre townscapes of New York to give insight into the history of the lives of its citizens. That would have been an art worth seeing—and one consistent with its origins. As things turned out though, the celebration took a different guise.

CHAPTER FOUR

The Commissioned Book Illustrations

When Elizabeth Riley commissioned the illustrations for *Jubilant for Sure* in 1953, Keats may well have regarded the work as just another element in his expanding career as a commercial artist. The year before, he had made his formal agreement with Estelle Mandel to act as his agent and he had been busily working on winning commissions for graphic work: on magazines, on paintings of cities for *Wings: The Literary Guild Review,* and on the dust jacket for Doubleday that had roused Riley's interest.

The illustration of books themselves, however—and of children's books in particular—does not seem, up to this point, to have entered his mind as a further possibility. Certainly the first dust-jacket commission had brought some excitement, as witnessed by his account, in his autobiographical drafts, of sitting up all night in "that hypnotic state, where nothing stands between you and your work."[1] But painting subjects for dust jackets bears only a tenuous relationship to illustrating books. You have to read the work in question at least to the point where you can assess its atmosphere or can fix upon a subject for the cover; your work is then governed less by any "pure" illustrative principle than by the practical need to produce a design that will

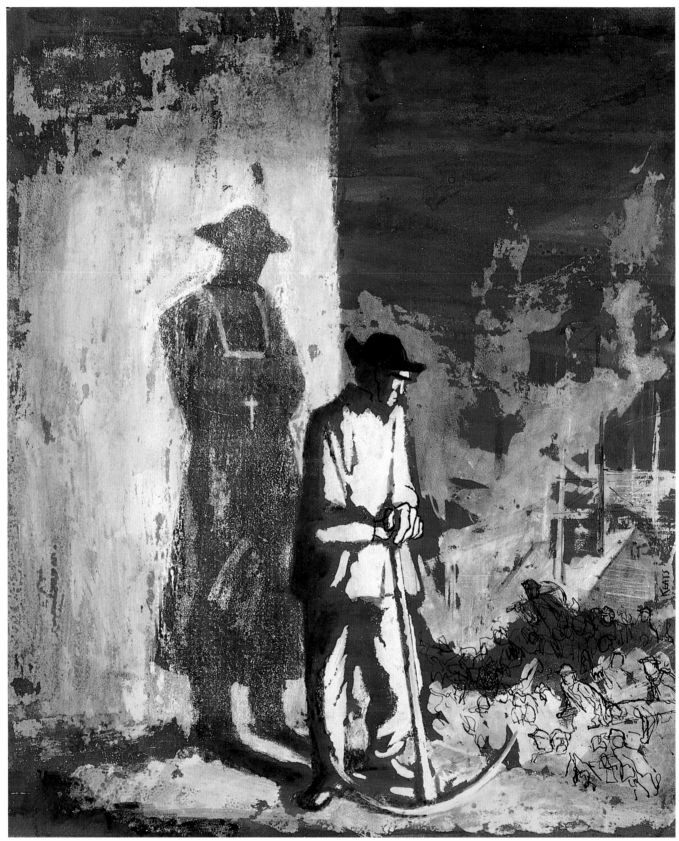

Original painting for the book jacket for Gilbert Cesbron's
Saints in Hell
Paint on board
455 x 352 mm, 1954

deG 0155.12

be eye-catching and will also accommodate whatever the publisher decrees in the way of titling and other copy.

Nevertheless, Keats seems to have enjoyed this work. Between 1952 and 1963 he produced some fifty jacket designs (independent of those for books he also illustrated) and part of the fun may have lain in the opportunity to create narrative or "mood" paintings, where the content was of a different order from that of his landscapes and cityscapes. His treatments ranged from the brashly dramatic, as in Frank Slaughter's *Epidemic* (1961), to the conventional, as in various books done for publishers' standard series, and from "advertisers' representational," as in Victoria Sackville-West's *No Signposts in the Sea* (1961), to the mystifying color patterns done for Irving Stone's *The Agony and the Ecstasy* (also 1961).

Furthermore, these one-shot commissions for paintings that were to be printed, rather than sold through galleries, gave him a fairly free hand to experiment with media and methods. From the originals that are now in the archive, we can see Keats playing around with a variety of graphic techniques to gain—or even to discover—visual effects. Thus in the dramatic image for the cover of Gilbert Cesbron's book about worker-priests, *Saints in Hell* (1954), Keats chooses dour colors laid onto a high-finish board, which allows him to work the paint with a knife or scraper as well as a brush; or, with Edward Stephens' *One More Summer* (1960), he turns to spattering paint in a way that he was later to follow in his picture books.

For all that these dust-jacket paintings demanded a response at one level or another to narrative, their distance from the sustained discipline of full-scale illustration meant that the arrival of the commission for the *Jubilant for Sure* drawings directed Keats towards an unexplored line of business. Such a change in direction may well have occurred anyway, for the speed with which his work on *Jubilant* was to be followed by other commissions suggests that Estelle Mandel had been active in seeking work for him in book illustration. What is noteworthy, though, is first the shift in emphasis from easel painting and commercial art to the unfamiliar field of children's books, and second the shift in graphic style. An artist whose work had long been confined to individual productions in color (paintings, advertisements, brochure illustrations, book covers, etc.) is now being asked to prepare a sequence of finished drawings.

Retrospectively, that change of direction can be seen as a reversion of activity for Keats just as much as an extension. As a child he

One of very few surviving examples of Keats' work in wood engraving: a card on thick paper, 135 x 112 mm, printed letterpress in dark green, with "Season's Greetings" printed inside, replaceable by a "Happy Chanukah" sticker (ca. 1932).

deG [scrapbook—19th leaf]

had copied drawings from books, and while he was still at school he had provided at least two monochrome illustrations for poems in school magazines: a linocut for his headmaster's lament "Worms Can't Cry" (see reproduction in chapter one) and a lithographed drawing for Ruth Warshavsky's "Terraces and Cobbles" (0157.02). He had experimented with wood engraving;[2] and his prewar work for Harry Chesler and for *Marvel* comics had given him professional experiences as a line artist. (More informally, he had also produced his own delightful picture story in the 1944 manuscript cautionary tale for GI's, noted in chapter one, while Mira Rothenberg recounts how, around 1952, he turned out at one sitting twelve watercolors to illustrate a set of mainly fairy-tale narratives for children that she had prepared as a term paper.)[3] At best, though, this experience must be seen as rather distant and insubstantial—a background for assurance rather than a foundation for development. From 1953 onwards, as the illustrating of children's books came to assume an ever-increasing prominence in Keats' working schedules, it dictated its own, new patterns of growth and technical variation.

In writing of book illustration as a "sustained discipline," I have in mind the complex of interrelated conditions which an artist must abide by if he is to complete a satisfactory job—especially if he is illustrating somebody else's text. To the casual observer everything may seem straightforward enough. The artist is given a manuscript and (if all is agreeable) is commissioned to do a quantity of drawings of a given size to be reproduced by a particular process. Within that apparently simple program, however, there lurk a number of conditions that will have a direct bearing on the success of the book as a collaborative venture between word and image.

Most obviously there is the question of the congruence between the content of the text as seen, or felt, by the writer and as visualized by the artist. In a work of children's fiction, the likelihood is that there will be fairly explicit accounts of setting, of characters, and of scenes of action which the artist has to reflect in a way that will seem valid to the reader of the text and that will have a degree of consistency equivalent to that subsumed in the text.

(The implications here must be acknowledged, even though an exploration of them would carry us beyond the purposes of the present chapter. Readers may justifiably ask what illustrators do about situations that they cannot experience, such as the events in fantastic or historical stories, or what they do about situations beyond their

Three Busy Children
Pen over pencil, with watercolor, on brown paper
300 x 400 mm, n.d. [ca. 1922]

An early drawing, probably copied from a children's magazine or annual.
In his autobiography manuscript (0074.18), Keats relates how he "discov-
ered carbon paper," which he would use —unbeknown to his fans—to
copy illustrations onto brown grocery-bag paper.

deG 0153.10

reach, in exotic or "closed" parts of the globe. Interpretive compar-
isons raise questions that cannot easily be given objective answers:
Why, for instance, is Tenniel's Alice deemed by some to be the "only"
Alice? What happens to our view of little Laura if we read *The Little
House in the Big Woods* as illustrated by Helen Sewell, and then by
Garth Williams? The scope for variation and argument is wide —
what if the author claims his own perceptions to be utterly misrep-
resented? Such considerations are endlessly ramifying, but at least

they help to support the contention that book illustration can be a complex and specialized art rather than a hasty answer to a demand to draw a few pictures.)

Even when illustrators are secure in the understanding of what their texts demand, they are still faced with a series of requirements and decisions which will determine their final contribution to the author's work. In physical terms there is a quest for what is elusively called "illustrative style": a graphic response that will suit the manner and tone of a given text. Imposing this may also be closely linked to the number, size, and placing of illustrations and the method by which they will be reproduced. (Ten chapter headpieces done on scratchboard require an entirely different mode of creative thought from, say, six full-page drawings, ten drawings in the text, and a concluding tailpiece, all done in pen and ink. Furthermore, the more complex the media—whether involving tone or color—the more they may inhibit a spontaneous response.) And when these physical and technical questions are answered there follows the nature of that response itself. How does the illustrator set about deciding which moments in the story need the support of illustration? How far—in theatrical terms—is he providing backdrops; how far is he "freezing" moments of dramatic action?

There is no evidence that Keats formalized his thoughts along such lines when he took the commission for *Jubilant for Sure*. Elizabeth Riley recalls that he was intrigued and excited by the prospect of a new and different kind of work, and his past experience as a graphic artist and his natural assurance as a draftsman fitted him well for the move to book illustration. His descent on Tennessee to give himself a visual portfolio that he could use for the book is at once a prompt to inspiration (*Jubilant* did not deal in matters with which he was very familiar) and a token of sincerity (a desire to bring his visualizations into equivalence with those of Elisabeth Hubbard Lansing). Perhaps, too, the trip gave support to his confidence that, as a "beginner" in illustration, he knew what he was portraying. In the next year or two he was to go to Scotland, to get the feel of the place for Phyllis Whitney's *Mystery on the Isle of Skye* (1955), and to Cuba, to see the actual setting in Cardenas for George Albee's *Three Young Kings* (1956). As confidence—and his work load—increased, however, he relied on reference sources, and his reliability as an illustrator of wild-country stories and of stories with an Oriental background came about without his wintering among wolves or visiting rice villages in Cambodia.

Whatever doubts he may have harbored over doing justice to *Jubilant for Sure,* the finished book does not show them. As a first venture into book illustration it is an entirely satisfactory piece of work. He chose the simplest and most adaptable medium—pen and ink,[4] which gives the blockmaker every opportunity to integrate pictures with text—and his interpretations of setting and character were convincing, within the pleasantly genteel traditions of the period. Most impressive is his sure handling of spare line drawing, his graphic imagination (as in the white-on-black night scenes), and an undercurrent of good humor, symbolized perhaps in the jolly frog on the dedication page.

The professionalism that is immediately apparent in *Jubilant for Sure* was to be sustained through most of his subsequent commissions. Between 1954 and 1964 (when all run-of-the-mill commissioned work ceased) he illustrated some fifty books for authors other than himself and managed to preserve a freshness in both manner

The cabin from *Jubilant for Sure* (1954); pen and ink on wove paper, marked for reduction. This is the only remaining original drawing for Keats' first illustrated book.

deG 0141.11

the Harper's Farm

A poem by DOROTHY ALDIS

We always drive along until
We reach a certain little hill,

And on the other side of this
The farm should be and there it is,

Waiting for us, white and neat
In the misty summer heat.

22

From "All Together" by Dorothy Aldis. Reprinted

One of two illustrations in two-color separation for some verses by
Dorothy Aldis, probably published in the magazine *Children's Digest*
or *Humpty Dumpty's* ca. 1953—an example of Keats' regular com-
missions for both adults' and children's periodicals.

deG 0157.05

and method that enhanced almost all the texts with which he had to deal. This cannot have been easy, since he was often lumbered with second- or third-rate work—the standard grist that keeps the mills of the publishing industry turning from year to year. But there is little evidence from his performance (and none from surviving records) to indicate that he did not view each commission as a technical challenge which it was his job to overcome.

Much of his work, especially for the children's fiction that he illustrated, was done in line, usually with a pen, but later, as he began to experiment more, with soft pencils or charcoal. Such adaptable tools of the trade gave him plenty of latitude to vary his graphic style, and the variations themselves indicate how he always tried to think his way into a mode of pictorial expression appropriate to the text. Thus, for stories like *Jubilant* with a modern setting, he aimed for a plain narrative rendering of scene and of dramatic moments that supported rather than supplemented what the author had to say. In jeux d'esprit, like the four *Danny Dunn* books he illustrated for his friend Jay Williams between 1956 and 1959, he veered towards a cartoon style—foregrounded drawing and a touch of caricature in his portraits of the regular performers—while in more serious stories like *Song of the River* or *Wee Joseph* (both 1957) he aimed for tauter, more intense and atmospheric effects.[5]

(His depictions of what was going on in the story were not always above reproach. Illustrators are renowned either for not reading their texts carefully enough or for being carried away by their own ideas for pictures, so that what lands on the paper is not exactly what the author says. Keats was no exception, and in several works there are occasional inaccuracies in the recording of detail. Thus Wee Joseph is not asleep in his box as he ought to be on pages 32 and 37, while several small errors mar the otherwise fine visualizations for Billy Clark's *Song of the River*.)[6]

Beyond these stories with a fairly conventional setting—which Keats sometimes directly "researched"—there were others of a more exotic or Romantic nature, which evoked from him less conventional, or more experimental, graphic responses. Sometimes, as in the *Wonder Tales of Dogs and Cats* (1955) or in the two Red Indian stories by Glenn Balch (1957 and 1959), he uses pen and ink with areas of dark shading, or with spatter effects, to give a stronger picture, and in the *The Peg-Legged Pirate of Sulu* (1960), his ingenious toned drawings, achieved by pencilling on a ribbed surface, are the best part of the book. Elsewhere, especially in the Oriental stories that began with Ruth Philpott Collins' *Krishna and the White Elephants*

The right-hand side (page 63) of a double-spread drawing
for an illustration for Billy Clark's *Song of the River*; this scene
should show only one boy on the bank
Pen (with spatter)
Approx. 210 x 140 mm (framed), 1957

deG (unnumbered)

(1961), he turns to broader pencil drawing of a more impressionistic character, and this, coupled with the squarer format of the book, nudges them a notch towards being picture books rather than standard children's novels.

Picture books, and storybooks with colored illustrations, figured only dimly during this period of Keats' work. Part of the reason for this is the unexciting nature of the texts that he was asked to illustrate. On the one hand these were thin, not very well composed stories, like Patricia Miles Martin's *The Rice Bowl Pet* (1962) or (probably the most undistinguished text that Keats was ever offered) Helen D. Olds' *Jim Can Swim* (1963). On the other hand, there were some rather randomly chosen "information books," which were much in vogue in younger children's libraries at this time.

This group of books is dominated—if that is the right word— by the five books that he illustrated for Tillie Pine, beginning with *The Indians Knew* in 1957. The idea behind the series was to show how certain peoples of historical significance—Native Americans,

Texture and movement in one of the drawings printed in
Cora Cheney's *Peg-Legged Pirate of Sulu*
60 x 105 mm, 1960

deG copy p. 67

the Pilgrims, the Chinese, the Eskimos, and the Egyptians—anticipated some of the ways of life and inventions of modern times. There was thus scope for illustrative contrasts between, say, Chinese and modern paper-making techniques, and the opportunity to plan integrated layouts. That was in strong contrast to other factual books that Keats worked on, such as *In the Night* (1961) or *Hawaii* (1963) where information was minimal and the illustration was chiefly decorative, and also to his two books done with Millicent Selsam: *How Animals Sleep* (1962) and *How to Be a Nature Detective* (1963). Selsam is one of the great practitioners in this field—knowing how to rouse children's interest in topics without engaging in whimsy or suffocating her subjects with too didactic an approach. Keats obviously enjoyed her way of presenting ideas to the child, and these two books drew from him some inventive page layouts which caught the spirit of Selsam's informal manner.

The footprints of a fox are in a single line, like a cat's footprints. But they have claw marks, like a dog's.

What kind of footprints will a rabbit make? You can see that a rabbit has little front paws and big hind feet.

The little front paws will make little paw prints, like this:

The big hind feet will make big tracks, like this:

20

21

Animal footprints and collage trees in Millicent Selsam's
How to Be a Nature Detective (Harper ed. 1966).

USM Cook Library copy pp. 20-21

The low-key—not to say uninspired—character of most of these picture-book texts was not helped towards more thrilling aesthetic levels by the need for Keats to illustrate all of them by color separation. This process aims for economy by giving the artist the job of determining the placing of whatever colors he is using, additional to his foundation monochrome drawing. Put briefly, color separation requires him to prepare a painting on transparent acetate sheets for each of the colors that are to appear in the finished job. Acetate is used so that the colored areas can be exactly registered on the key drawing and on each other, but the procedure for judging the placing and the strength of each painted overlay is complicated by the need to use only shades of grey strengthening to black. (The reason for this rests in the subsequent photographing of each separation so that printing plates can be made. If separations for red and blue were made in those colors there would be an unequal final balance between them since red will always photograph more strongly than blue.)

Although this process can involve the artist in complex and time-consuming work if elaborate four-color printings have to be organized with many tones being built up,[7] much of the separated printing that Keats prepared was utilitarian, and undemanding for a man trained in trade graphics. In storybooks like *Three Young Kings, The Rice Bowl Pet,* or *Jim Can Swim,* only one overlay was used to produce gradations of a single color additional to that of the key drawing; in the nonfiction titles one or two overlays might be used; but only rarely were sophisticated blendings of color attempted. These are to be found in the books that Keats was working on around the time of his success with *The Snowy Day* and they include the full color separations undertaken for *Tia Maria's Garden* (1963) and the complex use of marbled-paper collages in the separations for *Indian Two Feet and His Horse* and *Speedy Digs Downside Up* (both 1964).

In her essay on color separation in the Horn Book's *Illustrators of Children's Books: 1957-1966,* Adrienne Adams remarks that the work can be "painfully tedious." She acknowledges that it may give an artist more direct control over color weighting than may, at that time, have been possible with standard photographic plate making from color originals, and she indicates that publishers often found it cheaper to have artists do the separation rather than technicians. Certainly, so far as most of Keats' work for this process is concerned, there was very little pressure on him to do more than choose and harmonize second or third colors in such a way that they would give

Artwork for the cover of *Indian Two Feet and His Horse*
Marbled paper on board with collage and painted additions
195 x 473 mm, 1964

This painting was separated photographically for four-color printing; the
rest of the book was hand-separated by Keats for two-color printing.

deG 0069.01

a lift to the drawing that was the essential element in the composition. That "lift" was, for the most part, a commercial rather than an aesthetic requirement and it is therefore hardly surprising that—along with much of his monochrome work too—Keats' contribution was professional but, by the very nature of the commission, lacking the stuff of inspiration.

The Snowy Day and Its Successors: Their Making

There is, in heaven, a sequestered corner reserved for such people as Sunday poets, viola players, and the illustrators of other men's books. These are the artists who may lack nothing in skill and integrity but whose fate it is to be submerged by more glamorous colleagues. Here and there, uncharacteristic successes may occur. In illustration a few names—Cruikshank, "Phiz," Tenniel—are celebrated largely for their achievement as accompanists, but all too often, especially in the modern dispensations of children's-book publishing, an illustrator has to create his or her own books to gain a solid reputation.

This faintly metaphysic speculation gains some support from a conversation that Brinton Turkle describes in his autobiographic "Confessions of a Leprechaun":

> "Was your biggest moment when Viking accepted *The Snowy Day?*" I asked Ezra Keats. "No," said Ezra. "I think it was after I had seen the corrected proofs. I knew then that if I died before it was published, it would still come out all right."[1]

True, Keats' joy may simply have been that of knowing that a job had been completed to the best of his ability, but underneath that is also the awareness that this book was different from anything that

had gone before. *The Snowy Day* was *his* book, with no creative share apportioned to anyone else. For the first time as an illustrator, he was controlling what he wanted to say and the way in which he wanted to say it.

Keats perhaps also recognized in that remark that if he had died before *The Snowy Day* had been created, he would figure as little more than a footnote in the history of American children's literature. Although he may have illustrated more than fifty books with a skill that, for the most part, enhanced their attractiveness, they were not books that would evince much staying power in the tumultuous publishing activity of the sixties and seventies—and indeed hardly one of them is known, let alone kept in print, at the present time.

Undoubtedly, as I have said in chapter one, a continuing emphasis should be placed on Keats' breakthrough in *My Dog Is Lost!* Here indeed, with Pat Cherr's help, he was making his own book about his own territory. But, in retrospect, the narrative appears as too schematic to be natural, with its neat cueing onstage of children from different New York locales and with its interplay of English and Spanish vocabulary. Furthermore, it is a victim of two-color separation (made more complex, as the archive shows, by the typographic overlays of English and Spanish words). The red of the second color is dynamic enough, but, as often happens with separated work, it

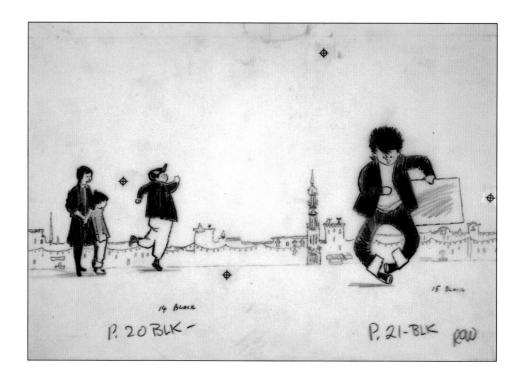

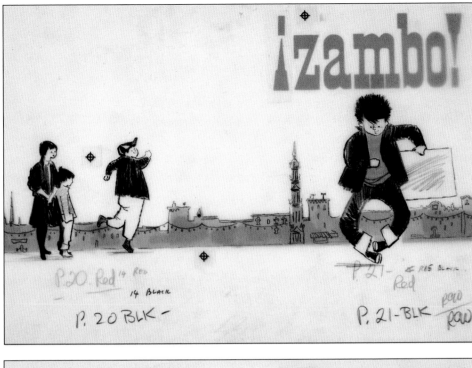

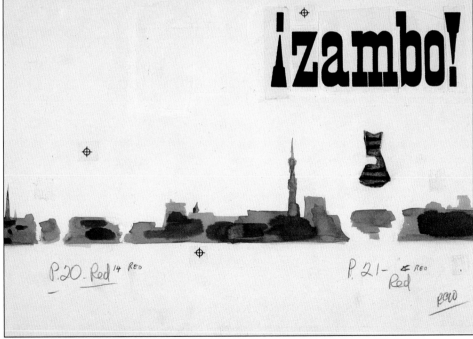

AT LEFT AND ABOVE:

These are the two-color separations that make up the illustration for *My Dog Is Lost!* shown in chapter one. The image to print black is done in heavy pencil on acetate (a). The red shading is done with grey wash (b). The letterpress exclamation is stripped in to print red (c).

deG 0041.10

shows up as a rather obvious device, detracting from the fluency of black and white and the drama of full color.

My Dog Is Lost! is nonetheless a portent of a new direction, and its significance is enhanced by Keats' performance in a book on which he was probably working at the same time: Eleanor Murphey's *Nihal* (1960), also published by Crowell. Because of its setting in Ceylon (now Sri Lanka), it might at first glance be thought just another of those Oriental picture-stories for whose illustration Keats must have been gaining something of a reputation. What is important about this book, however, is not its geographical location but its theme: Nihal's discovery of his powers as an artist. We do not have any biographical or graphic data about this book in the archive, but, on the evidence

Then Lauri told in a few words how he had found Manel early that morning holding onto his shattered boat. Lauri pulled out four little fish from a wet bundle. "I found these in the water of his catamaran. One has the fishhook still in it. But come and help me with Manel."

Manel, lying in the bottom of Lauri's boat, wrapped in his huge black coat, roused himself when he heard his friends approaching. Lauri and Nihal between them supported the exhausted fisherman while Rahini ran ahead to tell Manel's wife the good news.

Soon after, Lauri's house was bursting with excited villagers. Rahini made tea, while Nihal ran to the neighbors to borrow cups. Manel lay asleep on the cot in the boy's room. The curious fishermen crowded about Lauri with their many questions, but Lauri was staring at Nihal's work. "My boy did this!" he repeated again and again. "He understands the sea. He is so young; yet the sea is part of him."

The climactic moment from Eleanor Murphey's *Nihal*
240 x 350 mm, 1960

Private collection

108

of his published artwork, Keats can be seen responding to Murphey's plain, unpretentious story with an intensity that shows more than conscientious workmanship. The boy who knows painting to be his destiny was a figure with whom Keats totally sympathized, and we find in the vigor of his drawing, and in his resort to a variety of technical ploys, an energy that is lacking in most of his more routine productions: the monochrome drawings for *Krishna and the White Elephants,* say, or the San Francisco scene painting for *The Rice Bowl Pet.*

Seeing *Nihal* as a paradigm of Keats' own creative creed may help to demonstrate the extraordinary sense of release, of self-discovery, that came to him through the making of *The Snowy Day.* Its importance to him in determining the course of the rest of his life has already been indicated in chapter one, where I have also said that— through it—he came home to his proper place: a colorist celebrating the hidden lives of the city kids. The point is reinforced simply by looking at the new pattern of his working life that began to form itself over the next few years. In 1962, the year when *The Snowy Day* was published, six other books appeared with Keats as illustrator. In 1963—the Caldecott Medal year—there were as many as nine, most of which were probably commissioned before Keats knew how successful his own picture book would be. Four more spilled over into 1965, but from that time on Keats was never involved in a commission that did not derive from his own ideas or his own wishes. *The Snowy Day* was one ticket to freedom.

What gave the graphic performances that came out after 1962 their distinctive place in the art of the American picture book is unarguably the sequence of fourteen books, which forms a loose progression from the time of Peter's first solo arrival among the snow-heaps of the city. *The Snowy Day* (1962), *Whistle for Willie* (1964), *Peter's Chair* (1967), and *A Letter to Amy* (1968) all center upon that child himself, growing within his family from book to book. At the end of *A Letter to Amy,* however, a cluster of friends come partying along and in *Goggles!* (1969), *Hi, Cat!* (1970), and *Pet Show!* (1972) the stage is taken over by Archie, with a near-adolescent Peter assuming a role of decreasing importance. (Keats once remarked that Archie was his favorite among his inventions: ". . . the quiet one, the best at coming-through.")[2]

Dreams (1974) marks something of a transition, with the emphasis more on a fanciful conceit than on a definable character exploration, and with *Louie* (1975) Keats moves into the last, and strangest, part of the sequence. Self-absorbed, almost autistic to

Peter's Chair
Acrylic with cut paper
255 x 535 mm, 1967

deG 0050.11

A Letter to Amy
Watercolor with cut paper
256 x 505 mm, 1968

deG 0029.07

begin with, Louie does not engender stories as simple or straight-forward as those of the children who preceded him (and who continue to appear at the edges of his own adventures). In his first story, he is shown gaining confidence in himself, and moving towards a friendship with the group, through his attachment to Gussie, the puppet doll; in *The Trip* (1978), he is seen as a new kid on a new block, imagining his way into a fresh set of relationships; in *Louie's Search* (1980), he becomes the agent for his mother's meeting and marrying Barney, the junkman; and in *Regards to the Man in the Moon* (1981), the junk itself inspires him to take his old friends into a stratosphere of the imagination.

Two further picture stories can be added to this twelve-book sequence, even though neither relates directly to the group of children who come and go between *The Snowy Day* and *Regards to the Man in the Moon*. The first, *Apt. 3*, appeared in 1971, in between *Hi, Cat!* and *Pet Show!* In its early stages it did have direct links, for some early drafts (e.g., 0001.06, and following typescripts) have references to Archie and Amy. But these disappear as the book took hold of Keats' imagination and led him towards an entirely different vision of the life that goes on behind the battered doors of the tenement block.

The second book is set a long way from such surroundings. *Maggie and the Pirate* (1979) was inspired by a visit Keats paid to Venice, California, and the subtropical waterways of his pictures would seem to divide the book from all those sagas set among vacant lots and city streets. Nevertheless, this small drama of the stolen cricket cage is simply a transferral of children like Amy and Susie and the lads from one side of the continent to the other: what happens is intrinsically all of a piece with the rest of the stories about the hidden lives of the human child.

What Keats discovered through *The Snowy Day* was not only the potential for the exploration of childhood experience through these colorful stories, however. What he also found was something that had been apparent enough in *My Dog Is Lost!*: the problems as well as the pleasures of creating an independent picture book. Freedom from commissions may have its exhilarations, but it is also a cutting loose from the certainties of a known requirement. There may be interpretive leeway if you are confronted with the need to do fifty illustrations for a story about a boy gaining a hunting dog, or twenty-five color separations for a nonsense rhyme about another boy digging his way to Australia, but the substance and theme of the commission is given and you must work within its constraints. To create a picture book of your own, the only limitation will be one that you arrive at

with the publisher concerning matters of length, page size, and reproductive process. Come what may, your book will almost certainly have to be composed to fit into multiples of sixteen pages; those pages will have to have a shape that is consonant with the folding of the large sheet on which they are printed; and that printing will be according to a predetermined, prevailing technology (color separation for *My Dog Is Lost!*, full color for *The Snowy Day*). Within those physical limits, the choice and the difficulties of choice are yours.

Something of the essential challenge here was discussed by Keats in several drafts for a booklet that he hoped to publish on how his books came into being, and for a part of which he hazarded the section title "Where Do Ideas Come From?"[3] At an elementary level the question is easy to answer, and for almost all of his books one may discover a moment when the idea arrived and began to germinate. The beginnings of *My Dog Is Lost!* and *The Snowy Day* have already been noticed, the one deriving from observation of a neighbor's child, the other from direct recollection. To them, though, could be added, say, a weekend visit to Esther Hautzig's house at Spencertown, which triggered the idea for *Pet Show!* or the incident involving a "lonely and alienated" boy, recounted to him by the puppeteers of the Ohanashi Caravan, which formed the basis for *Louie*.[4]

To suggest that there is something easy about plucking these ideas out of thin air, however, is seriously to underestimate the exposed position in which the creative picture-book artist finds himself. As has been said, and as Keats himself confirmed, it would have been easy to capitalize on the success of *The Snowy Day* by using Peter as the focal character in a series of descriptive picture books about everyday events through a young child's years.[5] But such mechanical exploitation of one idea was entirely foreign to Keats' sense of responsibility to himself, as artist, and to Peter, as child, and the progress of these picture-book explorations thus depended upon the far more hazardous demand of being "open" to experiences that might lend themselves to stories. What if such experiences never materialized, or were never absorbed? What if the potential of an experience is recognized but then proves resistant to formulation in picture-book terms?

The outstanding value of the Ezra Jack Keats archive is that it allows a continuous view of how the artist struggled to find the most satisfactory answers that he could to questions of that nature. The many steps that had to be taken from the initial impulse for a story to its final, rounded completion were often complex—both in the intellectual planning and the physical accomplishment. To be able to

112

chart that progress—however hesitantly—is to gain a sharpened
awareness of the multiple shifts of working ideas and decisions that
may lie behind the most natural-seeming of children's stories.

By and large, leaving aside all the contingent, everyday muddles
that are common to us all, the method that Keats adopted in devel-
oping his picture-book ideas was fairly regular and consistent from
book to book. The very first requirement was to examine how read-
ily the idea could be shaped into the book's page sequence. For
Keats this seems to have been a matter of "knowing" the story, with-
out having it formulated in a worked-up text, and then encourag-
ing the words and pictures to develop together:

Storyboard for *Pet Show!*
Pencil on cartridge paper with text written in blue ball-point pen
460 x 605 mm, 1972

deG 0047.01

A spread from the dummy for *Pet Show!* showing
"Lady and Man Judges" under an umbrella
Pencil on cartridge paper
Approx. 140 x 317 mm

In this instance the dummy probably preceded the story-
board.

deG 0047.03

> It's expressed visually in my mind. I see it being acted out. I see it
> and I hear words too. But I think the picture . . . It's a matter of
> counterpoint, one complements the other . . . words suggest pic-
> tures, and pictures suggest words.[6]

This dialectical procedure can be seen at work time and again in
the progression of sketch plans and typescripts that were made before
ever work began on a final version. The sketches often began as sto-
ryboards (not always completed), which is to say a set of rectangular
frames, corresponding to the expected number of spreads, with some
often very rough outlines of scenes and, perhaps, ideas for the accom-
panying words. These storyboards would form the basis for dum-
mies—sheets of cartridge paper, cut and folded to make model
books—where a much fuller treatment could be mapped out. Dum-
mies were often the formulation of the story presented to publish-
ers' editors, through which final plans for the book were settled.

> Some illustrators do [them] in very elaborate detail. Others just
> make stick-figures. I remember once showing a dummy I had to
> an editor and she was so scared because she couldn't even fig-
> ure out what was in it. . . . There were just vague lines and a few
> crayons. . . .[7]

Simultaneously with these roughs Keats would be trying to write
the accompanying text, sometimes numbering paragraphs from the
start to show the page breaks. The broad "acting out" of events was

THE FUNNY DAY

by Ezra Jack Keats

7 Peter was watching a big boy across the street

whistling for his dog

8 Every time the boy whistled, his dog [rushed over] *ran*

to him. Peter wished he could whistle, too.

9 But he couldn't. *It wasn't any fun trying and trying and not even making a little sound.*
So he turned himself around, and around, and around, *faster and faster.*
began to

10 The street tilted down

The street
11 ~~Then it~~ tilted up — *and*

12 Peter saw his dog Henry coming *along* ~~down the street~~

Peter
~~He~~ hid in an empty carton, and tried to whistle.

Wouldn't it be funny if Henry heard him, but couldn't

see him?

Henry
~~His dog~~ would look all around, and wonder who ~~whistled.~~ *was whistling*

Then Peter would stand up and surprise him!

13 But Peter ~~still~~ couldn't whistle.

So Henry didn't hear anything, and just walked on.

often clear in his mind, but the phrasing of each incident— finding the right words for conversations, finding words to do what pictures couldn't—was often a tussle. When a complete text and page sequence were thought to be settled, the publisher would have a letterpress proof prepared, which could be either printed on paper or on transparent acetate for placing within the pictorial composition.

Even so, Keats would still worry over the writing here, and apparently insignificant textual changes would be made up to the last moment. (The progress of *Whistle for Willie* [0067]—which, as successor to *The Snowy Day,* was a crucial book for Keats' reputation—is a particularly good example of a manuscript being batted into shape by author and editor, with the latter pleading for last-minute decisions to be made at the point of going to press.) Keats was also very reluctant to settle upon a title for each book until it was finished, "because I feel that the title is the summation of the experience of the book,"[8] and he hovered over character names, too. Willie (who may have been christened by Annis Duff) was originally Henry; Amy was originally Amelia, until Debbie Hautzig suggested the shorter name—although both Amy and Katie had been noted as possible

First spread of an early dummy for *Maggie and the Pirate,*
with the heroine here called Annie
Color pencil on cartridge paper
204 x 455 mm, 1979

deG 0038.04

116

names for Peter's sister Susie; a very substantial dummy exists dealing with "Annie and the Pirate" and several friends, all of whose names changed as *Maggie and the Pirate* was completed.

Central to the completion of all these books was, of course, the artwork. The broad outline and sequencing of pictures may well have been settled through Keats' more comprehensible dummies, but he still undertook a great deal of preliminary graphic work before turning to the final images. Sketches done in sketchbooks would be supplemented by photographs—sometimes of objects or scenes, sometimes of posed figures (see, for instance, the 196 examples relating to *Apt. 3* [0004.01-8] and the immense number relating

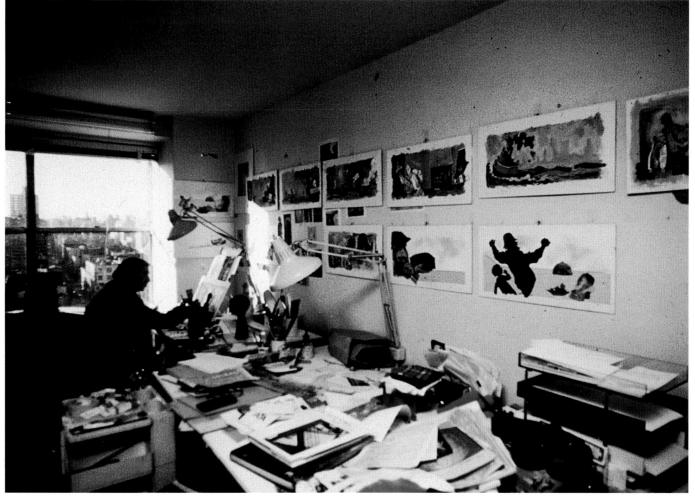

Keats' studio, with illustrations on the wall for *Louie's Search* (1980).

deG 0117.04 #27

117

Enlarged color photograph of a boy in a cap: one of a very large number that Keats took in preparing for *Apt. 3* (1971).

deG 0004.02 #31

Drawing in heavy pencil on tracing paper, preparatory to the final painting of this figure for *Apt. 3.*

deG 0001.20a

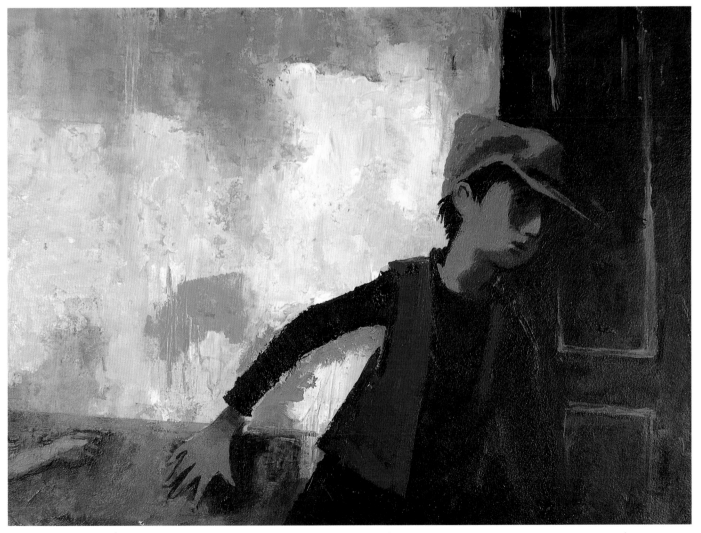

Part of the acrylic painting on board, approximately 292 x 575 mm, for *Apt. 3,* with the boy in the cap corresponding roughly to the photograph. Many similar equivalences are to be found.

deG 0003.04

to *Regards to the Man in the Moon* [0054-55 passim]). In addition Keats used tracing paper extensively, to sketch scenes for possible transference to his painter's board or to work at details of gesture or facial expression.

Only when he was sure of the effects that he wanted for a final composition would he go ahead and complete it—a process frequently made more exciting for him by his use of his own hand-marbled paper and selected collage materials. These trouvailles were incorporated, with varying emphasis, into paintings on board, which were mostly done with acrylic inks, a medium that can be worked like watercolor but has something of the strength and opacity of oil colors. As each painting was completed he would "hang" it on the wall of his studio, which he found to be an important element in the creation of the full sequence. For, quite aside from practical considerations—ensuring that a character retained his red socks throughout a run of action—he found that their presence "sort of choreographed" the story,[9] helping him towards an integrated "flow" of image and color that would match the flow of the narrative. Indeed, the presence of these pictures seems to have acted for Keats as a stimulus to refine the narrative, almost as though the pictures told him the story from the walls.

With the completion of text and illustration there came the often disturbing experience of seeing the book through the press. All illustrators, even when working with comparatively simple techniques, are liable to take exception to what they see as the laxity of printers. As Dante Gabriel Rossetti wrote in an address to his engravers, the Dalziel Brothers, in 1857:

> O woodman spare that block!
> O gash not anyhow!
> It took ten days by clock,
> I'd fain protect it now.

And he added as chorus, "Wild laughter from Dalziels' Workshop." So if even the demands of "black-and-white men" are not always easy to satisfy, how much more scope there is for error in the reproduction of color-work, and especially color-work with the complexity of Keats'.

During his wilderness years as a commercial artist Keats had attended classes, and had subsequently taught classes, on graphic methods. So he must have been well aware of the puzzles he was

presenting his printers in submitting to them collages and paintings with wide yet subtle color variations. Like Adrienne Adams, he acknowledged the value of being able to exercise some control over color reproduction through the kind of hand-separation that occurred in, say, *Indian Two Feet and His Horse*. But the procedure in such books was comparatively simple, involving broad areas of color, and, as Keats himself said of more extensive jobs: "[Hand]-separating three or four colors [of collage] presents extremely difficult problems. The materials are opaque, making visualization and registration virtually impossible. . . ."[10] As a result, the artwork for all his own picture stories was prepared in the knowledge that the colors would be photographically separated and that his fate lay in the hands of cameramen and plate makers.

Keats has given his own account of the technical process by which his books were printed, and how he viewed this process; an

A detail of the finished collage/painting for pp. 8-9 of *Pet Show!* (1972). This part of the painting makes impossible demands on printers, whose efforts to reproduce the somber details of the painted figure will be frustrated by the brightness of the collage.

121

edited version of his text is given here in the appendixes. What needs to be stressed at this point is his own determination to oversee as much of the technology as possible. He had a high regard for the Belgian photoengraving company P.A.G., to whom his artwork was shipped in order for the film for the printing plates to be made, and for several of his books he journeyed to Brussels to examine proofs and to approve the final pulls. (In the case of *Apt. 3,* the archive holds correspondence that shows a serious argument taking place — "wild laughter" from P.A.G.'s Workshop!—but this did not deter him from having later work sent there.) When the filmed proofs were accepted they were usually sent back to New York for plate making and printing, which was undertaken under the sharp eye of publishers' production managers as well as of the artist himself. Huge press sheets were run off, with the entire color-work for book, endpapers, and jacket printed on them, and these were used for settling the final balance of inking before the print run was engaged for the finished book. (Keats liked to hold a small stock of these rolled-up press sheets, and he was prone to give them away to schools and libraries who were interested in his work.)

Despite the immense care that went into the color printing of these books, there was bound to be some falling away from the depth and luminosity of many of Keats' originals. The swirling tints of his marbled papers, for instance, or his reckless tendency to introduce complex areas of dark paint into his pictures, created problems that were insoluble for plate makers working in four (even five) colors. Nevertheless, his assiduity in keeping the originals that form the central feature of the de Grummond archive ensures that the opportunity remains for students of his books to examine and judge the relationships between artwork and printed book (and to see how responsibly, in most cases, the original printers tried to cope with their difficult assignments). Furthermore, where complete files of artwork remain, the potential exists for re-originating film for printing if this is required. On the evidence of many reprints of Keats' books, both in hardback and paperback, the conscientious standards that he demanded for early editions are often allowed to slide, and new generations of readers may be confronted by books that are (literally) a shadow of the originals.[11]

Much of the material in the archive relating to the production of these books, and described in *Ezra Jack Keats: A Bibliography and Catalogue,* bears witness to the slow evolution of Keats' illustrative art from the original idea to the finished work. The following discursive

account of the making of one book, *Pet Show!* of 1972 (0047-48), may help to delineate the erratic stages in the creation of an apparently simple artifact.

Since the idea for *Pet Show!* was sparked by a PTO fair that Keats went to at Spencertown, while staying for a weekend with the Hautzig family, his first thoughts (0047.05) appear to circle around the idea of animals being exhibited and singled out for special commendation. Three sheets of rough paper carry sketches suggesting layouts for exhibitions and a mass of superlative designations: "blackest dog lowest to the ground," "cat most likely to catch a mouse," "worst tempered gerbil," "happiest turtle (smiles)," etc., etc. (There are also some random names, addresses, telephone numbers, and the words "puppet show?" which may be a germinating point for *Louie*.)

Another rough sheet of paper (0047.08) carries these sketchy notions a bit closer to the involvement of children in the enterprise, with some possible quotes. One had occurred on the earlier sheets ("It's a she but her name is Harold") and this is joined by phrases such as "Where's my worm?" and the parrot-cry "A prize, a prize, Peppi wants a prize!" accompanied by a sketch, "Judges under umbrella," and one—apparently of Willie—"Best dressed dog," with its hat marked as being "paper plate."

The listing of animals and their attributes was to remain incompletely resolved until the very last stages of the book's progress, with a last-minute change being made on the final printer's proof (0047.26, date 8/21/71). Keats kept jotting down notes and lists through many of the intermediate stages, but with the arrival of some typed notes (0047.09) we begin to see a story forming itself around the central idea of the exhibition. There is a sketch for what was to be the cover with "Pet Show" pencilled in; Archie, Peter, Willie, and Susie are mentioned, as well as Peppi, and the climactic point of the story—Archie losing the cat and presenting the germ as "last pet"—is noted down.

With these possibilities in mind, Keats now begins to try to shape out a book-length story, working ideas out almost simultaneously in dummy booklets and on storyboards. (The sequence of work has to be conjectured, but conjecture is helped by the fairly obvious drift of the names and events of the story towards what was to be their final form.) One dummy (0047.03) progresses only hesitantly—one of his exercises in "vague lines"; the next, larger but unillustrated (0047.04), sets out the stages of a text—including Peppi the talking parrot—as far as Archie's arrival at the show, at which point it peters

out into blank pages. A full articulation of the complete story, with ideas for pictures, eventually arrives on two sets of storyboards: the first in pencil (0047.02) being extended by the second, with text in blue ball-point (0047.01), and the progression being confirmed by, among other things, the dropping of the early idea to involve Peppi the parrot.

From these drafts it is clear that the problem of the book lies in the sequencing of the narrative crux, which is the arrival of Archie with his substitute pet, followed by that of the old woman, who adventitiously gets a prize for Archie's cat. The lead up to this, which eventually occupied nine spreads, is relatively straightforward—preparing for the show, losing the cat, and having a slightly irrelevant chase—but Keats had to expend much drafting power on his manuscripts and typescripts to work out on the concluding seven spreads how to dodge back and forth between Archie and his germ and the lady and the cat, with the final generous exchanges to round the story off.

Insofar as this drafting represented a textual complication, it reflected forward towards the next stage of the book, which was the making of the finished illustrations. The need to bring in Archie and, almost simultaneously, the old lady and the cat required illustrative reinforcement. Keats achieves this first by putting the old lady in the background of the silhouette picture showing Archie's arrival (before she is ever mentioned), second by showing the male judge looking across at her while Archie is holding up his bag with the jar in it, and then by having the judge "step out of frame" to pin the ribbon on the old lady while Archie does a double-take on the other side of the spread. With this diversion resolved visually, Keats can return focus to Archie and his jar and the story can take a natural course over the last four spreads.

In preparing his final illustrations, Keats seems to have spent some time perfecting these "difficult" pages, but the archive does not hold a very substantial run of the sketches and tracings that are sometimes present among the preparatory work for his paintings. In fact, the chief point of interest in his completion of the book is his decision to base his "Pet Show" notice on lettering submitted by children (0047.14), and his provision of a painted plain overlay on 0048.01, .04, and .09 so that foreign-language editions of the book could incorporate their own lettering on these prominent notices. As for the paintings themselves, progressing one by one onto the studio wall, they seek visual momentum by a continuously changing

124

A "reminder" sketch
for pp. 22-23 of *Pet Show!*
Pencil on tracing paper
Approx. 200 x 430 mm

deG 0047.18a

A more fully worked out sketch of the previous draft
Pencil on tracing paper
Approx. 200 x 455 mm

deG 0047.18b

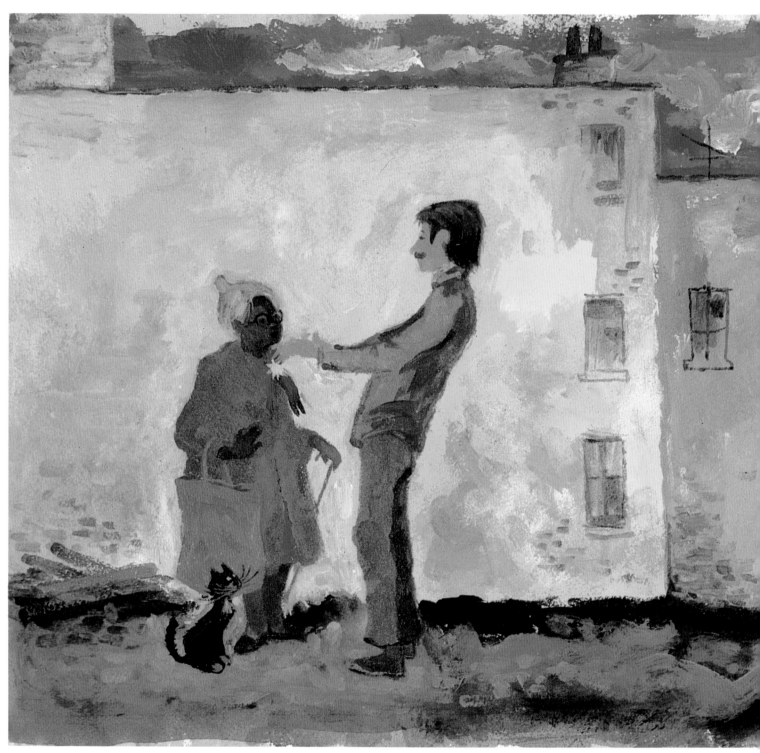

The finished painting
Acrylic
252 x 504 mm
deG 0048.14

Two enlarged examples of the "Pet Show" lettering submitted by children. The lower example was clearly the one used by Keats.

deG 0047.14

use of cutoff points in the foreground and at the edges of the pictures. On several spreads, heads and torsos show above the bottom of the page (with a nice use of Willie's distinctive features), then the focus moves back to fully staged scenes, only to revert to close-ups for the judging. Characters—most notably Peter—are found edging onto or off the sides of the pictures, and there is a diversity of small narrative touches that reward the careful observer: the cat, creeping off about its own affairs on the endpapers; the cat (lost) figuring only in graffiti; the silent presence of Susie as a "cementing" agent through the story, along with the comings and goings of the other kids on the block. A story that begins as something thin and rather contrived gains unsuspected depth, character, and humor through the artist's insight.

Street Scene with Sweet Potato Vendor
Oil on canvas
660 x 812 mm

A further working of the theme already noticed in the painting in chapter three. Note the faceless figures and the shrouded children in the doorway.

deG 01.05

CHAPTER SIX

The Snowy Day
and Its Successors:
An Assessment

Painters making incursions into picture-book art are always vulnerable to accusations of self-indulgence or overkill, for this art is essentially the province of the draftsman. The dynamics of stories told through picture books demand fluidity of design and a sense of the interrelationships between spreads, which are not qualities that are uppermost in the minds of easel artists.[1]

For Keats the transition may not have been too disturbing. After all, by 1961 he had had plenty of experience as an illustrator. But he had never attempted full-color work on the scale required for a book like *The Snowy Day* and the potential for difficulty in planning such a book would be compounded, as his career progressed, by the nature of his themes and their setting. The sequence of fourteen books that began with *The Snowy Day* is essentially concerned with children's direct experience of the surroundings and customs of their district. The stories' first allegiance is to a naturalistic presentation of events, which is not always susceptible to being schematized in a set number of spreads. What goes on in these books is part of a continuum of living, not easily sliced up into sections that possess that sine qua non of good stories: a beginning, a middle, and an end.

Furthermore, the continuum within which Keats chose to place his books was an urban one, where the defining qualities of traditional "naturalistic" picture books did not so readily operate. In such earlier "everyday" classics as Robert McCloskey's *Blueberries for Sal* or Gene Zion's *Harry the Dirty Dog*, set in the countryside or in "enclosed" families, events took place within predictable circumstances, which gave more leeway for narrative excursions. But the city life reflected in Keats' picture books was full of distractions and contingencies, which had to be incorporated into the "stories" if they were to have their proper flavor of reality.

Critics have not perhaps given sufficient weight to Keats' place as creator of "the urban picture book." Even if anyone wishes to argue that the urban setting of the first four books was accidental rather than fundamental and that the urban sequence really began in 1969 with *Goggles!* we still find very few earlier notable examples of picture-book making that take us into the world of the city child's experience. Certainly there were picture books—often of a kind of "travelogue" construction—that took young readers into cities to show them the sights. (In America these may date back to picture books about street vendors like the *Cries of New York* and *Philadelphia*, published at the beginning of the nineteenth century, which were modelled on European examples.) Alternatively there were books that "used" city appendages for fanciful purposes, like Ludwig Bemelmans' rather sophisticated *Madeline* series, or books that were early commentaries on environmental damage, like Virginia L. Burton's *The Little House* (1942). No American illustrator, however, had set about a consistent portrayal of the heartlands of city life and the children who dwell there before the coming of Ezra Jack Keats.

(The proviso *American* in that sentence is intentional, since, on the other side of the Atlantic and—so far as we know—without any interconnecting influence, another picture-book artist would tackle themes very similar to those taken up by Keats. This was Charles Keeping, whose first significant picture book, *Shaun and the Carthorse*, was published in London by Oxford University Press in 1966, and in New York by Franklin Watts in the same year. Keeping—like Keats—was a native of the inner city. He came from the famous London district of Lambeth, just south of the Thames, and many of his picture books confront the same structural problem as Keats': how to make credible narratives out of the daily lives of back-street children. In his masterpiece, *Through the Window* (1970), this is done with a

power and a daring use of imagery beyond anything that Keats attempted, but very often Keeping's "stories" are even more accidental or ruminative than Keats'. However, Keeping shared with him a painter's eye for the color that lurks in the most unpromising environment, and a native compassion for—and often delight in—the seedy characters who peopled his pages.)[2]

There can be no doubt that for Keats, the urban setting for his first full-color picture book was an essential part of its importance to him:

> I grew up in a slum area and when it snowed it was a transformed city—very quiet, very poetic and so different that I felt it in my bones. The city would become magical; all the dirt would disappear. . . . The snow trucks would come by and they'd make what seemed to me as a child like huge mountains of snow on either side of the street. . . .[3]

In the very impulse to convert that recollected experience into a picture book, however, lies the problem of construction. There is no "story" here. As his editor remarked: "*The Snowy Day* is, in a sense, a symbol of his own childhood's delight in snowy streets."[4] The challenge lies in selecting and organizing the constituents of this symbol so that the experience is brought to the reader in a coherent, manageable form.

Thus, for all the enthusiasm that has been expended on Keats' artistry and on his treatment of Peter, the fundamental quality that governs his success in this first book is the organization of his text. For one thing, by sleight of hand, it has to suggest that over a mere twelve spreads it has encompassed a whole day in the snow; and for another thing it has to recount Peter's random excursion in a way that the reader will find satisfying. This Keats achieves through the rhythms of his sentences. His text is extremely brief—317 words occupying twenty-eight pages—but he contrives to vary the phrasing of each event in Peter's day to give the impression of time passing more slowly than it ever would have done in reality. The tone is quiet and easy (the rhythms are those of a speaking voice and the text lends itself perfectly to being read aloud) and there are enough connections from spread to spread to give a flow that can then be matched by the illustrations—tracks in the snow; snow falling from trees ("plop!"); the cleverly introduced melting snowball, pocketed on one page and vanished two spreads later. Without this framework the book would lack an essential unity.

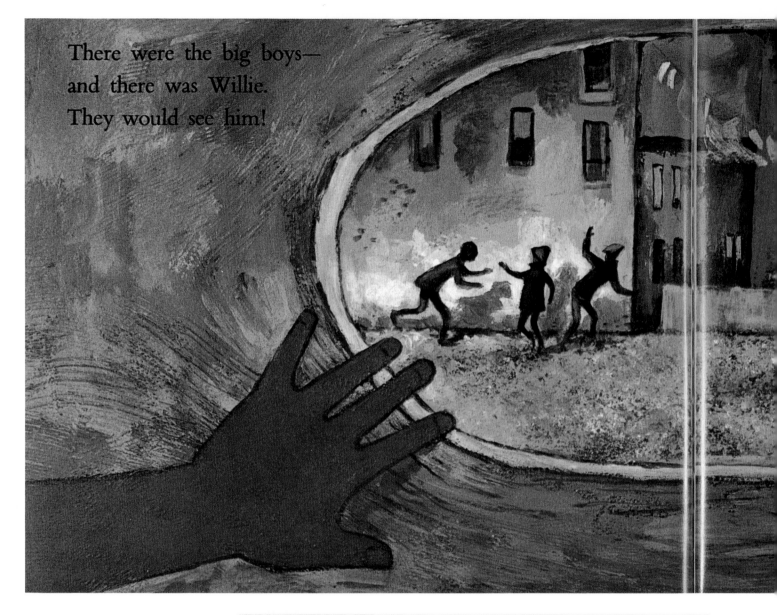

There were the big boys—
and there was Willie.
They would see him!

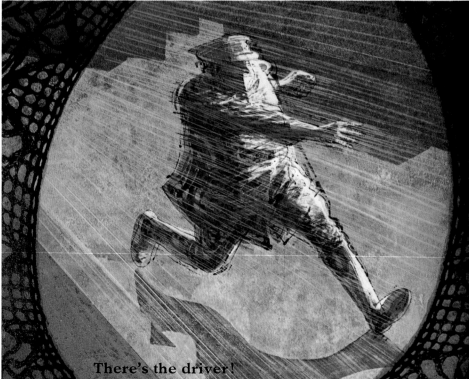

Jacob spies the driver in
Charles Keeping's
Through the Window
213 x 277 mm, 1970

Private collection p. 20

Copyright © Charles Keeping
1970. Reprinted by
permission of Oxford
University Press.

There's the driver!

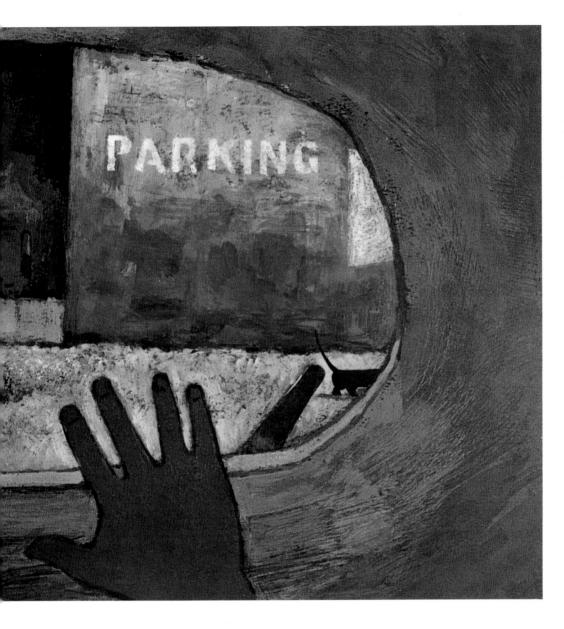

Spying boys: comparative views by Keats and Charles Keeping.

AT LEFT:
Archie looking through a hole in the hideout board in *Goggles!*
202 x 450 mm, 1969

deG copy pp. 22-23

At the start of her nine-line notice of *The Snowy Day* in *The Horn Book,* Virginia Haviland calls it "a 'mood' book."[5] The epithet is a just one and could almost be applied to Keats' oeuvre altogether; as painter and collage maker, "mood" was something that figured fairly high on his agenda. Nevertheless, for many of the books in "*The Snowy Day* sequence," a degree of storytelling did take over and only two later examples fall readily into that category where the page sequence is dictated more by a quest after something "symbolic" rather than after the telling of a story.

One of these books is *Dreams* (1974), which, like *The Snowy Day,* is rooted in Keats' recollection of his Brooklyn childhood and the hot summer evenings: ". . . all the tenements and all the buildings would merge and blend into the sky, and the sun would be setting . . . and there'd be the purple haze over everything and everything would be transformed, and the lights would go on in people's homes [and] I'd wonder what went on in these little windows as the lights went on and it got darker and darker. . . ."[6] On a first reading *Dreams* may not appear to be a "mood" book at all, since Keats has interrupted his evening meditation with the seven-spread episode of the falling paper mouse, which saves Archie's cat from the ravening red dog. But this is a divergence from his purpose—a concession, again, to picture-book structure—because what really interests him is those "little windows" and the lives being lived, or dreamt, behind them. The book's title is its pointer, and in his early sketches for its layout and text there is the recurrent phrase "one dreams" that seems to be running in Keats' head like a motto (0007.01-3). Unlike *The Snowy Day,* however, the inner function of the book here shifts from word to picture. Like the boy walking the Brooklyn streets, you must look at what is going on in those windows—even if it is nothing more than a firework display of colors. From start to finish *Dreams* is Keats' virtuoso performance as paper marbler, attempting simply through the controlled repetition of the head-on view of the tenement to encourage his readers towards their own "interpretation of dreams."

Altogether different is the other example, *Apt. 3* (1971), which has claim to be Keats' most original—and testing—picture book.[7] Yet again he gives its source as the conjunction of two childhood memories: the sudden revelation of the power of music (Tchaikovsky's *1812 Overture,* no less) in his tenement block, and the occasion when, guiding a blind man, he discovered how blindness had served to sharpen his other senses.[8] Once more he is after something

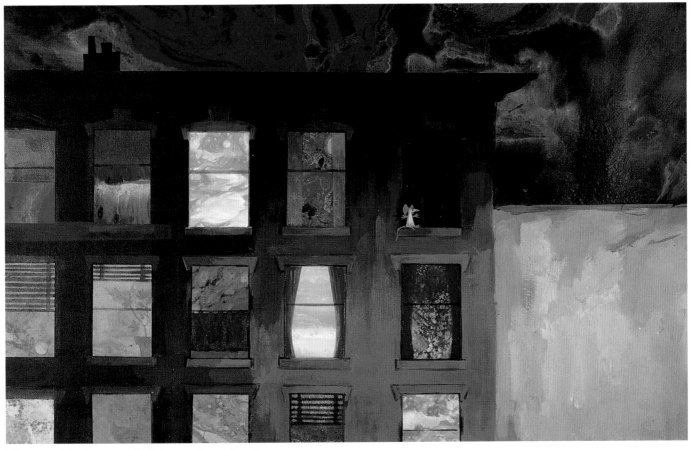

The marbled-paper lighting effects in *Dreams*
Acrylics on thin card pasted to artists' board
330 x 520 mm, 1974

deG 0008.07

symbolic rather than merely recounting Sam and Ben's search for the source of hidden music. Resolutely dour in color throughout—the dourness is accentuated by the glints of Sam's red cap—*Apt. 3* is (like a reverse side to *Dreams*) a journey into the lives within the tenement walls. There are no windows here, bar the rainwashed one at the beginning and the mauve-lit one at the end, and this pallid, claustrophobic journey among the stairwells depends absolutely on the drift of the text to sustain it. The long sequence of Keats' dummies, storyboards, and typescripts (0001.01-15, plus proofs) shows how conscious he was of this and how he tried to devise a narrative that would bring out the mood of constriction and release that he wished to mirror in his paintings.

He was a long time fixing on the participants in the book. To begin with he drafted it as being told only in the first person; then he shifted the emphasis simply to Sam; and only later did he bring Ben

in as a foil to Sam, more within the pictorial compositions than in the text. Equally the journey down the stairs from Apt. 12 to Apt. 3, although mood-setting rather than packed with significance, took a long time to find its eventual form. (And even then one is tempted to think it is less satisfactory than it could be. At one stage, Sam's finding of the worn-out mattress is coupled with invective against the super, which leads naturally to the introduction of the super himself, grumbling and slamming doors. As it now stands, Sam's comment— "That snorer sure's enjoying his new one"—has the ring neither of euphony nor truth.)

With the climax of events—the disappearing milk container and the visit to the blind man—Keats sticks by ideas that are present in the early drafts, but thereby involves himself in verbal maneuvers that seem unnecessary for the simplicity of his purpose. Verbal explanations abound, and they do not blend well with the sudden shift to a rhapsodic register as the harmonica player plays "purples and grays and rain and smoke and the sounds of night." Keats' text cannot finally match up to the strange, shadowy luminosities of his extraordinary paintings. It is easy to understand that the book meant a great deal to him—"I consider it to be one of the most important things I have done, in terms of my own personal satisfaction"[9]—but the flaws in its diction emphasize how complex is the job of perfecting the flow of a picture book, even with this intense artist's involvement.

The Snowy Day, Dreams, and *Apt. 3* have little in common beyond their origins in Keats' own experience and their efforts to explore a mood instead of to develop a story, but these features divide them from the other eleven books with which they may be loosely grouped, and which stem from observation and from a more determined move towards storytelling. Certainly the impulses differ (Keats' refusal to repeat himself, to traverse the same ground twice, is one of his most impressive characteristics). Establishing the framework of a narrative could be no less demanding than highlighting— or lowlighting—symbolic expressions, as I have shown in my earlier description of the evolution of *Pet Show!* Nevertheless, there is a beneficial security in working within a more formal structure, even though the need to be true to the circumstances and the psychology of his child participants has to be the ground from which the narrative grows.[10]

Almost all these stories follow the time-honored formula of setting up a crisis and then resolving it. The dimensions of the crisis may vary:

Peter wants to whistle, can't, and then does; Archie is reconciled to the cat who caused comic mayhem at the street show; the pirate makes up for the disaster that he brought to cricket-fancying Maggie. Keats' job was to find the verbal and illustrative register that would maximize the perceptions or the dramatic or vaudeville effects that were right for the story he was telling.

He helped himself in this task through allowing his books gradually to coalesce around the activities of children on a single block. There was nothing formal about this. He never seems to have had in mind any systematic exploitation of the children at his command—at least until the coming of Louie, who occupied his attention in a more fixed way. For the most part, like Peter discovering that his chair had gotten too small for him, the growth of Keats' themes was subconscious. Everything came about as naturally as the processes of book making allowed.

This casual underplaying of the larger story within which the small stories take place—glimpses of the continuum—is partly thanks to Keats' determined reticence as a writer. He claimed on a number of occasions that the formulation of his texts involved a paring down of wordage and not an expansion: "When it's my own story, I'm free to drop a word or even a whole sentence when the illustration can carry the meaning. What a good feeling it is to drop some ballast!"[11] And the manuscripts held in the archive frequently show this paring-down taking place. The struggle always tended to be with formulating the rationale of the story rather than telling it; by cutting out peripheral comment, the narrator's voice becomes anonymous, disembodied, so that the reader's attention can focus on the events in the pictures without distraction.

In contradistinction to the atmospheric effects that Keats sought in the three "mood" books, the paintings for the story sequence have a more dynamic purpose. Keats himself realized this when he slung each finished picture up on the studio wall, seeking a "choreography" for the train of illustrative enactments. (This was an astute recognition of the danger "painterly" picture books run of being a series of individual canvases rather than a fluent whole. One has only to compare, say, Walter Crane's *House That Jack Built* with Randolph Caldecott's, or Errol LeCain's *Thorn Rose* with Felix Hoffmann's *Sleeping Beauty,* to see the interpretive shortcomings of the painter/designer as opposed to the draftsman.)

Keats' chosen graphic platform for achieving this choreography quickly established itself as the double-page spread. In the early

books, centered upon Peter, he sometimes worked with single-page illustrations, alone or facing each other, and very occasionally he reverted to that procedure (once in *The Trip,* three times in *Hi, Cat!*—always to good effect—and three times in *Maggie and the Pirate*). Otherwise the storytelling proceeded steadily from one unitary spread to the next. Since his preferred page areas for his books was crosswise and "landscape," this gave him an expansive stage for the continuities of action; and he could vary emphases, from long shot to close-up, and distribute weight across different areas of the spread. Thus, in *Goggles!* you may find panoramic views of the vacant lot with its fringing tenements, center-stage focus on the goggles when Peter is knocked to the ground, periscope views through the hole in the board, and, in conclusion, Peter and Archie comfortably ensconced on the stoop on the last right-hand page, while the facing page unemphatically mounts the letterpress text above the younger kids at their private (and unadventurous) sidewalk game.

The narrative content of these compositions is often greater than a single glance at their packed colors will allow. Keats himself indicated his liking for using purely visual references to body out the story in an example from *A Letter to Amy* when Peter tells his dog, Willie, to go home and stop following him. "What the reader can see for himself from the illustration is that Willie does as he pleases, which is to tag along. The joke is funnier without words."[12]

Readers need to be alert to these apparently casual elements—observe, for instance, the baby's arm poking significantly out of the cradle in *Peter's Chair,* or, in *The Trip,* the yellow umbrella and the homemade ice-cream cone, waiting at the edge of a page before Louie puts them on to make his Halloween costume. But Keats also enjoyed scattering among his pages barely relevant images that gave depth, authenticity, and often charm to his back-street milieux. Willie, and sundry cats, are regular attenders around the edges (and sometimes in the middle) of the action—see how they all turn up, along with Keats' cat, Samantha, in the final, valedictory celebration at the end of *Regards to the Man in the Moon.*

Keats is also prone to amuse himself by slipping in recondite personal references for anyone "in the know." Graffiti are a natural repository for extranarrative contributions—a wall on the back cover of *A Letter to Amy* is laden with the names of friends and associates. Nor is Keats above putting himself and friends into pictures. Dean Engel modelled the pink rollers for the bystander in *Louie's Search* (she is also the proprietor of "Dean's Doughnuts" in *Maggie*) and Keats appears, reproduced from a photograph, in *The Trip,* and also

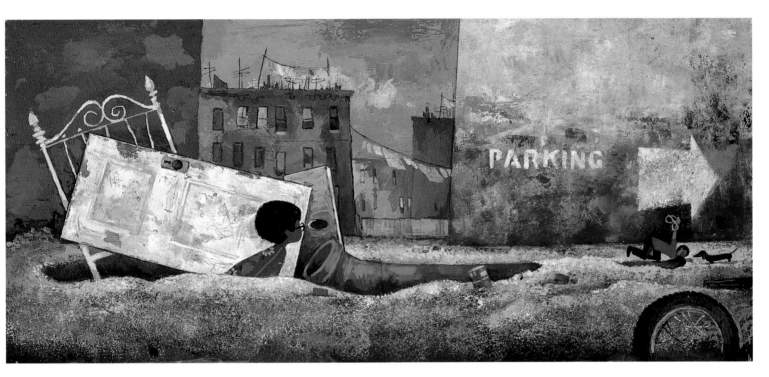

Two different focuses in spread illustrations for *Goggles!* . . .

ABOVE: a wide view of tenements and the vacant lot;

BELOW: a closer view of the fallen goggles

Acrylic, with some collage, on artists' board
250 x 505 mm, 1969

deG 0012.04 and .08

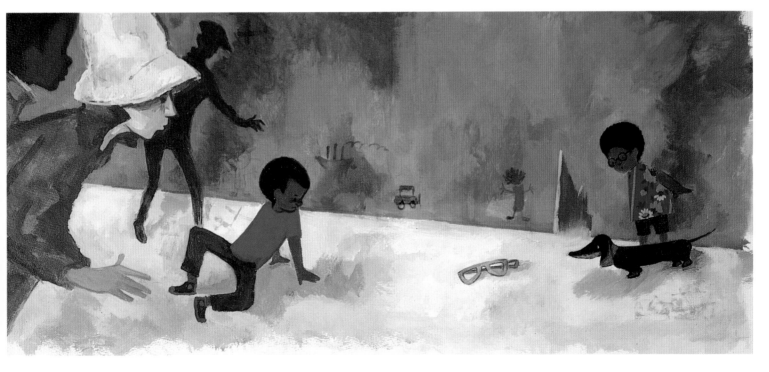

benignly shepherding children in *Louie*. Perhaps too he is the male judge in *Pet Show!* and an Easter walker in *Jennie's Hat* (1966).

The extent to which the narrative drive in many of these books comes from Keats' painting—his fluent use of acrylics—directs attention to his compositional skills, and especially to those that have nothing to do with painting: his much-acclaimed handling of marbled paper and collage.[13] For, although Keats acknowledged the "life" that he got from incorporating these craft processes into his work ("new relationships of colors and patterns, each expressing something in a very special way . . . a technique which I feel has great potential"),[14] they can also seriously inhibit the life and spontaneity of a picture book.

The reasons for this are threefold. First, the materials to be used will almost always be decorative or graphically "static." A cut paper shape or a cotton print or a mounted photograph may be dead on the page in a way that a drawn, colored shape will not be. Second, the presence of these *objets trouvés* may endanger the graphic unity of a book, partly because they are, by their nature, glued-on extras, accidental to the dexterous arts of drawing and painting, and partly because they often have to be integrated into a drawn or painted composition in a way that jars the visual whole. And this leads to a third objection: that the reader's amazement at the artist's ingenuity becomes a distraction from the essential narrative purpose of the picture. Thus, the clever cut-paper compositions in Eric Carle's *Seven Tales by the Brothers Grimm* (1976) are at once too static and too overdesigned for these simple, racy tales; or, in such elaborate montages as the picture books by Jeannie Baker (*Grandfather*, say, or *Home in the Sky*, 1977 and 1984), the integrity of the—rather factitious—stories is cut into by the illustrative tricks.

For all the enthusiasm Keats had for the potential of collage (and for all his loyalty to it as a legitimate technique) he nevertheless shows himself extremely sensitive to the method and relevance of its use. In "*The Snowy Day* sequence" he uses it with thoroughgoing consistency in the first four books about Peter, where it has a generic aptness. These are, after all, "first books" in the sense that they deal with points of new experience in the life of a small boy growing up, and are themselves books with an almost toylike quality. The simplicity of the stories (which begins to be disrupted in *A Letter to Amy*, where the collage becomes far more dramatic) is matched by the simplicity of the graphic forms, with collage being used almost exclusively. Moreover, Keats is extraordinarily skillful in the way he cuts and mounts his compositions so that he achieves an unusual degree

142

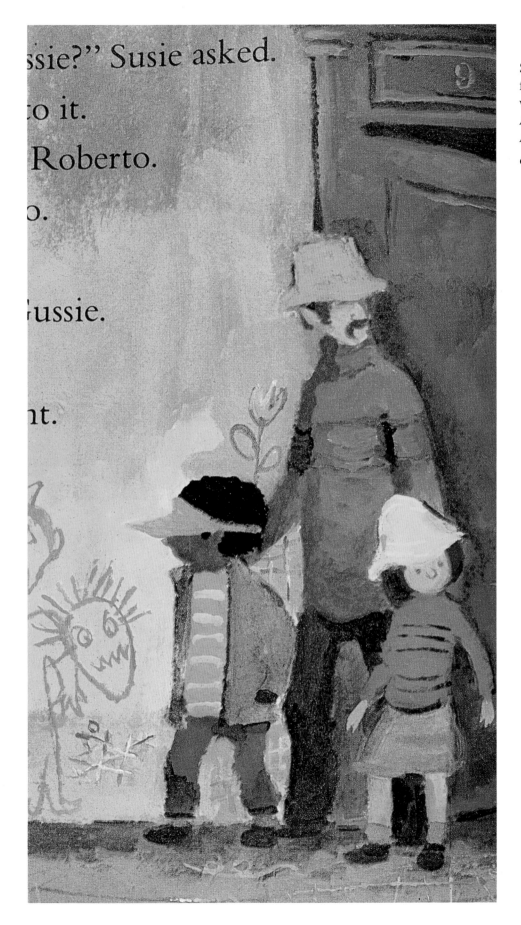

ssie?" Susie asked.

o it.

Roberto.

o.

ussie.

nt.

Self-portrait with children from *Louie*; part of the art-work for a complete spread
Acrylic on board
Approx. 110 x 240 mm, 1975
deG 0034.09

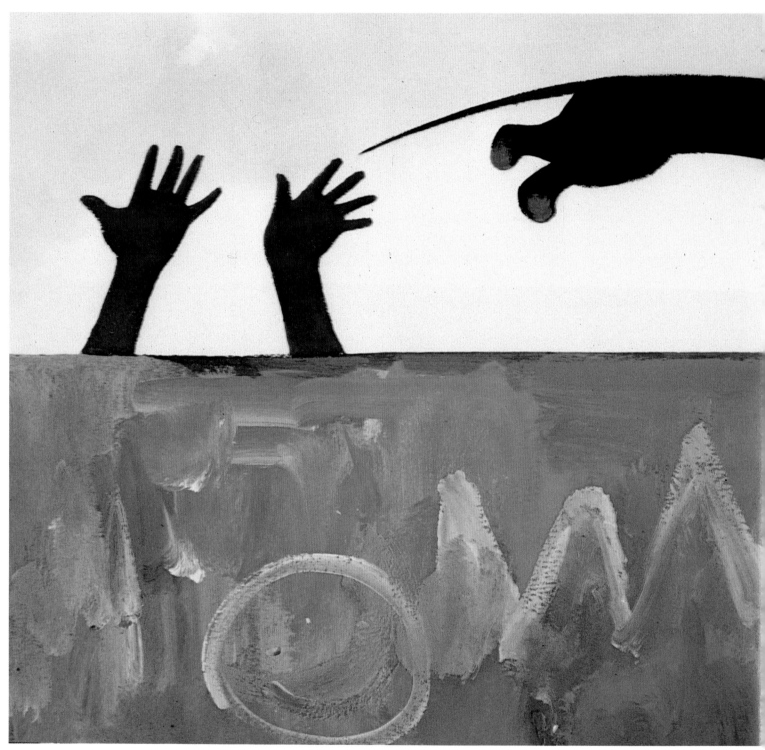

The tallest dog in the world cuts loose (full-color illustration from
Hi, Cat!)
202 x 440 mm, 1970
deG copy pp. 28-29

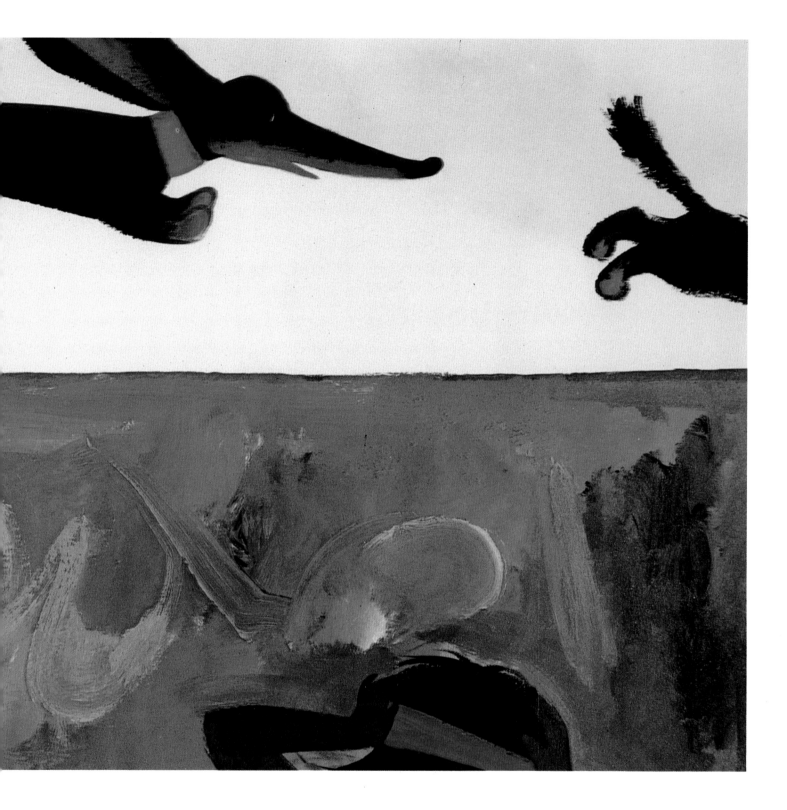

of rhythm both within and across spreads. The cutting of Peter's red hood, for instance, in *The Snowy Day* or the gesturing of Peter or of the skipping girls in *Whistle for Willie* almost have the fluidity of paint.[15]

From *Goggles!* onward however Keats used collage far more sparingly (and sometimes, one suspects, as a token rather than from any compulsion). The increased dramatic or psychological content of the stories seems to have persuaded him that paint's subtleties would allow him flexible expression, outweighing the visual intricacies of collage composition. There is a tacit admission of this in *Goggles!* itself. For the first two spreads of the story Keats employs quite a varied range of material. The door and sheet of timber and the top end of the pipe in the hideout are all painted onto a thin card, which is cut and glued onto the surface of the artist's board. Peter's shirt and jeans in the first picture, and his outstretched arm and Willie's head in the second, are also painted-card additions. Archie's shirt and a couple of printed items are also, and fairly obviously, collages. From that point on, however, even when he returns the boys to the hideout, Keats relies entirely on his paintbrush in the composition of the pictures—apart (again, obviously) from the shirt and sundry items of torn newsprint.

This simplified regime prevailed through many of the later books, often with collage being restricted to the portrayal of torn posters, paper garbage, and wearing apparel, where its use is hardly of importance and may be questionable. In *Pet Show!* for instance, Peter is distinguished by having a patterned linen shirt and Susie a floral dress; but these do not have any justification in pictorial terms and they break up the unity of compositions where everyone else, including the errant Archie, is part of the painting. And such technique is even more aberrant in *Louie's Search,* where the near-caricature treatment of Louie, the wondrously bewhiskered Barney, and several walk-on figures is starkly opposed by the all too extensive formal patterning of collage materials used for Barney's shirt, Peg's dress and chair, wallpaper, and Tiffany shade. How significant that for *Apt. 3,* "one of the most important things I have done," Keats painted everything except for a few random bits of newsprint.

In terms of the story's intentions, collage comes into its own in those late books where fantasy sequences occur. The marbled-paper symbols in *Dreams,* the peep-show journey in *The Trip,* and the space flight in *Regards to the Man in the Moon* are all elaborate superimpositions of collage effects in order to gain imaginative ends very different

146

from the wholesale narrative compositions of the early "Peter" stories. There is much to admire in the technical skill with which Keats designs these fantasias, which in *The Trip* and *Regards to the Man in the Moon* often involve a build-up of plain cut paper, painted paper, marbled paper, photographs, and textures. In narrative terms, however, they seem forced. Louie, on the two sides of the peep-show flight, is the person we are engaged by, and, as the *Kirkus Review* critic sagely remarked of *Regards to the Man in the Moon*: "that blatant recourse to imagination . . . isn't very imaginative, and the whole junk-is-what-you-make-it angle is pretty trite." The set-up looks to be a narrative excuse for "the phantasmagoric outer-space collages."

The uncertainties—of direction, or of composition—that are sometimes apparent in these late books are the price that Keats paid for his determination, like Louie, to explore the imaginative potential of his gifts. "*The Snowy Day* sequence" adds up to a remarkably varied celebration of the lives of its participants and, through them, of an emotional energy and delight that may be present in the most restricted of social circumstances.

For me, the most perfect expression of this is in *Hi, Cat!* where Keats achieves a marvelous balance of the qualities that give picture books their peculiar attraction. We are led into the story—the event—past the garbage cans on the endpapers and past the first glimpse of that "crazy cat" and the trashed umbrella on the title page. Keats' text then moves with great assurance from the "Hi, Cat!" on the first spread to the ". . . all I said was 'Hi, cat'" on the last. His reductive prose allows the storytelling to mesh perfectly with the turning pages—the cat-astrophe of Mr. Big Face, the wordless unmasking of "the tallest dog in the world"—and behind this is the presiding observation of the busy, comic, rueful world of the kids around the block. Words, paint, and the touches of collage are all integrated into the easy rhythm of the experience with a complete and convincing naturalness.

He looked in the weeds for a wild goose.
He didn't find a wild goose,
but he found an acorn with its cap on.
He looked in the mud for a mud turtle.
He didn't find a mud turtle,
but he found an old picture.
He walked all around the pond, looking for zoo animals.
He found a rusty key and a branch shaped like an arrow.

Then he was hungry, so he went home for lunch.
"Well," said his mother, "what did you find?"
"Junk," said Josh, emptying his bag on the kitchen table
for his mother to see. "Isn't it beautiful?"
"Beautiful," said his mother.
And it was.

Multiple collage of cut paper, marbled paper, photographs, etc.,
printed in full color for Ann McGovern's *Zoo Where Are You?*
364 x 380 mm, 1964

USM Cook Library copy

CHAPTER SEVEN

The Other Illustrated Books

The dozen or so commissions that Keats completed between the publication of *The Snowy Day* in 1962 and *Whistle for Willie* in 1964 bear little relation to his discovery of his true métier at that time. He makes some glowing color separations in up to four colors for Ann Nolan Clark's *Tia Maria's Garden* (1963), and he introduces collage and marbled paper in his illustrations for Millicent Selsam's *How to Be a Nature Detective* (1963), *Indian Two Feet and His Horse* by Margaret Friskey, and *Speedy Digs Downside Up* by Maxine Kumin (both 1964). But only after this taskwork is disposed of does he begin to reconnoitre alternative ideas and commissions that will allow him free play with the full-color techniques that would bring him such creative excitement (and marketable celebrity).

From this time on a lot of his creative energy will go into the sequence of books about Peter and the kids on the block, but this does not preclude him from working a parallel, and somewhat indeterminate, seam of ideas for individual titles. Some of these appear to have come about in a slightly frolicsome way—an eager response to his sense of liberation. Ann McGovern's *Zoo Where Are You?* (1964) offered him the chance for some elaborate collage making on a larger scale than in *Whistle for Willie*, of the same year, and may have

been part of Harper & Row's ploy to gain Keats for their list. Ursula Nordstrom, the editor there, was not one to let genius escape if she could help it, and genius was often stimulated through her brisk, perceptive sympathy. Harper duly published *Jennie's Hat* in 1966, and *Peter's Chair* in 1967, and through this Keats came to work with Susan Hirschman, who was to edit some of his finest books.

Jennie's Hat itself was a kind of road test for the potential of collage. Although it is Keats' third picture book with his own text, it lies outside the "urban" series and was apparently inspired by a reproduction of a painting that Keats once saw "the size of a postage stamp . . . two old people, palms out, filled with birdseed or breadcrumbs; pigeons were perched on their hands and shoulders and feeding from their hands."[1] The story that resulted seems to have been contrived to demonstrate the multiplicity of materials that can be applied to the purposes of collage: patterned and textured paper, patterned linen, painted paper, a photograph, marbled paper, and assorted pictorial scraps (see 0020.04-18). The elaborations contrasted sharply with another jeu d'esprit of this period, *The Naughty Boy*, done in homage to John Keats. This is the famous poem that has almost become a traditional nursery ballad in Britain:

Jennie's (actual) hat, made by Keats after his own collage invention.

deG 0137.01

Composite artwork for the opening spread of John Keats' *The Naughty Boy* Black line underlay with base drawing and text, overlay in black and red tone to print red 217 x 288 mm, 1965

See the discussion of color separation at the end of chapter four.

deG 0042.07

150

> There was a naughty boy,
> And a naughty boy was he;
> He ran away to Scotland
> The people for to see.

Keats (Ezra) made a pretty little pocket book out of it, unlike any other book that he illustrated—elegant, austere designs in pink and black, prepared as color separations.[2]

Verse became something of a feature among these miscellaneous projects, perhaps with the thought that its formal structures could be echoed by the formal patterning or the abstract designs of which collage was capable. Olive A. Wadsworth's counting rhyme *Over in the Meadow* (1971), with its succession of individual scenes, was a pushover:

> Over in the meadow, in the sand, in the sun,
> Lived an old mother turtle and her little turtle one. . . .

Each spread was virgin territory for a pretty piece of pastoralism, as the tally of creatures rose to the "little maybugs ten." All the artist had to do was to enjoy the challenge of constructing some elegant collages, without the pressure of having to sustain connections from page to page.

The same decorative diversity can be seen in Richard Lewis's anthology of Japanese haiku, *In a Spring Garden* (1965), and Keats' own brief assault on the philosophia perennis, *God Is in the Mountain* (1966). Both of these books were casual, in the sense that they had no predetermined length or shape. Their contents and sequencing were organized to fit the thirty-two and forty-eight pages of their respective formats and Keats was at liberty to design each spread "as the spirit moved him."

The results prove his versatility in finding a graphic style appropriate to the accumulated texts, however slight they might be. *Over in the Meadow* allowed its formalized but colorful animal population space on the page to run, fly, or swim. *In a Spring Garden*, though, with its thin, rather anaemic, little observations:

> Voices
> Above the white clouds:
> Skylarks.

held dangers of pretentiousness, especially since the chosen size for

a spread (10fi x 15 inches) seems a trifle large for a single haiku—or even for a couple of haiku on facing pages.

Keats' solution was to head for the voluptuous. He takes little account of the famed double entendres that haiku may sometimes imply; instead he lets his pictures expand upon the surface meaning, and often works two haiku into one double-page scene. The book is a compendium of rich effects—marbled skies in purple or orange, silhouetted animals and pagodas, and delicately painted insects (no wonder his niece, Bonnie, framed them as prints to hang on the wall)—but only occasionally, with a fragmented moon, or the Milky Way seen through a torn paper window, do words and picture take on a startling force.

Appropriately enough, *God Is in the Mountain* is altogether more restrained, moving toward abstraction for its cargo of gnomic sayings, headed by the Hindu intimation of the Divine: "I am in every religion as a thread through a string of pearls." The theme meant a great deal to Keats, whose native Jewishness was tempered by a sense of the truth common to all faiths ("there are ways," says the Taoist here, "but the Way is uncharted"), and he brought an extraordinary battery of techniques to bear in fashioning the simple but striking images that illustrate his chosen texts.

Using color separation for the last time, he treated both his foundation design on board and his superimposed designs on one or two overlays with great freedom and with no concern for achieving any graphic unity in the book as a whole. The board might be used for collages of cut paper, marbled paper, or textured work in paint or ink, while the overlays might also hold collage paper or cut shapes of "colorform" (a semi-opaque acetate that can be cut up to give tints), and these might be printed on pages inked, or partially inked, in grey or orange tints, or solid black. Everything is cool and subdued, belying the fact that six different colored inks were used in the printing, in addition to black. Keats the rampant colorist could be subtle as well as bold.

Perhaps the oddest of these "poetic" volumes—if not one of the oddest books in Keats' oeuvre —is *The Little Drummer Boy* of 1968. His text is the Christmas ballad, which first hit the market ten years before and was running a close second to "White Christmas" as a sentimental seasonal favorite. Keats claimed total ignorance of the song when, at the end of January 1968, Susan Hirschman put forward the idea that they might make a picture book out of it. (This is surprising, since the ballad must have been played ad nauseam, and it

This photograph of a resting drummer formed part of the preparation for *The Little Drummer Boy* (1968).
deG 0030.21 #29

Acrylic painting modelled on a reversed version
Approx. 240 x 250 mm, 1968

deG 0031.08

Dance of the Animals (in silhouette) from
The Little Drummer Boy
Acrylic on board
240 x 505 mm, 1968

deG 0031.12

has a rhythm so compulsive that once you get it into your head you can't get it out.) Having seen the text, however, Keats decided that it was a book that he had to do and—calling upon the services of young David Hautzig to be photographed as drummer—he worked with great expedition and completed the paintings by April against a Christmas publication.

Naturally the book was a runaway success[3]—a tribute to Susan Hirschman's shrewd perception of market needs, and of Keats' capabilities—and the speed of its production was probably of great value in preventing too much agonizing over how to convert this essentially aural experience into the far less fluent medium of print and picture. The drumming rhythm—and the wan melody—are impossible to replicate, and for the reader (who will inevitably have them running in his mind) there is bound to be a mismatch in the timing of the music and the timing of the turning pages. In the event, what was going to matter was the cogency of the images, their power to persuade the winter shoppers trooping through Macy's that this was indeed a drummer boy and a kingdom commensurate with what the song told them.

Imagination flinches at what a Tasha Tudor or a Michael Hague might have done with the commission. For Keats, though, the need for reticence must have been not only obvious, but must have accorded with the sobriety that characterizes so much of his picture making (from Peter cogitating in his bath to the serious, rapt expressions of Sam and Ben in *Apt. 3*). His drummer boy in that expressive hat might be one of the Brooklyn crowd—indeed there is a more than passing resemblance to Louie, conducting his search with a brown bag on his head. His scene-setting, apart from the portrayal of the collage-laden gift givers, is sparse, and he expands the hint of "ox and lamb kept time" into a telling commentary so that the finely judged graphic climax of the book gains force by arriving between the two beautifully silhouetted paintings: the near comic dance of the animals, watched by a gormless goat, and the last valedictory spread. There could hardly be a better solution to the job than the understated solemnity and joy in these pictures.

Susan Hirschman's role as instigator of *The Little Drummer Boy* exemplifies not only her flair as a publisher but also the critical position that publishers' editors may have in the shaping of illustrators' careers. This was especially relevant for Keats, who, once he had broken from Estelle Mandel, did not have an agent and conducted all negotiations—financial as well as creative—himself. His arrival as an illustrator of children's books had come about through the enterprise of an editor, Elizabeth Riley; the confidence to follow his bent as colorist had been encouraged by Annis Duff at Viking; and much of the subsequent "*Snowy Day* sequence" had been worked over with Susan Hirschman at Harper, at Macmillan, and at her own imprint, Greenwillow. (This company had been founded within the firm of William Morrow after a cataclysmic fuss at Macmillan in the autumn of 1974, when many senior staff were fired including most of the children's book department. Keats was deeply incensed. He joined the picket line. He protested to the president of the company. He withdrew *Owen* [later *Louie*] from contract before an advance was paid, and he offered the book to Susan Hirschman as soon as she moved to Morrow to set up Greenwillow.)

Being one's own master is a demanding occupation though, and the attractiveness of what look like new or unusual diversions, and the (perhaps intermittent) desire to maximize returns do not always make for easy working relationships. As an artist with a far from intermittent interest in his bank balance, Keats could often be a

155

touchy man to deal with, and although Susan Hirschman encouraged him through his most fruitful years of experiment, many of his peripheral activities at this time were undertaken for other firms and did not have the same underpinning of consistent editorial control. *Over in the Meadow* was done for Four Winds Press (an upscale division of Scholastic Publishing), *In a Spring Garden* for Dial, *God Is in the Mountain* for Holt, Rinehart & Winston, and another large-scale book, *John Henry* (1965), for Pantheon (a division of Random House).

John Henry is on the one hand a further endeavor to place the Negro more clearly in view as a picture-book hero. It is subtitled "An American Legend" and Keats researched it at the Schomburg Center for Research and Black Culture in New York. It is also another exercise in the expansive collage techniques that Keats was working with in *Zoo Where Are You?* and *In a Spring Garden*. Certainly he does not stint himself in the variety of effects, but the sheer diversity of his large, dramatic displays prevents coherence in the text, as a review in the *Christian Science Monitor* of May 6, 1965, pointed out:

> Folk songs are the product of a kind of community editing. The ones that endure are brilliantly simple and economical, and it is usually a mistake to tamper with them. Like most retellings, Mr. Keats' narration for 5-8's reads a little as if it were a translation in Basic English, padded out by footnotes. . . . The illustrations . . . make this a valuable book. Only read the original lyrics as you look at them.

Keats clearly had difficulties in shaping his text. His first thirty-two-page dummy (022.01) treated several incidents differently and did not have the over-urgency that mars the final version—but neither retelling has the racy vigor of the ballad singers' demotic, which contains the emotional authenticity that a legend needs:

> John Henry was a li'l baby, uh-huh,
> Sittin on his mama's knee, oh, yeah,
> Said: "De Big Bend Tunnel on de C & O road
> Gonna cause de death of me,
> Lawd, Lawd, gonna cause de death of me."[4]

Another big picture book of this period had an even more checkered career through the hands of the publishers. In December 1969, Farrar, Straus & Giroux contracted Keats to illustrate a children's story by Isaac Bashevis Singer: *Elijah the Slave*. The project was one dear to Keats' heart, for he knew Singer and was eager to work with him,[5] and he set about creating a series of intensely

156

powerful paintings, working mostly in acrylic on a heavily textured canvas board.

At some point, however, for an unexplained reason, the project was halted and in April 1970 Keats returned his $1,000 advance to Farrar, Straus. There was to be no *Elijah* with illustrations by him, and all he was left with were some rather wonderful paintings hanging in limbo. What was to be done?

The answer to that question came through a conversation he had with Ann Durrell, the children's book editor at Dutton, who put a call through to an author, Lloyd Alexander. Let Alexander give the narrative himself:

> Out of nowhere I was surprised by a call from Ann. "Come to New York tomorrow," she said (short notice for me), "and we shall meet Ezra Jack Keats in his apartment to talk about a book!"
>
> So I went to New York. We met in the apartment, and he showed me these paintings for someone else's book! He was very pleased with them and he asked me if I could create a story into which they would fit—a Mideastern tale, a Sufi story perhaps?
>
> We brainstormed around the proposal and I came up with the generalized idea of a humble person pitted against the highest possible person, which might be given a kind of philosophical point about power—the power to harm by depriving people of something essential, like water.
>
> "Hey, I like that," said Ezra, scribbling sketches as we talked, and after we'd pushed the idea 'round all afternoon he quit worrying and sent me off: "All you've got to do is write it," he said; and that way we got *The King's Fountain.*[6]

This looks to be a decidedly artificial means for creating a big picture book with philosophical pretensions, but Alexander was moved by the possibilities of his idea, and he wrote a parable that has the qualities of a folktale but moves with the formalism of a scriptural tale. And Keats sustained through the rest of his paintings the visionary power that had originally been inspired by *Elijah,* producing canvases that are rich in expressive color and dramatic organization but which hang together as a narrative sequence.[7]

None of Keats' other friendly collaborations met with the setbacks of *Elijah,* although none of them had the same intrinsic power as that book either. *In the Park: An Excursion in Four Languages* (1968), by his longtime friend Esther Hautzig, was the work that first brought him to Macmillan, where Susan Hirschman had become editor. Hautzig had mentioned to Hirschman that she would like Keats to do the illustrations, but was afraid to ask him—and

An example of how a design for one book was (dramatically) adapted to meet the text of its successor.

ABOVE: *"Never Had an Edifice of Such Splendor Been Seen by Human Eyes"*
Pages marked 28 and 29 for Keats' dummy for *Elijah,* with a portion of a typescript of Singer's text attached with Scotch tape
Pencil and colored pencil on paper
240 x 530 mm, 1970

deG 0024.01

BELOW: *"Finally He Reached the King's High Palace"*
Finished painting in acrylic on marbled paper on board for pp. [22-23]
of *The King's Fountain*
310 x 575 mm, 1970

deG 0025.15

Illustration based on a drawing for Florence Freedman's *Two Tickets to Freedom*
Heavy pencil or charcoal
210 x 270 mm, 1971

deG copy pp. 24-25

Hirschman urged her to show more courage. Keats, of course, readily agreed to work on the book (for which he got a $1,000 advance) but Hautzig remained nervous, confessing that she never dared ask him how work was progressing. The book is a slight one, intended by Hautzig as a simple introduction for American children to an ecumenical awareness that children from other lands may not be so very different despite the differences of customs and language. Keats met his commission with some cleverly designed spreads, integrating varying national features into single pictures.

Three years later there came about another touching renewal of an old association when Keats produced the illustrations for *Two Tickets to Freedom: The True Story of Ellen and William Craft, Fugitive Slaves,* by his former English teacher, Florence Freedman. The text over which their reunion took place was hardly an occasion for graphic jollification, but Freedman had chosen a subject that appealed to the deepest sympathies of them both. Keats' six double-spreads in pencil and (perhaps) charcoal were the only monochrome illustrations that he was to produce in the last twenty years of his life, but the rough style that he adopted and his emphasis on the hardships and the journeyings that brought the Crafts from Georgia to England and back again were entirely appropriate to the spare and moving story that Florence Freedman told.

Up to 1973 *Jennie's Hat* was the only picture book that Keats had devised and illustrated that did not relate to his sequence of books about the lives of city children. Through circumstances not fully

Dancing on Broadway, one of the set-piece scenes from *Pssst! Doggie*
Acrylic, gouache (?), and wax crayon on board
280 x 457 mm, 1973

deG 0052.09

explicable, however, he came in that year to publish two out of three almost wordless picture books that were a marked divergence from anything he had done before.

He had always had a chummy relationship with the animal world—especially dogs and cats. (As Martin Pope has said in his memoir, Keats' Weimaraner, Jake, was accustomed, with some material prompting from him, to write letters to his niece, Bonnie; and, during his last years, his inseparable studio companion was his cat, Samantha.) So he may have nurtured for some time the idea of making some books with animals as the chief participants, and this could have been further stimulated by his meetings with Jean Reynolds at Franklin Watts, through whom the scheme for picture books for younger children emerged. In any event, a contract for the three books *Pssst! Doggie, Skates,* and *Kitten for a Day* was signed on May 9, 1972 with Franklin Watts ($15,000 advance) and the printing of the first two was organized in Japan, with the publisher Holp Shuppan undertaking Japanese editions. (As noted in *Ezra Jack Keats: A Bibliography and Catalogue,* the reproduction of the paintings on a very heavy gloss paper did not appeal to the artist and *Kitten for a Day* was printed in the U.S.A.)

These fanciful productions—"lollipops" some might say—are an unexpected contribution from the painter of such books as *Apt. 3,* or the collagist of *In a Spring Garden.* A dog is invited by a cat to dance and, in a *ballo in maschera,* they whirl their way through a mixture of periods and costumes; a couple of dogs share a pair of roller skates in another kind of dance —frenzied and involuntary with frantic interjections from accompanying kittens; and a puppy finds himself among more kittens and prances heavy-footed through their neat routines. The books are little essays on the theme of movement, and although the content is slight and a trifle forced, they bring out the caricaturist that had lurked in Keats since his service among the comic books, and, in *Pssst! Doggie* and *Skates* especially, there is a virtuoso display of foregrounded color-work very different from the packed collages and impastos of his naturalistic storybooks.

The publication of *Kitten for a Day* and *Dreams* in 1974, and *Louie* in 1975, marks the end of a dozen years of intense creative activity for Ezra Jack Keats. In April 1975 he went to a conference in Fresno with Clyde Buller, who subsequently wrote to him about the dangers of "the circuit," which involved writers and illustrators of children's books in "too many extra-curricular activities,"[8] and which still

occurs. As an artist with a very distinctive "presence," and with a fund of individual ideas, Keats was much in demand on "the circuit," while his late-found success began to involve him in projects related to already-published books, and also stimulated his liking for travel. The Akira Ishida affair described in chapter one took him back to Japan for one more visit in 1977, and he also now made regular trips to Canada and to points across the Atlantic—Paris, Athens, Madrid, Venice, Cairo, Jerusalem . . . (the list sounds like that roll call of doom in T. S. Eliot's "The Waste Land").

There is no reason to question or regret these activities, and even to call them "extra-curricular" may be thought impertinent. Keats obviously enjoyed being fêted, and much of his travel stirred him in the way that his first trip to Paris had done. Nevertheless, taken with his increasing ill health, these diversions betoken a marked faltering in the progress of his work. Nearly three years elapsed without new books by Keats between the publishing of *Louie* in 1975 and *The Trip* in 1978, and the three books that followed these in the "urban" sequence all possess eccentricities of plot or design. (*Maggie and the Pirate*—which is "urban" only in spirit—is perhaps the most completely achieved of the three, but even here the initial premise of the pet cricket is just about as flimsy as the cricket's pretty cage.)

The one book that lies outside this sequence is Keats' last: *Clementina's Cactus* of 1982. Martin Pope, in an unpublished note on the book (0025.24), has pointed out that it "represents a radical departure from Keats' usual choice of urban themes" and he pinpoints not only the interpretive license Keats gives to his audience by abandoning a verbal text, but also the double implication of the "story": the flower springing from the dumpy, prickly, foreboding cactus, and the child rejoicing with her decrepit, hairy father. (With her ginger hair in its blue bonnet, and with her red-striped dress, Clementina proves a fairer flower than the cactus, which has lost some of its original glow through the ink and paper chosen for its printing.)

According to Dr. Pope, *Clementina* may have taken longer to flower than many cactuses do, since the original idea for the book was implanted in 1958 when Keats took a trip with the Pope family through Colorado, Arizona, and New Mexico. His reversion to the idea circa 1980 could be taken as an indication that he was aware of a need to redirect his thinking and that he was looking to build on the very simple graphic essays of the three Franklin Watts books.

"I've Never Seen a Seed Like This Before"
Finished draft for a spread of "The Giant Turnip"
Watercolor over pencil on cartridge paper
200 x 455 mm, n.d. [ca. 1982]

deG 0163.14

"Everyone Bowed in Respect and Honor to Little Mouse San"
Draft for the first spread of "The Giant Turnip"
Pencil on cartridge paper
200 x 455 mm, n.d. [ca. 1982]

deG 0163.14

During these last years, however, Keats was missing the guidance that may come from working with a sympathetic editor. There had been growing tensions at Greenwillow, and in 1978, after what need have been only a minor contractual argument, he bade farewell to Susan Hirschman,[9] but his subsequent books for Four Winds Press and Viking look to be "under-edited." He did not have the same chance to establish a close working relationship in these larger, and now more amorphous, companies; and, by this time, a new generation of editors had arrived, who were probably slightly in awe of him and were unlikely to suggest radical amendments to his submissions.

Nevertheless, Keats' interest in "departures" from his accustomed themes, especially in the direction of books for young children, was beginning to elicit from him drawings of freshness and wit, which, alas, he never lived to perfect. The archive does not possess any of his preliminary sketches and dummies for the series of activity books that he was devising with E. A. Hass, but from what I have seen of the surviving material these would have been books that combined his delight in color with a stylish simplicity of design.[10]

Some confirmation can be found for that in the drafts for "The Giant Turnip" (0163.11-14), which was approaching completion at the time of Keats' death. This was a Japanese version of the widely known cumulative folktale of how a huge turnip was eventually uprooted when a mouse came along to help the line of people and creatures who were heaving away at it. The double-spreads for the complete dummy of the story are plain and, where necessary, dramatic or funny pencil drawings, and, from the one draft watercolor that he made, Keats would seem to be thinking in terms of lucent color for the final pictures. The book would not have been the crown to twenty years of picture-book making but the crossing of a new horizon.

Draft design for the
Macmillan poster
Pencil on tracing paper
310 x 460 mm, 1972

The finished design
Acrylic, wax crayon, and
collage on heavy board,
mounted on hardboard
660 x 960 mm, 1972

deG (plan chest)

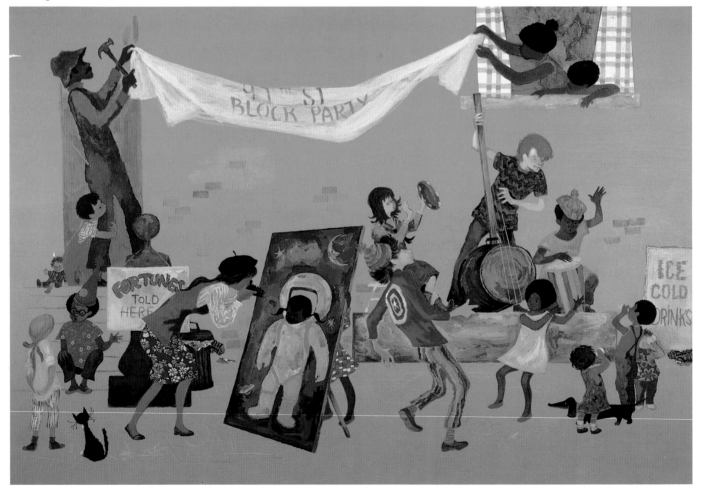

CHAPTER EIGHT

Ephemera

During the last years of his life Keats was concerned about the level of his income —perhaps because of the fewer new books that he was publishing. (By the late seventies and eighties publishers were concentrating on "frontlist" publishing—getting new titles on the market—to the partial, or total, exclusion of their backlist. This meant that the income from advance sales and new book subscriptions became markedly higher than that for seasonal sales of older titles, reprints—if any—and paperback editions.)

For this reason, Keats, as agent for himself, began negotiations with Upstart Library Promotionals over publicizing his own books. Under the slogan "Whistle for Books" he was beginning to design posters and other library-related goods, like bookmarks, using characters and scenes from his picture books (0163.03-6; see illustration near the end of chapter one). The scheme had not developed very far, or very satisfactorily, at the time of his death, but Upstart Promotionals must have realized that they were not dealing with an upstart artist with a naïve view of what promoting was all about. For, with fair regularity throughout his career as picture-book maker, Keats had been involved in promotional activities of one sort or another and "Whistle for Books" only differed in that it was generated by himself rather than by an individual publisher.

Keats with Florence Freedman at Hunter College for his "Tea and Talk" visit, November 1965. His Children's Book Week poster can be seen top left.

deG 0117.08 #3

As winner of the Caldecott Medal, *The Snowy Day* launched Keats into the publicity-man's world at the very start of his picture-book career, and he immediately recognized the value to himself of approving appropriate strategies to get his work known and talked about. Publishers' posters, based on scenes in the books, were often made to be used in libraries and bookstores, and Horn Book Inc. issued their own sets of posters from Caldecott Medal books. (*The Snowy Day* appeared in set No. 1 along with Katherine Milhous's *Egg Tree*, Leo Politi's *Song of the Swallows*, and Thomas Handforth's *Mei Li*.) A couple of years later, Harper tried an alternative ploy. When they published *Zoo Where Are You?* in 1964 they also issued prints of six of the pictures in a portfolio, which customers could then frame and hang on the wall.[1]

As well as posters directly related to the book art, further material came to be commissioned for more general publicity. (This happened in England too, where the Bodley Head issued bookmarks for their Keats books.) By far the most strenuous campaign was run by Macmillan who, beginning in 1971, produced the slogan "Kids Love Keats" and spread the message through newsletters, fliers, and buttons—their newsletter of May 1973 notes that 20,000 of these had been dispersed since the previous autumn. Keats also designed three special posters to go with this promotion ("At Home," "At School," and "In the Community"), a fairly lucrative event in itself since he was paid $6,000 for the job. There are also records for his making posters for Scholastic Publications, when his books were included in Lucky Club and See-Saw Club lists, etc., and here too the fairly undemanding work produced a comfortable return.[2] In January 1972, though, he rejected a suggestion from Franklin Watts to do some posters on the grounds that his publishing allegiance was first and foremost to Macmillan and they were "distressed" at what they saw as competition.[3]

Of much greater consequence than printed publicity—and of much sharper critical significance—was the growing interest in converting his books into other media. We well know that the marketplace, where diversion and diversity are of the essence, is not always comfortable with the austerities of print, and forward-looking persons who recognized the allure of sight and sound were eager to adapt the printed page to more dynamic functions. Around 1965 the innovative Bank Street College of Education in New York had contracted to make their first "Reading Incentive Films" from *My Dog Is Lost!* and *Whistle for Willie*. These films were primarily designed for

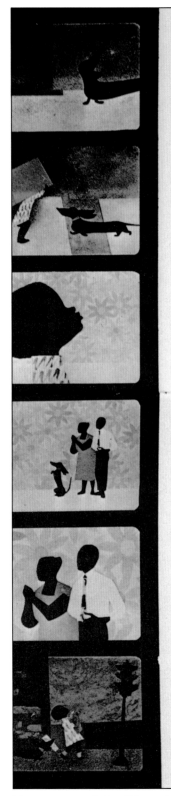

Willie stopped and looked around to see
who it was.

"It's me," Peter shouted, and stood up.
Willie raced straight to him.

Peter ran home to show his father and mother
what he could do.

They loved Peter's whistling. So did Willie.

Peter's mother asked him and Willie to
go on an errand to the grocery store.

He whistled all the way there,
and he whistled all the way home.

Two pages of the filmstrip text of *Whistle for Willie*, showing the
pictures to the left and the storyteller's "prompt" to the right.

use in inner-city schools in order to motivate children, and, indeed, their parents, towards a greater involvement in books and reading. "Each film presents a children's book of high story interest," wrote the president of the college in 1966; "an adult reader reads the book aloud directly into camera, and the film alternates between shots of the reader and close-ups of illustrations in the book."[4] It was a kind of filmic storytelling, attaching itself to the public's obsession with television. The hope was that it would not only encourage more children to discover books but would also lead to more books being borrowed and read aloud at home.

Despite its impeccable philosophy, the Bank Street method, as applied to Keats' books, now looks to be decidedly amateurish, especially when set beside the panache with which a commercial competitor was exploiting the same territory. This was Weston Woods Studios, a company set up by Morton Schindel in Connecticut in 1953 with the aim of making "audiovisual adaptations [of picture books] that are truthful reflections of the books themselves."[5] The idea had come to him when reading picture books to his own children, and had been confirmed by such experiences as seeing a teacher trying to read *The Tale of Peter Rabbit* to a class of children who could not make out what was going on in the tiny pictures.

From the very start Schindel insisted on the need for his screened interpretations to be as true to their picture-book sources as possible. Instead of adopting the clumsy Bank Street method of crosscutting between reader and picture he sought to edit the artist's own pictures in such a way that the reproduction of parts or of the whole could be closely attuned to the original intentions of the story. At its simplest, in the relaying of an "iconographic filmstrip," this resulted in a sequence of carefully edited stills being projected to the child audience while a teacher or librarian read from a printed edition of the text that was specially prepared to synchronize with the images. As time went by, and the company made commercial and technical headway, more sophisticated variants of this principle were developed: sound cassettes, with voice and music, that could accompany the filmstrip; films on which animators brought movement to the original stills; and live-action movies. All forms eventually found their way onto the simple and universally marketable medium of videotape.

In setting out his high-principled program, Schindel boldly confronted a swarm of difficulties. Quite apart from the often complex technology, he had also chosen to walk a high wire —a very serpentine high wire, if such a thing is possible —between the vested interests of authors and artists, the vested interests of publishers, and the

170

vested interests of a heterogeneous collection of children's-book enthusiasts, from librarians up to children themselves. Schindel, however, seemed to relish the difficulties of administration as much as the technical work that he was doing, and in his dealings with Keats almost every facet of the complex audiovisual business is revealed. (The Weston Woods section of Keats' correspondence is almost eight times as thick as his average correspondence files.)

Much of the everyday material here is to do with contractual affairs, where Weston Woods were, in effect, continuously middlemen. Keats' books were initially contracted to a publisher and the agreements with Weston Woods were dealt with under the heading of subsidiary rights. But because Schindel saw as paramount the need to complete work to the satisfaction of the artists involved, they too could easily become active participants in the contractual nexus.

This was especially true in the case of Keats, because not only was he his own agent but he was also, to some extent, a filmmaker manqué. He was keen to ensure that his books were not in any way diminished by being transferred to film; he was also eager to be involved in the production process. This led to some tense moments and one cannot but admire the patience with which Schindel managed his touchy client (although Ursula Nordstrom once remarked, in a memorable phrase, that "Mr. Schindel is well supplied with chutzpah").[6] On the one hand he agreed to what looks like very liberal terms for Keats to act as a consultant on the filmmaking, and on the other he did his best to accommodate a host of suggestions or criticisms relating across the board to film shots, readers' voices, and musical accompaniment. There were even expensive technical and legal arguments about such material matters as a defect in or damage done to one of the original illustrations for *Peter's Chair.*

The central issue though for Keats and for those with an interest in picture-book art is the critical relationship between work conceived in one form and its transference to another. Through the pages of a picture book the artist is making a direct address to his reader; through the progression of a filmstrip—however faithful in its reproduction—the artist's work is being reorganized and modified by an editor. There is no rule about how you may read a picture book. In a filmstrip, the sequences and the interrelationships of images are being determined for you in a way that is controlled by that editor's input and by the running of the machine.[7]

This substantive change is particularly obvious in the adaptation of Keats' work to audiovisual ends because his natural form of expression was the double-page spread—a graphic unit not easily

accommodated on an almost square screen. The camera must, of necessity, select smaller areas and details to the detriment of the artist's original intention, and with the loss of some unreproducible moments like the superb sequence of spreads in *Louie* where the boy encounters Gussie and the mouse, or the sequence leading up to the final spread of *The Little Drummer Boy*, which moved Barbara Fenton at Macmillan to write that it was "the most beautiful ending of any picture book ever."[8] (Given the serious misrepresentation of Keats' color-work in many reprints of his books, one should not enter additional reservations about the color in the films. Nevertheless, before the greater reliability of television videocassettes, many filmstrips—or the equipment with which they were used—did no justice at all to the subtleties or the drama of his painting.)

Keats himself worried over the fragmentation of his pictorial statements, which was inevitable in their transference to film. In 1968 he was moved to protest over what was happening to *A Letter to Amy:*

Keats (right) and Morton Schindel filming for the Weston Woods "Signature Collection" movie.

deG 0117.10

172

In the past, your production of all the books you did using the iconographic technique (and, later, with minimal animation) have preserved the original character of the illustrations and their structure and sequence.

In your storyboard for *Amy*, not a single illustration, which I carefully composed, remains. Instead, we have total fragmentation, completely ignoring the compositions, which are the integral visual structure of the story.[9]

This protest prompted a reply from Weston Woods' leading editor, Gene Deitch, who worked for them from a studio in Prague, Czechoslovakia, using the great technical skills of the Czechs, who had a long tradition in high-class film animation. Deitch clarifies as well as anyone the crucial problem when he admits the differences of the two media and goes on to justify his, and the Weston Woods, philosophy: "My effort is not to merely photograph the pages of the book as a series of static images, but to bring to life *the spirit and actions that a book implies* [his underlining]: to make the audience believe that they are seeing the book spring itself to life. . . ."[10]

How far this justification convinced Keats is not recorded, but *A Letter to Amy* was made and must have pleased him since it is used to exemplify his picture-book art in the "Signature Collection" movie that Weston Woods went on to make featuring his life and work. Furthermore, his letters expressing satisfaction at the company's solution of difficulties that worried him are almost as frequent as his letters that raise the difficulties and he could not help recognizing the integrity that lay behind Deitch's wish to sustain "the spirit and actions that a book implies."

In the end, though, a strange irony emerges. Weston Woods, as Schindel proudly claimed, sought only books that it was thought desirable to bring to a wide audience, and only books that would prove adaptable—at whatever cost. (Deitch claimed that he needed five years to perfect *Where the Wild Things Are*—"the Mount Everest of children's picture books.")[11] But by these very qualities of desirability and adaptability the books became mute offerings to the inspiration of filmmakers, who converted them to the new medium with such flair—and with such seductive trappings of voice and music—that the appeal to a television-nurtured audience made the "spirit and actions" of the film more natural than those of its original. Book became springboard for film; film became less and less an agent for the promotion of book. Under such a dispensation, who is to say

173

that the ingenuous crudities of Bank Street might not be more wholesome for an acceptance of "the lively art of picture books"?

During the later stages of Keats' association with Weston Woods, two projects were mooted with more intriguing creative implications than the production-line conversion of his picture books that had so far taken place. Lex Cochran, an editor with whom he had established a confident working relationship, was eager to make more out of the unity that subsisted in Keats' oeuvre. He put forward two ideas that had been maturing for some time: the first a filmed account of Keats talking about how he developed his characters, which would include complete showings of *Louie* and *The Trip*, the second a single film that would treat of Peter growing through his various experiences, from *The Snowy Day* to *Amy*.[12]

Nothing came of this, or of an alternative idea of having a one-hour videotape that would incorporate more disparate material from six books. But Cochran's initial plan opens up—rather belatedly—the potential that there is in highlighting Keats' books as the insights into a child's world that they really are. This had been a subordinate theme in the filmed interview in the Weston Woods "Signature Collection" series (within which were films of other artists like Maurice Sendak and Tomi Ungerer), but, by giving these insights greater prominence, the videotape would serve to return the audience to the source material in a way that does not necessarily occur with the viewing of a single filmstrip or video production. (There was a precedent for this in the television programs to which Keats contributed for the "Mr. Rogers' Neighborhood" series in the early seventies. But for anyone used to the comparative editorial and technical sophistication of British children's television at this period the amateurishness of these programs is slightly baffling. That is not to gainsay the attractiveness of Mr. Rogers himself, but the crudity of the editing and use of copy undercuts his efforts. This is noticeable in the features involving Keats, where Ezra—for all his screen aplomb—sometimes appears as an embarrassed participant. Well he might be. In the program that called upon *Hi, Cat!* for instance, an early part of the reading was so abridged that it rendered incomprehensible the later remark "Who ate your mustache, gran'pa?")[13]

Film and television have not, however, been the only alternative media where an expansion or an adaptation of the "spirit" of a Keats picture book have been attempted. In the very last letter in the Weston Woods file, dated March 2, 1983, Keats is gaining official

confirmation that his contract with the company will not be infringed by his involvement in a project for "a mini-musical dramatic version" of *The Trip*. ("No problem!" notes Schindel, in his personalized green ink. "Good luck with the project. . . .")

The idea for this production had come from Nina Trevens, producer's assistant at the First All Children's Theatre on West Sixty-fifth Street, New York. She wrote to Keats on September 3, 1982, that the theater was currently planning to translate some children's books into half-hour musicals. "I very much liked your book 'The Trip,'" she wrote, "would you be interested in having it included in our program?" Keats was not just interested but enthusiastic. He set about helping with the scripting of the story to turn it into a stageable event, working with Anthony Stein (book) and Stephen Schwartz (music and lyrics), and designing the sets and costumes himself. But like the new books that he was working on, this was to be another bright new promise that he did not live to see fulfilled.

The Trip: A New Musical was staged by the First All Children's Theatre for the Christmas season of 1983—and as a "Christmas Week Special" it was performed with a dance/drama based on *Clementina's Cactus*. John S. Wilson reviewed the play for *The New York Times* on December 11, and wrote that it had "a communicative magic for an audience beginning with 2-year-olds [with] an even deeper appeal for an older audience than the book might have had." He praised all aspects of Meridee Stein's "imaginative staging," noting especially the cast, whose ages ranged from 9 to 20, achieving "a fine balance between professionalism and a sense of real children putting on a show"; he also recognized that, by having Keats design the sets and costumes from his own illustrations, "the visual quality is transferred to the stage with no change in point of view."

A copy of the script for *The Trip* is in the archive (0064.33), but it obviously can give only a faint echo of what an all-singing, all-dancing, lights-music-curtain performance would have been like. What it can do, though, is suggest how much more liberating a treatment of the book this is than an audiovisual one —giving freedom of interpretation to cast and audience around a printed, pictorial original that retains its centrality. In these terms, the existence of the play as a fait accompli amounts to a model for future experiments and a confirmation of their validity. Indeed, in 1989, Nina Trevens—now the artistic director of the New York children's theater group Tada!—mounted a production of *Adventures from Ezra Jack Keats*: a

choreographed version of *Skates* and musical productions of *Apt. 3* and *Maggie and the Pirate*. Sets and costumes could not, alas, be by the author, but once again a sensitive (and very lively) production showed how this direct interpretation of his books by people rather than machines refocused attention on what *he* had to say.

CHAPTER NINE

Ezra Jack Keats
and His Reception

Before 1962 Ezra Jack Keats scarcely had a reception outside the offices of the editors who were commissioning his work. As a painter he occasionally received a kind mention for an exhibited item; as a commercial artist he could be relied on to turn in a professional job; and as an illustrator he gained some small random notice in a market that was crowded with talent and where the quality of work done was not matched by any equivalent quality in the public discussion of it.

In 1954 when *Jubilant for Sure* was published, book and magazine publishers in the United States could call upon a wonderfully diverse range of skills from resident draftsmen in black and white. Still busy from the 1930s were homegrown artists like Dorothy Lathrop and Robert Lawson, working with children's-book publishers alongside the many illustrators who had emigrated from Europe before the war, like Roger Duvoisin and Fritz Eichenberg. Their styles could range from the loose, apparently casual sketching of James Thurber and other cartoonists, to the densely drawn pictures of Lois Lenski or the transferred wood engravings of Lynd Ward— and to this standing reservoir of self-effacing genius there was being added the lively talents of the postwar generation. Garth Williams had arrived in 1945 with his illustrations for E. B. White's *Stuart Little*; Maurice Sendak's drawings for Ruth Kraus's *A Hole Is to Dig*

appeared in 1952; Erik Blegvad had begun his career in America at about the same time; Walter Lorraine was working as both illustrator and designer; and waiting in the wings were the new people who were to be part of the massive expansion of the children's-book industry from the 1960s onward. Such illustrators as Margot Zemach, the Lobels, and William Steig are rightly fêted for their picture books, but this should not be allowed to obscure the excellence of their work in black and white—comic, racy, and elegant by turns.

Very rarely though did these zealous accompanists receive any informed critical attention beyond their verbal debates with editors or with colleagues. Children's literature is not a field where commentators or reviewers have had the curiosity—or the space—to examine closely the performance of authors (let alone their illustrators) and, during the 1950s, the scope and content of discussion was limited indeed. Most of Keats' work before *The Snowy Day* attracted only cursory—but usually complimentary—remarks, along the lines of the following from Averil Randall's notice of *Jubilant for Sure* in *Library Journal*: "Illustrations by Ezra Jack Keates [*sic*] are in harmony with the descriptive regional scenes."[1] Many reviewers never mentioned his contribution, or included him merely by reproducing one of his illustrations, and in some cases, such as *The Horn Book*'s note on *Wonder Tales of Dogs and Cats* (October 1955), he did not even figure in the title transcriptions. This could be particularly galling when, as in a *Herald Tribune* review of *The Indians Knew*, the pictures were mentioned but not the artist. (Depressing variations on "Keates" also occurred. The *Herald Tribune Book Review* once muddled up their poets and called him Yeats, and, later on, he turned up in a review of *Jennie's Hat* as "Mrs. Keats.")[2]

As that last incident suggests, careless or uncommitted reviewing could be the fate of nationally known as well as obscure artists—a misfortune by no means mitigated by provincial papers' habit of using syndicated reviews, or simply plagiarizing other journalists.[3] At the same time, the enforced brevity of reviews—even by experienced commentators in professional journals—tended to prevent any detailed description, or argued criticism, of texts and illustrations.

Keats himself had experience of this, "on the other side of the fence" as he put it, when he undertook the Christmas reviewing of children's books for *The New Republic* in 1975 and 1976.[4] Both reviews extended to three columns within which he placed an introduction and, respectively, ten and twelve notices of new picture books. Some of these notices were drafted in his sketchbook (0140.02), where we can see him wrestling with adjectives—the

reviewer's nightmare—and with the problem of condensing a story into a few words. (We can also see a draft piece on Brian Wildsmith's *Python's Party*, which never appeared in the final article.) Keats states at the outset that he sees his job as one of recommendation, so that he is only giving the flavor of the books that he has selected in order to guide readers to possible choices. Even so, he is hard pressed to fit into a few column inches what the book is about and what is special about its illustrations. The level of his enthusiasm can be gauged by the distance that his writing travels from cliché: Big Anthony "unleashing a sea of pasta" in Tomie de Paola's *Strega Nona* hits home in a way that "told and illustrated with contemporary flare [*sic*] and subject matter" (for Ray Prather's *Double Dog Dare*) does not. But only rarely can he characterize illustrative style or the relationship of style to text—and he does his own version of "Keates" by letting "Ardizzoni" twice slip into print.

At the start of the first batch of these reviews Keats remarks that he had read reviews of his own books for the past twenty years "experiencing during that time the entire gamut of emotions from dark despair to sweet euphoria." An examination of many of those reviews, and of those that came subsequently, refines that "gamut" into a euphoria that might come from a sentence, or even a well-chosen adjective, in praise of a book, and a despair that might come from inadequately argued criticism. Keats might well have understood, and perhaps agreed with, Margaret Sherwood Libby's well-phrased conclusion to her notice of *Three Young Kings*, way back in 1956: "The strong, splashy illustrations in black and clay color have style and vigor but seem curiously gloomy for a lively Christmas story set in a sunny land."[5] But the reviewing of his own picture books may often have brought about gradations of despair because of the imperceptiveness or the curtness with which his often deeply considered work was accepted or dismissed.

This could occur in entirely positive reviews. Having established a reputation as a collagist, Keats often had his work summed up as though "collage" meant the same thing throughout his oeuvre—whereas, of course, the way collage was used in the early picture books is entirely different, and thus carries a different significance, from such other disparate works as *In a Spring Garden* and *Dreams*. The nuances here, closely related to the different demands of texts, are often too subtle for reviewers to spend time on, even when hasty praise is the aim. But with certain crucial books—say *Goggles!* or *Apt. 3*—the lack of considered attention must have been very frustrating.

AND HIS RECEPTION

Goggles! certainly did not meet with any seriously adverse criticism, but if you bear in mind that this was the book in which Keats broke out of "the family circle" with its simplifying collages and into the back-street lots with a far greater graphic drama, then you may be surprised to find how little his new direction is remarked upon. Leaving aside thoughtless error (Zena Sutherland in the Center for Children's Books *Bulletin* calls the goggles "rimless," and the reviewer in *Booklist* calls Archie "Andrew"),[6] there is very little departure from a knee-jerk reaction that sees Keats' illustrations as variously "kaleidoscopic," "gorgeously-colored," and "charming[!]" Most reviews simply attempt to retell the story without more comment than that, and only Charlotte Blount in the Winston-Salem (N.C.) *Sentinel Journal* makes an effort to line up the character of the book's text and pictures and its relation to a readership. (She tends to gush, but she several times devoted more space more sensibly to Keats than the "professional" journals.)

With *Apt. 3* the reviewing must have induced even more despair. The book may have meant more to Keats than anything he had done previously (so that he would hope for appreciation of its intensity), but it was a difficult book to cope with. Its unusual size, its somber coloring, its hint of a drama that resolves itself into a "felt experience," its crabwise text—these all defied the easy summing-up to which most reviewers were accustomed, with the result that a general unease failed to crystallize into a fully argued critique. Ethel Heins in *The Horn Book* wondered about "the necessity [to whom?] of the somber naturalism of the words and pictures which tell a story of urban squalor," but she then complained that "some of the words are as needlessly sumptuous as the paper and paint." Zena Sutherland, by contrast, in the *Bulletin* found it a "delightful" book and then said that "the slight plot and its decrescendo ending weaken the story," without apparently perceiving that Keats was attempting a *crescendo* ending that he hoped would give point to "the story." Only *Kirkus Review* tried to place *Apt. 3* in the context of Keats' earlier books and to express a concern over its controversial ending. The last sentences of the review are: "Keats' reluctance to coast with the successful Peter stories is understandable. It's too bad that the story that he invents here is just a sentimental occasion for his backgrounds, but the backgrounds are impressive as usual, and the tone as well as the hero are mature enough for new readers too sophisticated for the usual picture book fare."

180

British reviewers of *Apt. 3* found themselves in the slightly more fortunate position of being able to write about the book alongside Charles Keeping's deeply mysterious *The Spider Web,* although few took the opportunity to tackle the intriguing parallels between Keats' and Keeping's probing of child-experience here and elsewhere. Shelagh Webb's piece in the *Guardian* probably comes nearest of any review to the reaction that Keats hoped for (she said, "It's a real world, not sentimentalized, but structured with notions of beauty and kindness by a considerable artist in this odd genre") but she deserved more space to examine how it and *The Spider Web* were "written and drawn behind the head."

Such comparative reviewing would have helped us towards a full appreciation of Keats' place as a picture-book maker, but not only has the equivalence to Keeping in themes and in graphic technique never been fully explored, but Keats' relationship to his American contemporaries—and, hence, his peculiar quality—has not been clearly delineated. Barbara Bader, in her admirable *American Picture Books* of 1976, provides a foundation by setting *My Dog Is Lost!* among those few books that tried to give an honest picture of the child in the city—and it would have been instructive to see her pursue a hint that that book owed something to Will and Nicolas's *The Two Reds* (1950), which preceded it by ten years (kids in backyards, hand-separated colors, etc.). But her further treatment of the Keats full-color books barely indicates their continuous embroilments in city children's affairs, which, whatever the level of performance, constitutes their distinction.

Here and there a picture-book artist has touched on a theme similar to one chosen by Keats. Sendak, for instance, has a town child run away from home in *Very Far Away* (1957), and has kids from around the block making the best of a long summer day in *The Sign on Rosie's Door* (1960)—with the significant dedication:

> Remembering Pearl Karchawer
> all the Rosies
> and Brooklyn.

But the huge difference in Sendak's treatment of these themes highlights Keats' commitment to a downbeat authenticity. For one thing, Sendak's writing in his two books possesses a rhythm and a shapeliness that was entirely foreign to Keats' simple, prosaic texts, and

Sendak uses this to create a synthesis of word and image which together make the impact that Keats achieves largely through painting. *Very Far Away* may now seem precious beside the solidity of *Peter's Chair* but that does not detract from the quality of its construction. *Rosie* (which, along with *The Nutshell Library,* I take to be Sendak's finest book), with its fluent integration of narrative and image, gains effects which the more limited narrative of *Hi, Cat!* translates into visual terms.[7]

Sendak's multifaceted career itself helps to emphasize Keats' persistence in dealing with the three-dimensional world outside his studio window, but few of their contemporaries even offer the comparative possibilities of *Very Far Away* and *Rosie* (and heaven forbid that anyone should try to establish any flighty parallels between *In the Night Kitchen* and *Regards to the Man in the Moon*). The one picture-book maker who stands fair and square on Keats' patch is John Steptoe, another Brooklyn-born illustrator who burst on the scene before he

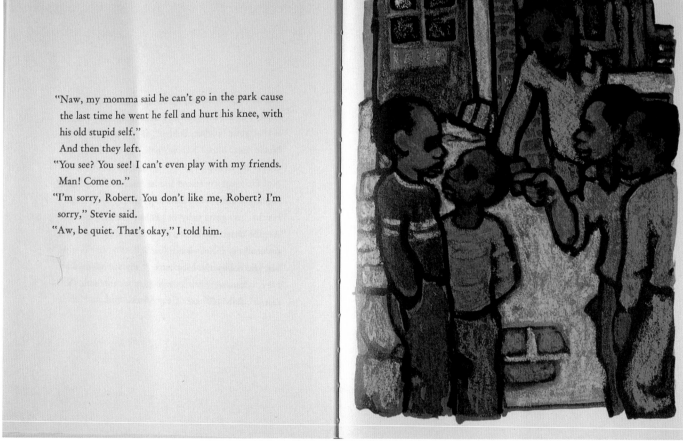

"Naw, my momma said he can't go in the park cause the last time he went he fell and hurt his knee, with his old stupid self."

And then they left.

"You see? You see! I can't even play with my friends. Man! Come on."

"I'm sorry, Robert. You don't like me, Robert? I'm sorry," Stevie said.

"Aw, be quiet. That's okay," I told him.

Double-page spread from John Steptoe's *Stevie,* showing both his demotic text and his heavily outlined illustrations
Crayon
230 x 350 mm, 1969
deG copy pp. 13–14

was twenty with *Stevie* (1969). This book and its immediate successors, such as *Uptown* and *Train Ride,* stemmed directly from Steptoe's urgent concern that young black children in the city should have books that were true to their own environment.

The New York setting, the unblinking acceptance of what that environment was like, suggests an immediate equivalence with Keats' picture books—but the differences are more prominent than the similarities. For Steptoe, text was all important. "I was amazed to find," he once wrote, "that no one had successfully written a book in the dialogue which black children speak,"[8] and the strength of his stories comes from his fine ear for that dialogue and the shifts of feeling that he discovers within it. Often the printed text is entirely divorced from the illustrations and these, unlike Keats' panoramic displays, have a slightly claustrophobic air, heightened by the heavy, Rouault-like use of painted outlines. (Later, Steptoe was to show great versatility in choosing a graphic style that he felt needful for an increasingly diverse range of texts. In one of his last "urban" books, *Daddy Is a Monster . . . Sometimes* [1980], featuring his own children and still seeking to hold on to authentic speech patterns, he employs what his publisher calls "prismatic paintings" which bear interesting similarities to such experimental books by Charles Keeping as *The Garden Shed.*)

Steptoe's commitment to black city culture was one element in a debate over the black child in picture books, which proved—regrettably—to be almost the only critical discussion of Keats' work during his lifetime, beyond the largely bland reviews and the sometimes adulatory interview-articles on how he made his books. For although *The Snowy Day* was published to universal acclaim and, along with the other books about Peter, has been recognized in many countries as an exemplar of "multiculturalism," it had to make its way during the decades when arguments about topics like ethnicity and social relevance were running on overdrive. The slightly belligerent comments that Steptoe made —with justification—as an artist were also being replicated and expanded upon by the single-issue critics in ways that caused serious distortions in the balance of judgment.

Keats first encountered this when *The Snowy Day* was introduced as an example in Nancy Larrick's article "The All-White World of Children's Books," published in the *Saturday Review* on September 11, 1965. Larrick, a "former President of the International Reading Association," wrote her article primarily to draw attention to "the blatant racial bias" that was observable in trade books as well as

school textbooks, and to advertise the newly founded Council for Interracial Books for Children, which was planning to redress the balance. Carried away by her all too convincing evidence, however, she set about her task with indiscriminate zeal and implicated *The Snowy Day* in her commination, first because it showed a Negro boy in the pictures "but omitting the word in the text," and second because Peter's mother was portrayed as a stereotype: "a huge figure in a gaudy yellow plaid dress, albeit without a red bandana."

Such gratuitous—and snide—criticism deeply upset Keats, and it is probably true to say that (as happened with the disgraceful assaults on Margot Zemach for *Jake and Honeybunch Go to Heaven*) he never completely got over it. He wrote at once to the journal to say that he was "sickened" by the reference to his book and to make the rebuttals that Larrick should have anticipated. "In a book for children three to six years of age," he said at one point, "where the color of one's skin makes it clear who is a Negro and who is white, is it arbitrarily necessary to append racial tags? Might I suggest armbands?"

Larrick scrabbled to justify herself in a subsequent letter,[9] but did not greatly improve her case, failing to appreciate the irony of "armbands" and crashing to defeat when she closed by saying that she rejoiced "in the fact that a Negro child is depicted as joyfully as Willie is in the two books" and hoping "that the living child of whom Willie is a counterpart may grow up in a world . . . untouched by racial prejudice. . . ." So much for the close reading of the single-issue critic.

Proponents of interracialism were not done with Keats at that point, however, and his despair over their blinkered attitude was aggravated when Ray Anthony Shepard, "winner of the Third Annual Writing Contest" of the CIBC, published his article "Adventures in Blackland with Keats and Steptoe."[10] This absurdly tendentious piece sets out to denigrate Keats' picture books as "a position statement from the liberal literary establishment" and to contrast his "outsider's" view of the slum or ghetto with Steptoe's celebration, as insider, of "the ethnic difference of Blacks." The article is avowedly political and seeks to damage by innuendo: black kids shown as human by "presenting them as colored white kids," "mommy and daddy dressed like a nice middle-class white family," natives happy in the "underdeveloped setting" of *Goggles!* Ultimately, however, the only crucial distinction between, say, *Stevie* and *Peter's Chair* is the admitted one of Steptoe's authentic dialogue.

This places *Stevie* geographically not in a generalized Blackland but specifically in Harlem; as far as the story is concerned, Stevie's sadness at losing his friend is no less widely applicable than (and just as much a picture-book cliché as) Peter's jealousy of the new baby.

What pained Keats most about these accusations of closet racism[11] was that they impugned his absolute commitment to children as individuals. (As a Jewish boy brought up on Vermont Street in the 1920s he didn't need lessons on deprivation and discrimination from anyone.) A couple of years before Nancy Larrick's notorious article, he had himself written a piece for the *Saturday Review* on "The Right to Be Real."[12] This began by celebrating the hope that "we shall relegate to the past the kind of books . . . in which an entire people and a great heritage have been deliberately ignored," but he then went on to assert the right of writers and artists to "draw with love and be responsible for what they create" and not to surrender their identity in pursuit of improbable perfections. "All people want is the opportunity to *be people*"—and that went for children too.

The latent ecumenism in that belief takes on the comforting strength of fact as Keats' books made their way in the wider world. The natural channel for such an entrée to new audiences was through London, since, in the 1960s, British publishers had much easier access than American ones to the rest of the English-speaking world, and, furthermore, publishing events in Britain tended to come more readily to the notice of entrepreneurs in Europe. Even if they did not, though, American publishers were themselves becoming a strong presence at the annual book fair at Bologna in Italy, which was turning into a major forum for the exchange of international contracts.

Oddly enough, the first of Keats' books to be published abroad was not *The Snowy Day,* but *Whistle for Willie,* which the Bodley Head brought out in London in 1966 (apparently un-English activities like "making angels" were felt to be an inhibiting factor in the earlier book). But the welcome that *Whistle for Willie* received was such that *The Snowy Day* soon followed, and Keats gained an assured place among the "new men" of picture-book making in England as well as in America. Judy Taylor at the Bodley Head, Julia MacRae at Hamish Hamilton, and Kaye Webb at the paperback firm of Puffin Books all forged friendly relationships with him, and Taylor not only commissioned ephemera from him, like bookmarks, but also discussed independent projects like the board-book series (which was eventually

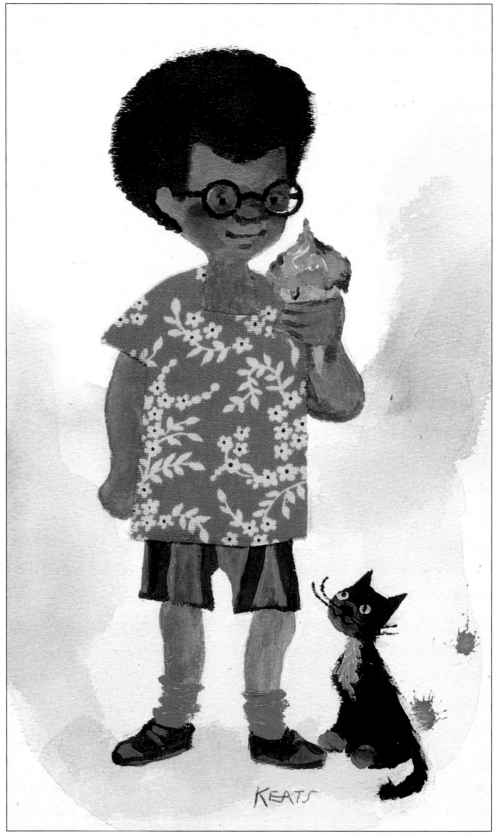

Design for a bookmark prepared by Keats to be issued by
one of his English publishers, the Bodley Head
Gouache and collage
Approx. 210 x 140 mm, n.d.

Private collection

undertaken by Robert Broomfield and Maureen Roffey). In 1978 she also used *Hi, Cat!* for an early experiment in dual-language publishing, in the hopes that it could be used with immigrant groups in Australia. English/Greek and English/Italian printings (1,500 copies each) were produced and the books were issued with a plea that they be used "not in classrooms, but in families."

The enthusiastic reception of the books in England was matched by the interest of foreign-language publishers, especially in Scandinavia. One of their problems, however, was the high cost of reproducing the color-work. Eventually, during 1965-66, a tripartite arrangement was worked out and *The Snowy Day* was published in Denmark and Sweden in 1967 and in Finland in 1968.[13] From this point onwards there was a continuous stream of negotiations: from newcomers to Keats, wanting to introduce his books to their countries, to old friends who were coming back for more.[14] Understandably, the early "domestic" titles about Peter were the most popular and the most frequently reprinted; after *Pet Show!* the subjects and treatment of the stories had something of a self-limiting effect. Nevertheless, applications to work on new translations have never died out, and as of 1993 sixteen of his own books could be found translated variously into seventeen languages, with the Japanese unsurprisingly dominating the foreign-language market.

From the beginning Keats showed a keen interest in the way that his books were presented in other countries (hence his delight when Julia MacRae agreed to take on the difficult job of publishing *Apt. 3* in England). For foreign-language editions, he frequently sought advice over the translations and his correspondence files contain a number of instances of anxiety that the books match his original intentions. Thus, for example, he seeks to preserve "Amy" in a Swedish edition, rather than a more Swedish "Annie"; in a book like *Pet Show!* he prepares his artwork so that the notice of the show can be given as a translated poster; and on some occasions there are intense discussions. (The most complex of these, over a Japanese edition of *Peter's Chair,* is summarized in detail in the *Catalogue.*)

Keats' attention to the printing of these editions extended also to their promotion, and on several occasions when he was abroad—especially in England and Japan—he would try to meet his child-readers as well as his publishers, much as he did in America. As an "ex-kid" who perhaps always knew himself to be one (many folks forget), Keats had a natural affinity for his chosen audience. People who

remember his incursions into their own childhood—kite flying, zoo visiting, photographing, dog walking—are united in their love for his easygoing, stimulating presence; and this presence is evident in the multiple records of his activity as a renowned public figure. ("He was nicer to his audience than anyone I'd ever seen," said Susan Hirschman in the introduction to a catalogue of her work as editor, which was to be exhibited in Japan.)

Such niceness, such obvious enjoyment of the eagerness and the debonair illogicalities of children, has caused some of his adult audience to wonder why he never had children of his own. This comes from an unexamined belief that the writers and illustrators of successful children's books are never happier than when they are down on the hearthrug romping with the subjects of their art. In whatever terms you choose to apply this, however—social, psychological, historical—no such generalization can hold. Some of the greatest or the most renowned figures in children's literature—H. C. Andersen, Edward Lear, "Lewis Carroll," Louisa May Alcott, to name but a few from the nineteenth century—wrote from an unmarried and childless state; some too are known to have adopted distinctly curious or even antagonistic attitudes towards children. What mattered to them would seem to be a need to explore their own childhoods or to express their own pleasure in the observation of children, and it was their good fortune that what they had to say appealed to the young. Thus it was with Keats. *My Dog Is Lost!* and *The Snowy Day* brought home to him a congruence that existed between children and himself as sharers in picture stories, and every book of his after that—even those that border on the factitious—communicated a complex of feelings about children and childhood: adult curiosity, expressive delight, and simple love.

The archive holds large quantities of material that show the reciprocal influences between himself and children beyond the fundamental craft of picture-book making. The most expansive coverage is of events like the Portland procession, for which amateur film exists as well as many photographs (0021 and 0131), and the birthday parties at Warrensville, Ohio, where photographic records and other memorabilia (0092) are supplemented by an affectionate correspondence with the library staff who set up and sustained the events. (There are also photographs and press coverage of the case of Tori Boyd, a girl from Shaker Heights who had met Keats at the Warrensville party. On June 13, 1973 she wrote:

One of what were said to be a thousand paper mice modelled for Keats' visit to Warrensville, Ohio in 1973.

deG 0119.01 #9

188

3987 Roseberry
Wichita, Ks. 67210
Sept. 1, 1982

Dear. Mr. Keats,

I have being reading your book that you wrote
Jenny's Hat 7 times and, I like the part that
Jenny put the pot of flower on her head.
Well, what book are you writing about and
now can you tell me what the name of your
book is and why did you want to write the
name of Jenny. Can you write a funny book
about a little mouse who lives in a birdhouse.
Do you know I like to read about mouse and
with some pitures too but not too many words
ok write it and don't froget to put the coilor
in it. I will see it maybe 20 times oor over.
Can you mail me the list of your books?

Your friend

ThuDung Nguyen

(Save
letter)

One of the many hundreds of letters written to Keats by children.

On Memorial Day I wanted to go to a pet show but they said no cats and dogs. I only have a cat. So I took a jar and coughed into it and now it is a germ. His name is Ralph. In one week there was my picture in the Sunpress. The way I got the idea was from the great Mr. Keats!!

Love,

Tori

PS. I won first prize for the most unusual pet. A doctor told me that Ralph eats cells.[15]

The pleasures of marbling paper.

deG 0119.09 #25

Life, for once, was copying art.)

Letters from children like Tori who encountered "the great Mr. Keats" either in person or through his books exist in abundance (0100-116). A lot have that rather depressing uniformity that comes from decisions made by class teachers or librarians to have the young write en masse to a famous person; many though have a genuine spontaneity and may include drawings, paintings, collages, or bits of marbled paper that have been created under the spell of his picture books. From time to time enthusiasm overtakes exactitude and—while there can only be hard thoughts for "Yeats" in a review—there is a certain charm about the child who wanted *Louie* by Essa Jackets or the letter for Mr. Ezra Keats Jackson.

One extended example may best show the care that Keats took over these exercises in public relations and the enjoyment—for everyone—that flowed from them. On February 22, 1973, Bettie DuPree, the librarian of Maple Avenue School, Burlington, North Carolina, wrote to Keats saying that she had long been fascinated with his books and that for two years running her fifth graders had been trying their hands at illustrating *John Henry*. Would Keats be willing to write a note to them with comments about his collages and other illustrations?

Keats did so, sending some materials as well, and the fifth graders decided to have a Keats Festival, doing lots of work on nine of his books. ("The library was chaotic for a while, but the results are well worth the confusion.") The school principal was so impressed with this that she put up the idea of a conference call, so that Keats and the children could at least meet over the telephone—and this conference call eventually led to Keats visiting the school and its district for two days. He brought films of his books; he went around every classroom, meeting as many children as wanted to talk to him; he

Sketch for a theatre poster
Pencil and colored pencil on paper
610 x 458 mm, 1983

The last work of Ezra Jack Keats.

Private collection

met local librarians; and "he had autograph sessions and the occasional nap."[16] The PTA even presented the school with a new rocking chair for the library, which sported an engraved plaque: "The Keats Rocker."

As happened on a number of other occasions, that visit did not end Keats' connection with Burlington. Maple Avenue School closed, but Keats maintained a friendship with Bettie DuPree and her family, whom he later visited, and her last letter to him was dated January 3, 1983.

Such friendships, such experiences in seeing how warmly his work was received by children, were surely the reception that gave Keats his profoundest satisfaction. The books were always a mixture of dour and exciting work. Some inevitably emerged truer to his hopes and intentions than others; but the knowledge that any part of the whole might stimulate creative responses "out there" made everything worthwhile. "I believe that children matter," he once wrote.[17] "More, I know that what the children of poverty have to say can, if heard, make some mark on this world. I know, because I and other members of my generation were children of poverty who had a chance to speak—and that chance made all the difference." Drawings, paintings, books, and a multitude of friendships—these are the testimony of one child who had the chance to speak.

APPENDIXES

Art: New Style

Reprinted from the *Jeffersonian* of Thomas Jefferson
High School, 1934?

The purpose of this article is to aid "The Society for the Abolition of Amazed Faces in Museums of Modern Art." Its aim is not to produce future art critics, but merely to change the present attitude toward this movement and mercifully rescue the museum attendants from hearing conversations like the following.

Standing before a painting of modern art, a gape-mouthed individual turns to his companion who looks no less amazed and philosophically exclaims: "Whatever this is supposed to be, it certainly doesn't look natural! And he calls himself an artist!" To which his comrade in distress answers that Smith's boy, who lives across the street, drew a picture of Tucker's baby last week that was "truer to life" than this.

The unfortunate attendant, who seems to be fated for some asylum, has heard this for the seventeenth time that day. The art "connoisseurs" laughingly trip away, pitying the poor painter who has such bad eyes. Little do they know that they have left a man in grey uniform in a greyer state of mind.

Had they looked upon the picture without prejudice and asked, "What did the artist try to say?" instead of being utterly disappointed at not seeing what they had expected, they might have seen a different picture. They are accustomed to pictures that were only technical and impersonal records of what the painter had seen—camera-like—with none of the artist's imagination included. In the picture they had just seen the imagination is supreme, not the eye. The artist had observed certain objects that excited him, and he wished to reproduce that feeling—not the object.

For example: he sees a tree blown in the wind; to him it appears as a mystic, bony hand; the moving branches, fingers grasping for something unseen, unearthly. He wishes to create this vision as he has experienced it. He has two alternatives: to paint the scene as it really exists, or to change or distort the branches of the tree so that

they suggest a hand. In the first, the spectator will merely see the same tree he saw before and will not experience any new reactions. In the second, the observer will see with the eyes and imagination of the artist. He will witness a new interpretation.

Of course there are people who will question whether branches really look that way. When they arrive at the decision that the poor artist did not know how trees look, away they go ridiculing and searching for a tree that really looks like one.

Painting everything we see without changing, selecting, and excluding—like the camera—is as useless as trying to play the piano by banging all the keys at once. The pianist selects some keys, excludes others, and blends them into a throbbing symphony. If he is an artist he will put that "certain something" into it; that is, he will stress certain keys in order to express himself. So it is with painting. The painter selects, changes, excludes, and stresses. The key-board is his palette; the keys, his colors. These he blends into powerful creations—expressions of his soul that sing his song forever.

Modernism stands for imagination, originality; not for scientific and anatomical recording. The expressionist disregards the object itself; it is the reaction to the object that counts. Of course, the picture may resemble the object, but that plays the same part as the plot in an opera. Its purpose is to provide an excuse to build beautiful songs around it. So it is with the objects that are painted. They serve only as motifs about which the artist may create burning symbols of beauty and philosophy, set fire to his imagination by that spark—the object.

He may utilize the object as another motif by using it as an excuse for a different form of distortion. He can change it so that the canvas becomes just a beautiful surface of rhythmic lines, splashes of color, curves, and patterns. Thus we find that in a picture called "A Bowl of Fruit" we cannot, search as we may, find any sign of fruit. The intention of the painter was not to represent a bowl of fruit but to select certain lines and colors that appealed to him and arrange them in such fashion as to get a magnificent harmony. These abstractions are created for the sheer beauty of line, form, color.

Therefore the artist may paint just for the charm the paint itself possesses, or for the ideas the distortions may help him express.

The distorted portrait is in reality a truer likeness than the careful academic one. It is not a surface likeness but something more; it delves deep into the soul of the sitter and reveals his character. It exaggerates various features in order to emphasize certain characteristics. We are no longer slaves to the eye. No longer do we see mere skin and bones.

194

Robert W. Chanler more than once had his millionaire sitters rush from the studio furious and amazed. Being more or less a psychologist, he would, when he got the notion, paint the man he saw behind that usually perfect mask commonly known as the face. On the canvas would be revealed the man's portrait, but certain features of the face were so changed that they suggested a sly fox or a grinning wolf leering out from the canvas. With these brilliant distortions he achieved a portrait that not only resembled the sitter but also revealed his character accurately. These pictures are not exact likenesses, but the sacrifice was worth while.

Albert P. Ryder, undoubtedly America's greatest painter, was constantly haunted by such mystical scenes as a frail boat tossed on a great expanse of sea and a lonely cloud drifting past the moon. In this way he expressed the insignificance of the soul, a thought which forever burned in his heart. In these unholy turmoils we cannot but be thrilled by the visions and philosophy of this truly great artist.

In these pictures the objects are so exaggerated that they do not conform to those we see. But what if the clouds are so elongated that they look like black brooding hearts; what if the sea becomes a boiling tempest and the moon's radiant beams softly clothe themselves about the scene as in a dream? The boat is tossed upon the sea like a pathetic lonely note in a rhapsody of color. We should, instead of searching for common reality, be grateful for being carried on the wings of imagination into this wondrous world.

The story is often told of the woman, who upon seeing a certain painting, exclaimed: "Why, I don't see the scene that way." To which the artist answered: "Don't you wish you could, madame?"

Only two simple factors are necessary in judging the average modern painting. What did the artist try to express? How well have the symbols or distortions succeeded? This does not include every picture. There are certain parasites that take advantage of this movement and paint anything that will astonish the public. These pictures are usually bought by the "patrons of art" because it is fashionable to do so.

The academicians, who claim that this "new fangled idea" is a failure because it does not follow the "rules", seem to forget that the old masters employed distortion as well, only not to so great an extent; that our modern environment has dulled our minds (therefore pictures that speak more abruptly "hit home" more readily); that art is like love —a very personal affair.

JACK KATZ

Ezra Jack Keats in London:

A Transcript of Part of His 1949 Letter to RB

14 Rue Stanislas
Paris VI, France

. . . During the past month I visited London, intending to stay for 2 days, to see some advertising people, but I found it so damn interesting I stayed a week. Unfortunately I had to leave a day or so before the Williams' got there . . . [paragraph on a Parisian meeting].

As for London—the old waterfront pubs and shops were so reminiscent of Whistler and Charles Dickens, it was really thrilling to see.

There were many and beautiful things—for instance, due to some chemical reaction of the exploding bombs on the blocks that were hit [during the war], great clusters of delicate little yellow flowers have sprung up among the craters some of which are a half block or a block in size. Sometimes you see half a building standing, a cross-section of rooms exposed, displaying such intimate evidence of the life of people now gone.

I had a memorable experience one sunny Sunday afternoon while walking past one of these buildings on Oxford St., one of the main avenues. There was gaiety in the air, red double-decker buses, girls in their summer dresses, peddlers hawking fruit and those big red, English strawberries—everyone was in a holiday mood. Suddenly I heard a sharp report! I turned and saw the door on the 3rd floor of this exposed building swinging open and shut by the wind. When I saw the wallpaper and a picture hanging lop-sided in the room, and all the aspects of the life once lived, the sound of the door slamming was a voice that gripped me and held me to remember— a voice mute and compelling and for a moment I could not move. Around me London was throbbing with sunlight and life.

Another aspect of the country tho, is revealed by the monuments, which I suddenly realized offers an interesting background. In contrast to Paris, where all the statues of horses and people looked as though they are winged and will fly away any minute —where nearly

all the monuments are to poets, composers, etc., in England they very often have just a statue of a cannon on the pedestal with no people—or some scowling Colonel/Trumpetblower with big mustachioes riding a horse that's stubbornly refusing to move —so (how's my drawing coming along?) his legs firmly planted in front of him and the ol' Colonel urging him on. This sort of statue appears so often it's amazing. I really think that the attitudes of the people who ordered the monuments—the rulers of colonies—had penetrated the thinking of the sculptors so that without being aware of it, the portrayal of the struggle between the horse and the Colonel, so often seen raging on pedestals, is the struggle between the rulers and the colonial people (the horse).

And the monuments to the war dead—even when these poor guys are dead, they're separated in spirit! "To the Officers, Warrant Officers, non-Commissioned Officers, and Enlisted Men of the King's Footmen and to the Officers, Warrant Officers, non-Commissioned Officers and Enlisted Men of the Queen's Footmen who fell—" instead of the inscriptions we are accustomed to seeing, "To the men of such and such regiment, etc.".

But I found the people to have a fine, jolly, jaunty spirit—they bounced back after a terrific struggle with the Nazis and have, as they put it—"tidied up the place". All evidence of bombing has been cleaned up and there seems to be a considerable amount of reconstruction—more than I've seen in France. I liked their humor too. . . .

The Full-Color Reproduction of Keats' Artwork

Keats' highly developed feeling for the nuances of color is evident throughout his picture books, from the kaleidoscopic collages of the early books to the dramatic painting in books like *Apt. 3* or *The King's Fountain* and the watercolor washes in *Maggie and the Pirate*. Like any illustrator in color, he was heavily dependent upon his printers for achieving as accurate a reproduction as possible of his intentions, but the variety and intensity of his work often set tough technical exercises for them.

The following account gives a simplified explanation of the main process that was used for preparing the color-work in most of his picture books. It is based upon his own description in the preparatory manuscript for "Where Do Ideas Come From?" (0087.01) but has been edited and expanded where necessary to give it greater clarity of detail:

Color separation is done by a separation department at, or associated with, the printers. The full-color artwork is place before a camera, which can be fitted with color filters so that film can be made of just one color at a time. The camera filters out all colors but yellow, all colors but blue, all colors but red, and all colors but black. These separations, when printed one on top of the other, will rebuild the original color image with a close resemblance to the artwork (or so one hopes).

What are known as progressive proofs are now made. The photographic images—a set for each color—are transferred to the printing plates, which are thin sheets of sensitized aluminum that can be wrapped around the "plate cylinders" of a lithographic press. The plate cylinder, as it revolves, will allow the appropriate colored ink to be transferred to the positive image on its surface; this inked image will in turn be transferred, in reverse, onto a "blanket cylinder" from which it is printed, as a positive, onto the paper, which rolls over an

"impression cylinder." In the final print run the paper will go on to further similar impressions that will print the additional colors.

The proof stage is important. The artist or the publisher's production manager will be able to see "pulls" of each single color, and also pulls of the colors as they are progressively added to each other—yellow, blue, red, and black (the blue and red are usually referred to as cyan and magenta). The black is generally printed last, with the typographic text, because the other colors, being semi-opaque, would diminish the power of the black if they followed it.

The artist compares these proofs with the original artwork, examining them carefully. It's never really perfect the first time —there may be too much red showing up, say, or not enough blue —and the proof-sheet is marked so that the printer can make corrections to the gradations of each color. A second set of proofs will usually be made based on these corrections and the final plates for the print run can then be prepared. Minor corrections can also be made while the sheets are being printed by adjusting the flow of ink on the plate cylinder. You use your final approved second proof, which is closest to what you want, as a guide and you ensure that the ink-flow is correct. Sometimes accidents occur to the balance of inking in the press and you realize that it is giving you an improvement over what you had decided upon before. So you let it run that way.

Modern "web-fed" presses will print a whole picture book on both sides of a single sheet of paper—part of a gigantic roll. This means that the pages printed on the sheet will have to be so juxtaposed that, when the sheet is cut and folded they will appear in the right order. The jacket is also usually included on the sheet, so when it finally comes off the press it looks like a crazy quilt. I like to keep samples of these "press sheets" to give to schools or libraries that appreciate my work.

Some Notes on Marbling and Collage

Treating paper so that its surface takes on the eccentric patterning and veining of polished marble is an ancient craft. So far as we can tell, it has its beginnings (like so much else) in China, where paper may have been so decorated about a thousand years ago. From China the art travelled westward, and when it first came to be practiced in Germany at the beginning of the seventeenth century it was viewed as a "Turkish" or "Persian" invention. Once taken up in Europe it gained ready favor and by 1655 marblers were at work in England, making decorated papers for a variety of domestic and trade purposes, including bookbinding.

From surviving evidence, marbling was also used, both in the East and the West, for making decorative pictures. Various "stopping-out" and stencilling processes were used so that the patterning could appear to be the mottling of a horse's coat or the formal design of a lady's dress. Such a use was, naturally, a one-shot process, and its effects depended on the way in which the surface of the paper was worked rather than on the scissor-cutting of wished-for shapes. Nevertheless, the practice demonstrated an early appreciation of the pictorial possibilities of marbled paper.

By a happy accident, one of the first appearances of collage as part of a work of literature also involved the use of marbled paper—making up one of the ingenious jokes Laurence Sterne introduced into his comic masterpiece *Tristram Shandy* (in volume III, chapter xxxvi, 1761). Tristram is aghast that the reader may not know who "Tickletoby's mare" was and he urges reading as a remedy: "For without *much reading*, by which your reverence knows, I mean *much knowledge*, you will no more be able to penetrate the moral of the next marbled page (motley emblem of my work!) than the world with all its sagacity has be able to unravel the many opinions, transactions and truths . . . hid under the dark side of the black one." The last reference is to a black leaf inserted in volume I, dividing chapter xii

from chapter xiii, symbolizing the death of Parson Yorick, and this is matched by the piece of inserted marbled paper, which is the subject of Tristram's further rumination.

Sterne was hardly a trend-setter for games like this, and although there were a number of ingenious graphic devices used in picture books during the early nineteenth century, it was left to the Victorians to make the most dramatic use of collage. During the busy 1860s in England, London publishers such as Thomas Dean and Frederick Warne introduced true collages into a number of children's books, such as *Rose Merton, the Little Orphan,* where patterned fabrics were actually pasted on to the printed illustrations.

None of this japery is likely to have come the way of Ezra Jack Keats, whose interest in collage was inspired chiefly by the cubist and surrealist experiments undertaken by artists like Picasso and Braque, and especially by Kurt Schwitters, whom he praises in his *Publishers Weekly* article, "Collage as an Illustrative Medium." (Even these had precursors, however, in the trompe l'oeil painters of earlier centuries and in more recent experimentation. The English poster designers, the Beggarstaff Brothers—William Nicholson and James Pryde—had put together a huge collage picture of *Children Playing* as early as 1895.)

Where illustrated books were concerned, there was no longer any likelihood of collage being incorporated in the pages "raw" as the Victorians had done and it now came to form part of the illustrator's composition, to be photographed for reproduction like any standard piece of color-work. Art-deco illustrators were attracted to the idea in the thirties, an early example of the use of cut-paper collage in a children's book being Esphyr Slobodkina's illustrations for Margaret Wise Brown's *the little fireman,* which was published by the innovative William R. Scott in 1938. (Many years later Slobodkina was to create a massive collage mural, introducing characters from her own books, to decorate one wall in the Cook Library building at the University of Southern Mississippi.) When Keats produced *The Snowy Day* in 1962 there were already a number of examples of postwar collagists at work in children's books—most notably perhaps Paul Rand with *Sparkle and Spin,* with its subpoetic text by Ann Rand, 1957.

Most modern illustrators use collage as a kind of decorative extra, a playful graphic ploy not integral to whatever narrative or literary purpose their books possessed. Keats however—to his own surprise, as he claimed—found that he was using collage as part of an armory of resources to win him the natural effects that he wanted in his

realistic stories. Where other illustrators, like Leo Lionni in America or Maureen Roffey in England, tended to rely on designing with cut colored paper, he (like Schwitters) called upon a wide range of materials, and this gave him greater versatility in organizing the detail in his pictures. *The Snowy Day* contains examples of cut or torn colored paper, cut white paper with painted additions, patterned fabric, wood-grain paper (perhaps produced by Keats with wax crayons), paper textured with shredded lint, Japanese paper, marbled paper, and, of course, the Belgian canvas that he often wrote or spoke about, since he surprised the retailer by buying about an inch of the stuff from a huge roll.

We do not know what first drew Keats to paper marbling—perhaps an experiment in the course of his work on book-jacket design—but the opportunity to improvise with color patterns must have had a natural appeal for him, and he enjoyed the process for most of the rest of his life. Part of the Weston Woods "Signature Collection" film shows him at his marbling-bath—swirling paints onto the surface of the water and pulling a print with accustomed ease, which may have been deceptive for the many teachers and their pupils who set out to follow his example. Although craft marbling has always had something of a medieval "mystery" about it, with its own secret dodges, and with much stress now on sophisticated attention to sizing the water, controlling temperature, etc., Keats appears to have worked in a far more cavalier fashion. How successful the results were as adjuncts to picture stories might well depend on how they were linked to other graphic media; but seen simply as marbled patterns they were often stunning.

Books Illustrated by Ezra Jack Keats

The following lists provide a short-form entry for all the books in whose illustrations Ezra Jack Keats was involved. The first section lists those books that he wrote or edited himself, the second those that he illustrated for other authors or compilers. Both lists are arranged chronologically (and alphabetically by title where more than one publication occurs within a single year); place of publication is New York, or Garden City, unless otherwise stated, and London publication dates have been added for titles subsequently published in the United Kingdom.

BOOKS WITH TEXTS BY, OR EDITED BY, EZRA JACK KEATS

1960 *My Dog Is Lost!* [with Pat Cherr]. Thomas Y. Crowell

1962 *The Snowy Day.* The Viking Press (UK ed. London: The Bodley Head, 1967)

1964 *Whistle for Willie.* The Viking Press (UK ed. London: The Bodley Head, 1966)

1965 *John Henry: an American Legend.* Pantheon Books

1966 *God Is in the Mountain.* Holt, Rinehart & Winston

 Jennie's Hat. Harper & Row

1967 *Peter's Chair.* Harper & Row (UK ed. London: The Bodley Head, 1968)

1968 *A Letter to Amy.* Harper & Row (UK ed. London: The Bodley Head, 1969)

1969 *Goggles!* Macmillan (UK ed. London: The Bodley Head, 1970)

 Night [with the photographer Beverly Hall]. Atheneum

1970 *Hi, Cat!* Macmillan (UK ed. London: The Bodley Head, 1971)

1971 *Apt. 3.* Macmillan (UK ed. London: Hamish Hamilton, 1972)

1972 *Pet Show!* Macmillan (UK ed. London: Hamish Hamilton, 1972)

1973 *Pssst! Doggie.* Franklin Watts

Skates. Franklin Watts

1974 *Dreams.* Macmillan (UK ed. London: Hamish Hamilton, 1974)

Kitten for a Day. Franklin Watts

1975 *Louie.* Greenwillow (UK ed. London: Hamish Hamilton, 1976)

1978 *The Trip.* Greenwillow (UK ed. London: Hamish Hamilton, 1978)

1979 *Maggie and the Pirate.* Four Winds Press

1980 *Louie's Search.* Four Winds Press

1981 *Regards to the Man in the Moon.* Four Winds Press

1982 *Clementina's Cactus.* The Viking Press (UK ed. London: Methuen, 1983)

BOOKS BY, OR COMPILED BY, OTHER AUTHORS, ILLUSTRATED BY EZRA JACK KEATS

1954 *Jubilant for Sure,* by E. H. Lansing. Thomas Y. Crowell [here listed first as Keats' first commissioned book]

Animal Stories: Tales of the Old Plantation, by Joel Chandler Harris. [Doubleday] Junior Deluxe Editions

Chester, by Eleanor Clymer. Dodd, Mead

1955 *Mystery on the Isle of Skye,* by Phyllis A. Whitney. Philadelphia: Westminster Press

The Peterkin Papers, by Lucretia Hale. [Doubleday] Junior Deluxe Editions

Wonder Tales of Dogs and Cats, compiled by Frances Carpenter. Doubleday

1956 *A Change of Climate,* by Jay Williams. Random House

Danny Dunn and the Anti-Gravity Paint, by Jay Williams and Raymond Abrashkin. Whittlesey House (UK ed. Leicester: Brockhampton Press, 1959)

Sure Thing for Shep, by E. H. Lansing. Thomas Y. Crowell

Three Young Kings, by George Sumner Albee. Franklin Watts

1957 *Danny Dunn on a Desert Island,* by Jay Williams and Raymond Abrashkin. Whittlesey House

The Indians Knew, by Tillie S. Pine. Whittlesey House

Little Hawk and the Free Horses, by Glenn Balch. Thomas Y. Crowell

Panoramas, ed. by William S. Gray et al. Chicago: Scott, Foresman

The Pilgrims Knew, by Tillie S. Pine and Joseph Levine. Whittlesey House

Song of the River, by Billy Clark. Thomas Y. Crowell

Wee Joseph, by William MacKellar. Whittlesey House

1958 *The Chinese Knew,* by Tillie S. Pine and Joseph Levine. Whittlesey House

Danny Dunn and the Homework Machine, by Jay Williams and Raymond Abrashkin. Whittlesey House (UK ed. Leicester: Brockhampton Press, 1960)

1959 *And Long Remember: Some Great Americans Who Have Helped Me,* by Dorothy Canfield Fisher. Whittlesey House

The Brave Riders, by Glenn Balch. Thomas Y. Crowell

Danny Dunn and the Weather Machine, by Jay Williams and Raymond Abrashkin. Whittlesey House

The First Easter, by Henry Denker. Thomas Y. Crowell

1960 *Grasses,* by Irmengarde Eberle. Henry Z. Walck

Nihal, by Eleanor Murphey. Thomas Y. Crowell

The Peg-Legged Pirate of Sulu, by Cora Cheney. Alfred A. Knopf

The Tournament of the Lions, by Jay Williams. Henry Z. Walck

1961 *Desmond's First Case,* by Herbert Best. The Viking Press

Felipe's Long Journey, by Edna Jennings Sorensen. Franklin Watts

A Flood in Still River, by Bianca Bradbury. Dial Press

In the Night, by Paul Showers. Thomas Y. Crowell (UK ed. London: A. & C. Black)

Krishna and the White Elephants, by Ruth Philpott Collins. Henry Z. Walck

Three Children of Chile, by Ella Huff Kepple. Friendship Press

1962 *Apple Orchard,* by Irmengarde Eberle. Henry Z. Walck

The Eskimos Knew, by Tillie S. Pine and Joseph Levine. Whittlesey House

How Animals Sleep (A Time for Sleep), by Millicent Selsam. Scholastic Book Services

The Rice Bowl Pet, by Patricia Miles Martin. Thomas Y. Crowell

The Time of the Wolves, by Verne T. Davis. William Morrow & Co.

What Good Is a Tail? by Solveig Paulson Russell. Indianapolis: The Bobbs-Merrill Co.

1963 *The Buffalo and the Bell,* by Myra Scovel. Friendship Press

Farm Dog, by David Malcolmson. Boston: Little, Brown

The Flying Cow, by Ruth Philpott Collins. Henry Z. Walck

The Gobbler Called, by Verne T. Davis. William Morrow & Co.

Hawaii, by Juliet Morgan Swenson. Holt, Rinehart & Winston

How to Be a Nature Detective, by Millicent Selsam. Scholastic Book Services

Jim Can Swim, by Helen D. Olds. Alfred A. Knopf

Our Rice Village in Cambodia, by Ruth Tooze. The Viking Press

Tia Maria's Garden, by Ann Nolan Clark. The Viking Press

1964 *The Egyptians Knew,* by Tillie S. Pine and Joseph Levine. Whittlesey House

Indian Two Feet and His Horse, by Margaret Friskey. Scholastic Book Services

Speedy Digs Downside Up, by Maxine W. Kumin. G. P. Putnam's Sons

Tres Casas, Tres Familias, by Edna Beiler. Friendship Press

Zoo Where Are You? by Ann McGovern. Harper & Row

1965 *In a Spring Garden,* ed. by Richard Lewis. Dial Press

The Naughty Boy, by John Keats. The Viking Press (UK ed. London: Whiting & Wheaton, 1966)

1968 *In the Park: An Excursion in Four Languages,* by Esther Hautzig. Macmillan (UK ed. London: Collier-Macmillan, 1968)

The Little Drummer Boy, by Katherine Davis et al. Macmillan (UK ed. London: The Bodley Head, 1969)

1971 *The King's Fountain,* by Lloyd Alexander. E. P. Dutton

Over in the Meadow, by Olive A. Wadsworth. Four Winds Press (UK ed. London: Hamish Hamilton, 1973)

Two Tickets to Freedom: The True Story of Ellen and William Craft, Fugitive Slaves, by Florence B. Freedman. Simon & Schuster

1972 *Penny Tunes and Princesses,* by Myron Levoy. Harper & Row

Notes

PREFACE

1. During the time that this study was being written, a long-term project was in progress, funded by the National Endowment for the Humanities, to create a precisely detailed catalog of all the manuscripts and drawings in the collection.

2. The Ezra Jack Keats Foundation had been inaugurated on April 21, 1964, with Keats himself as president, Martin Pope as secretary, and David Epstein as one of the directors. Little of consequence occurred in the foundation during Keats' lifetime, but at his death, by the terms of his will, the foundation became the repository for his copyrights and the recipient of royalties. On October 27, 1983, Martin Pope was elected president of the foundation and from that time on he has ensured that the foundation has continued to keep the artist's work as a "living experience," while directing royalty income to many causes related to children and children's books. Among these are the UNICEF-Ezra Jack Keats International Award for children's-book illustration, the Ezra Jack Keats New Writer Award, administered by the New York Public Library, and the New York City Board of Education awards to children for creative book-making. There is a lectureship at the University of Southern Mississippi, an annual program at the Library of Congress, a fellowship at the University of Minnesota, and an Ezra Jack Keats Bookmobile in Jerusalem. In 1984, Martin Pope contributed Keats' papers and correspondence to the de Grummond Collection as a first step towards establishing the Keats Archive.

3. I dwell on this a little more fully in my introduction to *Ezra Jack Keats: A Bibliography and Catalogue.*

4. In the course of referring to individual pieces in the Keats archive at Hattiesburg, catalogue numbers of the items in question have been added in parentheses. These numbers correspond to those assigned in the *Catalogue* following the present volume.

CHAPTER ONE

1. An elaborate certificate exists commending Benjamin Katz as a "live-wire" salesman of the month.

2. Autobiography manuscript 0075.01, 30.

3. Hard times after the Wall Street Crash (if not before) were felt by most members of the East New York community: a dreadful equality of deprivation. Nevertheless, there was a sense of togetherness in this crowded neighborhood, felt among the children playing together—even in the child-wars that smoldered between one territory and another. Martin Pope recalls the hot days of summer when the children would gather on a roof or fire escape and look across Brooklyn to the Empire State Building on Manhattan, or watch the birds flying from the Highland Park reservoir to Jamaica Bay. He also records that Jack's mother "was famous among the children of the neighborhood for her lemonade and her cookies" and that the kitchen in the Dumont tenement was a place of pilgrimage "particularly on hot days." An unresolved question remains over Benjamin Katz's descent to the Coffee Pot. At one time, apparently, he set up a restaurant with a friend (a photograph exists of them standing in a superior-looking kitchen) and a suggestion has been made that Benjamin dropped out of the enterprise while the friend moved on up.

4. Autobiography manuscript 0087.14, 3.

5. Ibid., 0075.01, 23.

6. Keats was fairly obsessed by his own past and made numerous attempts to come to grips with it: through written drafts and taped interviews. The Keats Collection at USM holds much of this material, which often repeats or offers varied versions of individual events. See the calendar in the *Catalogue* relating to Keats' autobiography material for a full listing of USM holdings.

7. Autobiography manuscript 0075.01, 26.

8. Ibid., 0071.22, 3.

9. Ibid., 0075.01, 8.

10. For a published example of a typical incident, whose telling was by no means confined to Lee Bennett Hopkins, see his short introduction to the selection from Keats' memoirs, "From 'Collage,'" *The Lion and the Unicorn* 13, no. 2 (December 1989): 56.

208

11. These anecdotes are now well known; see for instance the selection "From 'Collage'" noted immediately above, and the essay by Esther Hautzig in *The Horn Book* 39, no. 4 (August 1963): 364-68.

12. Autobiography manuscript 0074.23, 6.

13. *Red and White* 16, no. 2 (May 1934): 1.

14. In correspondence file: Smith, Al.

15. Ezra Jack Keats, "Ezra Jack Keats Remembers: Discovering the Library," *Teacher* (December 1976): 41.

16. *Liberty Bell* 21, no. 3 (October 26, 1934).

17. Ibid.

18. Maggie ("Jiggs") Choy's letter from Honolulu is preserved in the correspondence files, but despite its importunate tone it does not seem to have been answered. Sobel's letter to Lieberman, with the latter's manuscript note introducing Jack Katz, is also in the correspondence.

19. Florence Freedman, personal communication.

20. Florence Freedman's recollections of this early period first appeared in *Elementary English* 46, no. 1 (January 1969): 56.

21. Autobiography manuscript 0074.23, 46.

22. One of Keats' accounts of the incidents surrounding this portrait is given in "From 'Collage,'" 64-67.

23. Autobiography manuscript 0070.23, 6, and 0075.01, 11.

24. Autobiography manuscript 0075.01, 24. Keats appears here to have telescoped two events: leaving home for Elm Avenue and a later move to Greenwich Village. Further uncertainty exists over his movements during this period, since there are discrepancies between archive documents and the recollections of friends. Keats may have lived at Dumont Avenue during much of this time, and he may have worked as a cartoonist before, as well as after, the WPA project.

25. Autobiography manuscript 0075.01, 14.

26. Ibid., 0087.14, 1.

27. Ibid., 0075.01, 16.

28. Personal communication.

29. Transcript of an interview with Jean Reynolds of Franklin Watts (about book production) 0087.04, 18.

30. Autobiography manuscript 0075.02, 1-2; lightly edited.

31. Ibid., 3-5; lightly edited.

32. Ibid., 19.

33. Autobiography manuscript 0087.14, 1.

34. Untitled sketch sequence 0141.07.

35. VA papers at 0078.12.

36. Autobiography manuscript 0075.01, 17.

37. Mae has only a marginal place in this biographical summary but that should not be allowed to obscure her crucial role in caring for Gussie and in being the anchor man in matters of family business. Furthermore, Martin Pope records that "she was a fine artist who excelled in clay modelling and small sculptures." Some of her paintings and clay models, and some of the paintings that Gussie herself did late in life, are in possession of Millie and Bonnie Keats, sister-in-law and niece of Keats. Examination of these confirms Pope's judgment and also the hereditary element in Keats' own genius.

38. AAF Personal Affairs statement 0078.12, July 11, 1945.

39. Autobiography manuscript 0074.25, 47.

40. Journal entry, in file with RB correspondence.

41. Autobiography manuscript 0087.14, 3.

42. RB correspondence; letter dated April 22.

43. Translation: "The only institution with a world reputation which, in contrast to the Ecole des Beaux-Arts and to official art education, takes account of the divergent aims of Independent Art, which has been the glory of France since the beginning of this century." From the prospectus 0079.05.

44. Jay Williams, *A Change of Climate* (New York: Random House, 1956), 51-53, 203-14.

45. Ibid., 212.

46. RB correspondence; undated letter ca. early August, 2ff.

47. Personal communication.

48. RB correspondence; undated letter, mid-June, 1. This letter contains some perceptive observations on postwar London, which have been transcribed in the appendixes.

49. Certificates at 0079.06.

50. VA papers at 0078.12.

51. Correspondence: Cox and Campbell.

52. Correspondence: Eaton Paper Corporation.

53. Correspondence: Williams, Jay, undated.

54. Correspondence: Cleland, January 27, 1952. The subject was not closed for good though. Twenty-eight years later Mrs. Cleland (now Mrs. Proffitt), who worked for a local paper, read Keats' name in an article and wrote to inquire if this famous author was the same person who had painted her landscape. Keats replied, and she was "astounded" that he recalled the hotel in New York where she and Mr. Cleland had stayed when they bought the picture.

55. Tear sheet "at the Pierre" (September 1952), with photograph showing Keats and a Parisian scene, 0086.01.

56. Correspondence: Mandel, August 13, 1952, and later letters. On Keats' tax return for 1953, the first full year of the agency, he showed an income of $3,520.75 from Estelle Mandel (plus $300 from the Workshop School), but by 1956, after the arrangement became non-contractual, he claimed that she was finding him very little work.

57. Autobiography manuscript 0073.06, 20-21, where he describes working through the night at his jacket painting. Nowhere is the book title given, but the only Sackville-West book published that year by Doubleday was *The Easter Party*. No copy with a jacket has yet been found to verify Keats' recollection.

58. Ibid., 0075.01, 28.

59. Ibid., 0073.06, 22-23.

60. Correspondence: McCain.

61. Correspondence: Scott, Foresman. *Panoramas* is more fully discussed in *Ezra Jack Keats: A Bibliography and Catalogue.*

62. Personal communication.

63. Autobiography manuscript 0073.06, 14. Mira Rothenberg is of the opinion that he was Italian, not Puerto Rican.

64. Pat Cherr is not well known as a writer for children and her contribution to *My Dog Is Lost!* is not easy to establish. Esther Hautzig, who worked as publishing manager for Crowell at this time and who became one of Keats' dearest friends, has said that the value of her presence was to give him confidence. "He was the bricks; she was the mortar." (Personal communication.)

65. Autobiography manuscript 0071.22, 70-71.

66. Ibid., 71.

67. Personal communication.

68. Correspondence: Crowell, May 22, 1967.

69. Personal communication.

70. Florence Freedman, ed., "Tea and Talk" (New York: Hunter College, 1965), 1. Tape transcript. See n. 91 below. Keats made several other references to this discovery of Peter's growth, which was made simultaneously by Peter and himself.

71. Autobiography manuscript 0071.22, 68.

72. Ibid., 72-74.

73. Correspondence: Gagliardo, July 26, 1963.

74. Correspondence: Szelich, undated (October 1976).

75. Correspondence: Warrensville, December 27, 1973.

76. Ibid., Keats letter dated March 12, 1974. He visited Warrensville again for his birthday in 1975 and, later that year, entertained Eula Lane and her colleagues when they visited Manhattan. And not long before his death he visited Maggie Duff, who had been a puppeteer at the library and had moved to Colorado. By way of gratitude for the stay he sent her a copy of *Clementina's Cactus*.

77. Correspondence: Kaisei-sha, June 6, 1979.

78. Correspondence: Weston Woods, undated newssheet (1968) on the company's new form of standard contract. A fuller discussion of Keats' involvement is given in chapter eight.

79. 0094.02, letter from Hagir Daryouche, the executive secretary.

80. Daniel Posnansky, associate librarian, letter dated July 18, 1975.

81. International publication gave splendid opportunities for tax-deductible trips to Europe as well. Keats made several visits to Scan-

dinavia, where his picture books were particularly well received, and on one occasion he went to Athens to discuss a possible Greek translation.

82. Correspondence: Kaisei-sha, January 9, 1969.

83. *Publishers Weekly* 204, no. 3 (July 16, 1973), 56.

84. From 0099.01, part of an extensive file on Akira Ishida.

85. Esther Hautzig, personal communication.

86. The collection at USM includes seventeen boxes of these. The complaint to the publisher is in the Viking correspondence, June 3, 1969.

87. Quoted by Keats in a Four Winds Press handout.

88. Correspondence: Spellman.

89. Correspondence: Simon & Schuster, January 14, 1983 and the Bodley Head, July 2, and July 16, 1968. In her working diary for June 1968, Judy Taylor notes: "Keats is most anxious to do two board books for us and we discussed this at some length. He feels that one on insects would have an interesting appeal and perhaps another on children's playthings (i.e. tricycles, scooters and so on). What I have suggested is that he send us a dummy incorporating his ideas. . . ."

90. Archive: uncataloged.

91. A typescript exists of nineteen of these meetings, retranscribed from tapes, including that with Keats on November 3, 1965 (also preserved on the tape). Archive: uncataloged.

92. Correspondence: Moser and Henkin, August 3, 1982.

93. RB correspondence; letter dated December 12, 1982. The visit probably occurred at the time when he also called on Maggie Duff in Colorado. *Brothers: A Hebrew Legend,* retold by Florence Freedman, was published by Harper & Row in 1985 with Robert Andrew Parker as illustrator.

CHAPTER THREE

1. 0087.14, 1. Transcript of an interview, probably with Florence Freedman.

2. Keats recounted this incident several times. This quotation comes from a Four Winds Press brochure.

3. Dean Engel also recalls the vitality of his perceptions, which could turn a simple walk through the streets of Manhattan into a visual adventure.

4. See "My Life in Crime" in "From 'Collage,'" 58-59.

5. As noted before, an unknown number of paintings from this period may have been destroyed by Keats himself.

6. Freedman mentioned the stillness of some cityscapes in conversation. She also recalled in her dialogue with Keats (0087.14) that his Parisian scenes were also empty of people and that he painted in some figures to please her.

7. The whole essay is reprinted here in the appendixes.

8. Autobiography manuscript 0075.06, 10-11.

9. He described himself this way on the form for the VA ca. 1950 requesting a study grant.

CHAPTER FOUR

1. Autobiography manuscript 0073.01, 21.

2. Although he must have been talented in media such as woodcut and linocut, the discipline may not have appealed to him. He is said to have studied wood engraving under Frasconi and the Christmas card illustrated here is attractive.

3. The watercolors are still in Rothenberg's possession.

4. Observation of Keats' commissioned work is hampered by the absence of examples dating back to these early years. One or two drawings survive for *Jubilant* (0141.11) and for some of the other books, but most of his drawings were probably kept—and disposed of?—by his publishers.

5. It would be tedious to comment here on Keats' work for all his commissioned books. Individual notes have been given in the bibliography in *Ezra Jack Keats: A Bibliography and Catalogue.*

6. One of the most famous illustrative blunders was by Ernest Shepard in a drawing for chapter two of *The Wind in the Willows* where he had Rat rather than Mole sculling the boat. And while this chapter was being written I was reading a new book, *Is* by Joan Aiken, where her normally impeccable illustrator, Pat Marriott, makes an error very similar to one that Keats made in *Song of the River.*

7. A good account of the building up of a complex four-color illustration by color separation is given by Adrienne Adams in Lee Kingman et al., eds., *Illustrators of Children's Books: 1957-1966,* vol. 3 (Boston: The Horn Book, 1967), 28-35.

CHAPTER FIVE

1. Brinton Turkle, "Confessions of a Leprechaun," *Publishers Weekly* 196, no. 2 (July 1969): 135-36.

2. Conversation with Fran Manushkin.

3. Work on this project was undertaken with Jean Reynolds, editor at Franklin Watts. Although nothing eventuated, the archive contains a cassette tape, various transcriptions of conversations, and other drafts showing work in progress (0087.01-13).

4. Conversation with Esther Hautzig, and a typescript on the origins of *Louie* prepared for Weston Woods (0033.08).

5. "After *The Snowy Day,* I thought I might do a happy day, a sad day, etc. One of my friends suggested this. I frightened my editor. She turned pale. . . ." "Tea and Talk" interview with Florence Freedman, 189.

6. "Where Do Ideas Come From?" (0087.01), transcript 5-6.

7. Ibid., 9.

8. Ibid., 8.

9. Ibid., 6.

10. Ezra Jack Keats, "Collage as an Illustrative Medium," *Publishers Weekly* 189, no. 14 (April 1966): 95.

11. Deterioration of quality (or even failure from the outset to meet artists' standards) has always complicated the critical assessment of color-printed work, and is often prevalent once an artist, or his agent, ceases to oversee proofs. In past times, failure of register and inadequate color control and inking often vitiated illustrations printed from wood or from lithographic stones. More recently, the dispersal of originals by artists such as Arthur Rackham, who worked for the camera, has resulted in illustrations being re-originated from the printed half-tones rather than from the artist's watercolors, so that clear tints and shades were regularly muddied.

CHAPTER SIX

1. I have tried to argue this point in some detail through the handbooks accompanying two exhibitions in England, *Looking at Picture Books* (London, 1973) and *Sing a Song for Sixpence: Randolph Caldecott and the Art of the English Picture Book* (Cambridge, for the British Library, 1986).

2. Charles Keeping was a prolific illustrator whose career ran from 1953 up to his all-too-early death in 1988. An almost complete listing of his work is given by Douglas Martin at the end of his brief essay on Keeping in *The Telling Line: Essays on 15 Contemporary Book Illustrators* (New York: Delacorte, 1989), and this is expanded in a longer study, *Charles Keeping,* also by Martin (1993).

3. Quoted in "The Poetry of Ezra Jack Keats," a sales brochure put out by Weston Woods in 1978.

4. Annis Duff, "Ezra Jack Keats: 1963 Caldecott Medal Winner for *The Snowy Day,*" *Library Journal* 88, no. 3 (March 15, 1963): 1293.

5. *The Horn Book* 39, no. 1 (February 1963): 51.

6. Autobiography manuscript 0075.01.

7. It certainly tested his publishers. The correspondence files indicate that he was worried about the reaction of his American editor, while in Britain the book caused some consternation at his regular publisher, the Bodley Head. Judy Taylor could see no way of recouping the expense of issuing this potentially "difficult" picture book, and it was eventually taken on by Julia MacRae at Hamish Hamilton, whose enthusiasm touched the author. Many of his subsequent books were published in England by her.

8. Complementary accounts of this occur in the Weston Woods brochure, cited above, and in the typescript of his "Tea and Talk" interview with Florence Freedman, 190.

9. Correspondence: Shaw, Spencer, July 25, 1971.

10. Some earnest analyses of the implications here have been published by Joseph Schwarcz in his *The Picture Book Comes of Age* and by W. Nikola-Lisa in a series of essays.

11. Essay draft for "Where Do Ideas Come From?" (0087.02), 3.

12. Ibid., 4.

13. A discursive background note on these graphic devices has been given in the appendixes.

14. "Collage as an Illustrative Medium," 94.

15. An instructive contrast can be made with another master of cut-paper collage, Leo Lionni. When he selects a simple *fabliau* like *Inch by Inch* (1960) his elegant designs carry both wit and visual delight; but in his longer, sometimes verbose, picture stories, like *Nicolas, Where Have You Been?* (1987), much of the collage is routine and tedium is only held at bay by Lionni's uncanny gift for getting expression into the black-dot eyes of sundry mice and birds.

CHAPTER SEVEN

1. "Tea and Talk" interview with Florence Freedman, 193.

2. Complimentary copies were sent to several (John) Keats scholars, and letters of appreciation turned up from Walter Jackson Bate, Aileen Ward, and the editor of the Keats-Shelley Memorial Association Bulletin (correspondence: Bate, Hewlett, Ward).

3. The Ezra Jack Keats Foundation possesses some graphs that Keats kept to show the relative success of a number of his books during their early life in print. These were apparently based on royalty statements and all, naturally, reach their highest point with the trade subscription orders at publication or soon after, when news of the book has spread. (*Goggles!* jumps from 14,000 copies on publication to 19,000 copies at the next statement—presumably as a Caldecott Honor Book.) On these charts *The Little Drummer Boy* far outstrips any other title at publication, achieving a first sale of some 38,000 copies. *The Snowy Day,* its nearest rival, had a first sale of 27,000 copies; *In the Park* (1968), the picture book exploring simple terms in other languages, on which he collaborated with Esther Hautzig, did not quite achieve a subscription of 4,000 copies.

4. However, Jim Comstock, proprietor of *West Virginia Hillbilly,* wrote on July 6, 1966 that he was "strong for things like new books on John Henry." He had tipped the state governor off on Keats "and he will be putting the touch to you for one of your . . . drawings." He did too, and Keats was "honored" to send the painting for the jacket, which could most easily be spared should the artwork ever be called upon for re-origination (correspondence: Comstock, and West Virginia).

5. Some of Singer's letters to Keats are in the archive (not directly about *Elijah,* but in October 1971 he hopes that they will be able to have lunch and talk "like in the good old times"). In 1978 he writes: "I still hope that we will make a book together."

6. Edited transcript of a telephone conversation with Lloyd Alexander, subsequently checked and approved by him.

7. The loss, of course, was Singer's and Farrar, Straus's. *Elijah the Slave* was published in 1970 with strong, formal, quasimedieval illustrations by Antonio Frasconi (Keats' old teacher), but they have none of the vibrancy of the work that Keats would have done.

8. Correspondence: Buller, May 10, 1975.

9. The immediate cause of the rift was a mistake in a Greenwillow agreement licensing Scholastic to publish a paperback edition of *The Trip*. Greenwillow had failed to include a time stipulation, preventing paperback publication before the hardback had had a fair run. The matter was resolved, but Keats left nonetheless.

10. I am grateful to Betsy Hass for letting me see some of the material in her possession relating to this project.

CHAPTER EIGHT

1. The portfolio was sold separately under the title "Nursery Animals" and Harper put out a four-page "Note from the Artist" about the pictures, in which he writes about his use of "found" and "made" materials in collages (0087.21).

2. The archive has a "Happy Halloween" poster advertising Scholastic's publication of *The Trip*, for which Keats was paid $6,000, and correspondence shows that he also did a "See-Saw Number Chart" ($1,200 with a subsequent royalty on sales of three cents a copy), a "Mother Goose Wall Frieze" ($2,000 advance against royalties), and a poster and card based on *The Little Drummer Boy*, which the company used for its Christmas greeting in 1977.

3. Correspondence: Watts, January 12, 1972.

4. John H. Niemeyer, "Reading Interest Films," *Education Leadership* 23, no. 6 (March 1966), 0088.09. A copy of the Bank Street film of *Whistle for Willie* has been donated to the Keats archive by Ms. Dona Helmer.

5. Printed on the inner front cover of a publicity brochure: "Storytelling in the Audiovisual Media: A Thirty-Year Retrospective" (Weston Woods, 1986).

6. Manuscript note by Nordstrom at the head of a letter, copied to Keats, which was part of some slightly acrimonious negotiations over audiovisual rights to *Peter's Chair* (correspondence: Harper, June 16, 1970).

7. A cogent and systematic account of the critical issues involved here is given by Adele Fasick in "Weston Woods Films as Interpretations of Literature," *Children's Literature Association Quarterly* 7, no. 3 (Fall 1982): 20-22.

8. Correspondence: Macmillan, April 5, 1968.

9. Correspondence: Weston Woods, December 9, 1968.

10. Ibid., December 30, 1968.

11. Schindel in the brochure noted above, and, quoted with Deitch, in Lesli Rotenberg, "CC Studios: Children's Books on Video Come Out of the Woods," *Publishers Weekly* 28, no. 18 (November 1985): 35-37.

12. Correspondence: Weston Woods, letter and typed draft dated June 4, 1981.

13. Comment based on a viewing of videos of the "Mr. Rogers" programs in the possession of Millie Keats.

CHAPTER NINE

1. *Library Journal* 79, no. 1 (June 15, 1954): 1237. Randall was head of the children's and schools' department of Cossitt Library, Memphis, Tennessee. Her review contained fifty-nine words in all.

2. Review of *Wonder Tales, Herald Tribune*, November 13, 1955; review of *Jennie's Hat, Los Angeles Herald Examiner,* January 17, 1966.

3. Christmas roundups in the *Albany Times Union* (December 4, 1966) and the *Knoxville News-Sentinel* (December 18, 1966) appear to be syndicated from the much earlier *Saturday Review* piece on *Jennie's Hat* (April 16, 1966). The *New Haven Register* review of the same book (May 8, 1966) is plundered from George Woods' review in *The New York Times* (April 3, 1966).

4. "Ezra Jack Keats on Children's Books," *The New Republic: A Journal of Politics and the Arts* 173, no. 23 (December 6, 1975): 22-23; 175, no. 22 (November 27, 1976): 31-32.

5. *Herald Tribune Book Review,* December 16, 1956.

6. That mistake seems only trivial beside a review of *Pet Show!* in the *Washington Post* (Nov. 8, 1970) where Archie is referred to as Peter throughout.

7. Sendak's 1993 picture book, *Down in the Dumps with Jack and Guy,* was published in New York by HarperCollins. As a fantastic adaptation of two arbitrarily linked nursery rhymes it bears no relationship

to Keats' down-to-earth narratives, but its packed coloring and intense emotion indicate parallels of intention that are worth exploring.

8. Joyce Nakamura, ed., *Something about the Author,* vol. 8 (Detroit: Gale, 1976), 198.

9. Keats' letter and Larrick's reply are in *Saturday Review* (October 2 and 16, 1965): 38 and 79.

10. *Interracial Books for Children* 3, no. 4 (Autumn 1971): 3.

11. In fact, the antiracialists were not the only single-issue critics to have a go at his books. Head-counting feminists were also present, complaining of the absence, or the low profile, or the stereotyping of girls.

12. *Saturday Review* 9 (November 1963): 56.

13. Correspondence: Jensen, Virginia; and Viking.

14. Listing translations here would make for tedious reading. Notes have therefore been appended to relevant titles in *Ezra Jack Keats: A Bibliography and Catalogue.*

15. Letter etc. filed with *Pet Show!* (0047) and at 0092.05.

16. Correspondence: DuPree; and Becky Shoffner (director of community relations, Burlington City Schools), "An Author Meets His Fans," *North Carolina Public Schools* 39, no. 3 (Spring 1975): 4-5.

17. In a review of *Black Children, White Dreams* by Thomas J. Cottle in *The New Republic* 171, no. 10 (September 7, 1974): 26-27.

Designed and composed in Adobe New Baskerville by Dana Bilbray.
Produced by Regent Publishing Services, St. Louis, MO.
Printed on 113 gsm matte artpaper and bound in Hong Kong.

Index